Digital Color and Type

A RotoVision Book
Published and distributed by RotoVision SA
Rue du Bugnon 7

CH–1299 Crans-Près-Céligny
Switzerland

RotoVision SA, Sales & Production Office
Sheridan House, 112/116A Western Road
Hove, East Sussex BN3 1DD, UK

Tel: +44(0)1273 727 268
Fax: +44(0)1273 727 269

E-mail: sales@rotovision.com
www.rotovision.com

10 9 8 7 6 5 4 3 2 1

ISBN 2-88046-688-1

Book design by Rob Carter

Printed and Bound in Singapore by Kyodo Printing Pte Ltd.

Digital Color and Type

Rob Carter

RotoVision

Contents

Introduction

Working with color and type poses numerous challenges. Paying attention to all of the minute but critical details in type such as typeface selection and spacing requires sensitivity, patience, and practice. When color and type join forces, the challenges are significantly magnified. Color should not only be chosen to create a desired effect or mood; it should also be chosen with typographic legibility in mind. We are accustomed to seeing black type on white paper, and traditionally this combination is most readable. From the moment color is added to either type or its background, legibility is compromised. As a result, the designer's task is to juggle the properties of both color and type, thus optimizing their communicative potential. Arm in arm, color and type are capable of breathing life into otherwise dull communication.

Prior to the onslaught of desktop computers, designers selected color from swatch-books and palette of colors. Now the designer is able to select millions of colors from electronic palettes that can be accessed instantaneously. The sheer number of color choices is overwhelming. With innumerable fonts and a tremendous number of colors available on the desktop, how does one begin the complicated process of meaningfully combining type and color on the desktop? What factors specific to combining type and color should you consider, and how do you know when the type and color combinations you have chosen are the right ones? *Working with Computer Type: Digital Colour and Type* tackles these questions and others, offering a practical guide for art directors, graphic designers, and desktop publishers at all levels.

The book is a guide for working with color and type, as well as a practical tool for selecting color combinations for type. A panorama of type and color specimens based on basic color schemes

derived from the color wheel provides an invaluable guide for selecting your own type and color combinations. 30 case studies related to working with color and type reveal how some of the world's leading graphic designers integrate type and color, use color as a communicative element, and create color schemes for expressive and communicative purposes. While the book focuses on printed communication, the timeless concepts presented apply also to electronic and interactive applications.

With the advent of desktop publishing, two seemingly incompatible approaches to typographic practice have emerged. The first holds faithfully to typographic tradition. The second rebels from tradition, sometimes appearing to cajole and harass the typographic establishment by seeking alternative means for typographic expression. Inevitably, we come to the conclusion that both approaches are valid, for typographic design is always contextual in nature: different problems require different solutions. A look at today's typography reveals tremendous diversity from traditional books to the effusive pages of subculture magazines.

Typographic standards have endured for centuries because they are thought to make type more legible, and thus more readable. But legibility has become a relative concept. The immediacy of television and electronic media, and new trends in printed communication have in recent years raised the level of typographic literacy among the general public. What was considered unreadable yesterday is readable today. The public is more visually sophisticated and typographically savvy than ever before.

The personal computer has become as much a toy as a tool, inspiring designers to playfully stretch typographic boundaries. "Rules" from past generations are ceremoniously bent, twisted, skewed, and ignored. The pixel has freed designers from the restraints of metal and film, enabling them to freely explore the language of type. If there is a loss of tradition, there is most certainly a gain in creative invention and discovery.

Typographic experimentation is not new. Art and design movements from the dawn of the 20th century – Futurism, de Stijl, Dada, Constructivism, and Post-Modernism – responded to new technologies, challenged the status quo, and made significant advances in the field of typography. But of all technologies, none (save the invention of moveable type) has rocked the typographic establishment's boat as vigorously as computer desktop technology.

Ultimately, this book is a call to action. It challenges you to extend your understanding of typography and its visual potential by using the computer to engage in risk-taking experimentation. This can occur in the process of working on actual projects, or as an end in itself by playing with type during moments of free time. Squeeze in the time whenever possible. Exploring type is fun, and ultimately, it changes the way you think about type and work with it.

Before throwing yourself into experimentation, it is essential to have a firm grasp of traditional typography. Walking precedes running. You will find this book enthusiastically supporting this premise.

Chapter 6 provides a review of long-established typographic guidelines. These "rules" provide a meaningful departure point for typographic experimentation. Chapter 7 offers a systematic way of breaking the rules and freely and effectively exploring the visual and expressive nature of typography. Chapter 8 takes you on a journey of typographic exploration and presents a portfolio of experimental compositions by typography students. Chapter 9 reveals the results of an experimental typographic workshop by a group of Dutch and American students. Chapter 10 profiles four international typographic designers. Included are portfolios of each designer's work, and typographic experiments made specifically for this book.

Some things never change, and in the typographic realm, principles upon which sound practice relies have remained essentially the same for centuries.

Fundamentals of type

Some things never change, and in the typographic realm, principles upon which sound practice relies have remained essentially the same for centuries. These principles have over time developed in response to the way in which we read – the way in which we visually perceive the letters and words on a page. Working effectively with computer type (or working with type using any tool, for that matter) requires a solid knowledge of these typographic fundamentals. The following pages provide the reader with the basic vocabulary needed for informed practice, and a fuller understanding and appreciation of the case studies presented within this book.

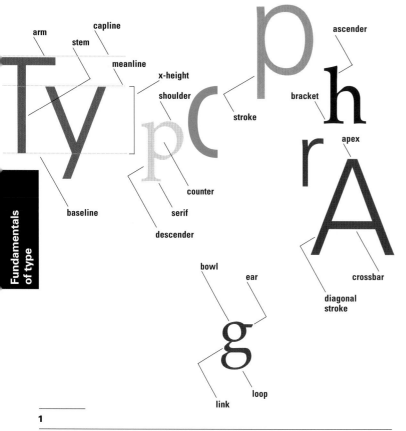

1

B B B B B B B

2

eye

Old Style characteristics:
Medium stroke contrast
Slanted stress
Oblique, bracketed serifs
Medium overall weight

Transitional characteristics:
Medium to high stroke contrast
Nearly vertical stress
Sharp, bracketed serifs
Slightly slanted serifs

Modern characteristics:
High stroke contrast
Vertical stress
Thin serifs
Serifs sometimes unbracketed

Egyptian characteristics:
Little stroke contrast
Little or no stress
Thick, square serifs
Large x-height

Sans serif characteristics:
Some stroke contrast
Nearly vertical stress
Squarish, curved strokes
Lower-case *g* has open tail

**Display typefaces do not
possess a fixed number of
characteristics.**

Old Style

Transitional

Modern

Slab serif

Sans serif

Display

k

leg
foot

j

tail

3

The anatomy of type

The colorful terms used to describe type are not unlike the terms used to describe the parts of our own bodies. Letters have arms, legs, eyes, spines, and a few other parts, such as tails and stems, that we fortunately do not possess. These are the parts that have historically been used to construct letterforms. Learning this vocabulary can help the designer gain appreciation for the complexity of our alphabet, which at first glance appears very simple (fig. **1**). The structure of letters within the alphabet remains constant regardless of typeface. An upper-case *B,* for example, consists of one vertical and two curved strokes. These parts, however, may be expressed very differently from typeface to typeface (fig. **2**).

Type classification

An inexhaustible variety of type styles is available for use today, and many attempts to classify these into logical groupings have fallen short due to the overlapping visual traits of typefaces. A flawless classification system does not exist; however, a general system based on the historical development of typefaces is used widely. This delineation breaks down typefaces into the following groups: Old Style, Transitional, Modern, Slab Serif (also called Egyptian), Sans Serif, and Display (fig. **3**).

The typographic font

In desktop publishing, the terms typeface and font are often used synonymously; however, a typeface is the design of characters unified by consistent visual properties, while a font is the complete set of characters in any one design, size, or style of type. These characters include but are not limited to upper- and lower-case

spine

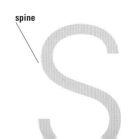

letters, numerals, small capitals, fractions, ligatures (two or more characters linked together into a single unit), punctuation, mathematical signs, accents, monetary symbols, and miscellaneous dingbats (assorted ornaments or fleurons designed for use in a font). Supplementing some desktop fonts are expert sets, which include characters such as small caps, a good selection of ligatures, fractions, and nonaligning figures. Minion Regular provides an excellent example of a font and its attendant expert set (fig. **4**).

The type family

A type family is a group of typefaces bound together by similar visual characteristics. Members of a family (typefaces) resemble one another, but also have their own unique visual traits. Typefaces within families consist of different weights and widths. Some type families consist of many members; others are composed of just a few. Extended families such as Stone include both serif and sans serif variations (fig. **5**).

Typographic measurement

The two primary units of measure in typography are the pica and the point. There are approximately six picas or 72 points to an inch; there are twelve points to a pica (fig. **6**). Points are used to specify the size of type, which includes the cap height of letters, plus a small interval of space above and below the letters. Typefaces of the same size may in fact appear different in size, depending on the size of the x-height. At the same size, letters with large x-heights appear larger than letters with smaller x-heights. Points are also used to measure the distance between lines; picas are used to measure the lengths of lines. The unit, a relative measure determined by dividing the em (which is the square of the type size), is used to reduce or increase the amount of space between

abcdefghijklmnopqrstuvwxyz
ABCDEFGHIJKLMNOPQRSTUVWXYZ&
ABCDEFGHIJKLMNOPQRSTUVWXYZ&
(.;:,!?""''~''\\'/··/^˅ ~'"«»‹›- — —)
1234567890 1234567890 ($^{1234567890}/_{1234567890}$)
¼⅓½⅔¾⅝⅞%‰ [+√π=≠±≤≥÷∞°]
ﬀﬁﬂﬃﬄŒßæœ $£§¢
ÂÅÁÇÍÎÏØÓÒÔÚ áéíóúåäëïöüàèìòùâêîôû
¶‡†•⋆∧ ©™@

4

Stone Serif

Regular
Regular Italic
Semibold
Semibold Italic
Bold
Bold Italic

Stone Sans

Regular
Regular Italic
Semibold
Semibold Italic
Bold
Bold Italic

5

6 picas = 1 inch
12 points = 1 pica
72 points = 1 inch

6

letters, a process called tracking. Adjusting the awkward space between two letters to create consistency within words is called kerning.

The typographic grid

A typographic grid is used to aid the designer in organizing typographic and pictorial elements on a page and establishing unity among all of the parts of a design. Grids vary in com-

Legibility

plexity and configuration depending upon the nature of the information needing accommodation, and the physical properties of the typographic elements. Standard typographic grids possess flow lines, grid modules, text columns, column intervals, and margins (fig. **7**).

If the goal when working with type is to make it more readable, then heeding established legibility guidelines is of utmost importance. Departure from these "rules" should be attempted only after a designer is totally familiarized with them, and when content lends itself to expressive interpretation. Legibility represents those visual attributes in typography that make type readable.

Choosing typefaces

The first step in making type legible is to choose text typefaces that are open and well proportioned, typefaces that exhibit the regularity of classical serif faces, such as Baskerville, Bembo, Bodoni, Garamond; and the sans serif faces Franklin Gothic, Frutiger, and Gill Sans (fig. **8**). Typefaces with visual quirks, stylistic affectations, and irregularities among characters are less legible. Typefaces such as these may be fine, however, when used as display type.

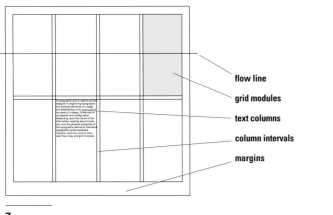

flow line

grid modules

text columns

column intervals

margins

7

Type size, line length, and line spacing

Text that flows naturally when read is achieved when a harmonious relationship exists between type size, line length, and the spaces between lines of type (line spacing or leading). Even well-designed typefaces suffer from legibility impairment when just one of these aspects is out of balance. An adjustment to one of these factors usually requires an adjustment to one or more of the others.

Serif

Bembo

Baskerville

Bodoni

Century Expanded

Garamond

Sans serif

Franklin Gothic

Frutiger

Futura

Gill Sans

Helvetica

8

Continuous text type that is too large or too small easily tires the reader. Optimum sizes for text type are between 8 and 11 points. Also, typefaces with a relatively large x-height improve readability.

Overly long or short lines of type also tire the reader and destroy a pleasant reading rhythm. Long lines are burdensome and tedious, whereas short lines cause choppy eye movements. Paying attention to the number of characters per line is a key in determining appropriate line lengths. It is generally agreed that lines of type consisting of a maximum of sixty or seventy characters promote readability (fig. **9**).

Line spacing ensures that the reader is not distracted by lines of type that visually run together. Without adequate space between lines, the eye struggles to distinguish one line from the next. Where lines are too widely spaced, the reader has trouble locating the next line. For optimum sizes of text type (8-11 points), one to four points of line spacing can help the reader easily discern each line, thus improving readability (fig. **10**).

8/9
Line spacing ensures that the reader is not distracted by lines of type that visually run together. With inadequate space between lines, the eye struggles to distinguish one line from the next. Where lines are too widely spaced, the reader has trouble locating the next line. For optimum sizes of text type (8-11 points), one to four points of line

8/11
Line spacing ensures that the reader is not distracted by lines of type that visually run together. With inadequate space between lines, the eye struggles to distinguish one line from the next. Where lines are too widely spaced, the reader has trouble locating the next line. For

8/10
Line spacing ensures that the reader is not distracted by lines of type that visually run together. With inadequate space between lines, the eye struggles to distinguish one line from the next. Where lines are too widely spaced, the reader has trouble locating the next line. For optimum sizes of text type (8-11

8/12
Line spacing ensures that the reader is not distracted by lines of type that visually run together. With inadequate space between lines, the eye struggles to distinguish one line from the next. Where lines are too widely spaced, the reader has trouble locating the next line. For

10

Overly long or short lines of type also tire the reader and destroy a pleasant reading rhythm. Long lines are burdensome and tedious, whereas short lines cause choppy eye movements. Paying attention to the number of characters per line is a key in determining appropriate line lengths. It is generally agreed that lines of type consisting of a maximum of sixty or seventy characters promote readability.

Overly long or short lines of type also tire the reader and destroy a pleasant reading rhythm. Long lines are burdensome and tedious, whereas short lines cause choppy eye movements. Paying attention to the number of characters per line is a key in determining appropriate line lengths. It is

Letter spacing

A number of factors determines correct letter spacing, including the typeface used, and the size and weight of the type. Consistent letter spacing provides an even typographic "color," a term referring to the texture and overall lightness or darkness of text. Consistent and even color is an attribute that enhances readability. Tighter letter spacing darkens the text, as in this sentence. L o o s e r l e t t e r s p a c i n g l i g h t e n s t h e t e x t. Pushed to either extreme, text becomes less readable. The chosen effect can enliven a page and enhance communication.

Word spacing

Word spacing should be proportionally adjusted to letter spacing so that letters flow gracefully and rhythmically into words, and words into lines. Too much word spacing destroys the even texture desired in text and causes words to become disjointed, as in this sentence. Toolittlewordspacing causeswordstobumpintooneanother. Either condition is hard on the reader.

Weight

The overall heaviness or lightness of the strokes composing type can affect readability. For typefaces that are too heavy, counters fill in and disappear. Typefaces that are too light are not easily distinguished from their background. Typefaces of contrasting weight are effectively used to create emphasis within text.

Width

Narrow typefaces are effectively used where there is an abundance of text, and space must be preserved. But readability is diminished when letters are too narrow (condensed) or too wide (expanded). Condensed letters fit nicely into narrow columns.

Italics

Italic and oblique type should be used with prudence, for large amounts of slanted characters set into text impede reading. Italics are best suited to create emphasis within text rather than to function as text.

Capitals versus lower case

TEXT SET IN ALL CAPITAL LETTERS NOT ONLY CONSUMES MORE SPACE THAN TEXT SET IN LOWER CASE, IT SEVERELY RETARDS THE READING PROCESS. LOWER-CASE LETTERS IMBUE TEXT WITH VISUAL CUES CREATED BY AN ABUNDANCE OF LETTER SHAPES, ASCENDERS, DESCENDERS, AND IRREGULAR WORD SHAPES. TEXT SET IN ALL CAPITALS IS VOID OF THESE CUES, FOR IT LACKS THIS VISUAL VARIETY.

Serif versus sans serif

Because of the horizontal flow created by serifs, it was thought at one time that serif typefaces were more readable than sans serif typefaces. Legibility research, however, reveals little difference between them. Sensitive letter spacing is a more important consideration.

Justified versus unjustified

Text can be aligned in five different ways: flush left, ragged right; flush right, ragged left; justified; centered; asymmetrically.

Flush left, ragged right text produces very even letter and word spacing, and because lines of type terminate at different points, the reader is able to easily locate each new line. This is per-haps the most legible means of aligning text.

Flush right, ragged left alignments work against the reader by making it difficult to find each new line. This method is suitable for small amounts of text, but is not recommended for large amounts.

Justified text (text aligned both left and right) can be very readable if the designer ensures that the spacing between letters and words is consistent, and that awkward gaps called "rivers" do not interrupt the flow of the text. Desktop publishing software enables the designer to fine tune the spacing.

Centered alignments give the text a very formal appearance and are fine when used minimally. But setting large amounts of text in this way should be avoided.

Asymmetrical alignments
are used when the designer
wishes to

break
the text down into logical "thought units,"

or to give the page
a more expressive appearance.
Obviously,
setting large amounts of text
in this manner

will tire the reader.

Color is visual magic, a language of illu- sion. Color is also reflected light, and as lighting conditions change, so does color. This explains why as night falls colors fade, and why the colors of a landscape vary significantly when viewed at different times of the day.

Understanding color

Color is visual magic, a language of illusion. Color is also reflected light, and as lighting conditions change, so does color. This explains why as night falls colors fade, and why the colors of a landscape vary significantly when viewed at different times of the day. When we see a color, what we actually see is an object that absorbs certain wavelengths of light and reflects others back to our eyes. For example, a red object absorbs all of the light rays except the red rays which are filtered back to the eyes. Black objects absorb all of the light rays, reflecting none back to our eyes; white objects absorb no rays, reflecting all of them back to our eyes. This phenomenon was first revealed in 1666 by Isaac Newton who found that by passing a beam of white light through a prism, he could break it up into the familiar spectrum of rainbow colors: violet, indigo, blue, green, yellow, orange, and red. We are most familiar with this spectrum, and the human eye easily perceives it. In reality, the spectral colors consist of a vast array of hues, each corresponding to a specific wavelength of light.

This chapter reviews basic color theory, and defines important color terms. For the beginner, it lays a solid foundation for building a deeper knowledge of color. For the professional designer and desktop publisher, it provides a welcome review. Learning to see color and obtaining an understanding of its inherent properties are the first steps to working effectively with color and type.

The color wheel

The color wheel is a helpful tool that shows the basic organization and interrelationships of colors. It is also used as a tool for color selection. This color wheel provides basic color terminology that anyone working with type and color should be completely familiar with. Many color wheel models exist, and some are quite complex. This wheel consists of 12 basic colors (fig. 1). It is conceivable for a wheel to consist of an infinite number of variations, too subtle for the human eye to discern. Contained within the circle of color is a square of black, which is obtained by mixing together all of the surrounding colors. Though this color wheel consists of only 12 colors, it is the root of all other colors, a pure statement of chromatic harmony, and a fountain of imagination and emotion.

1

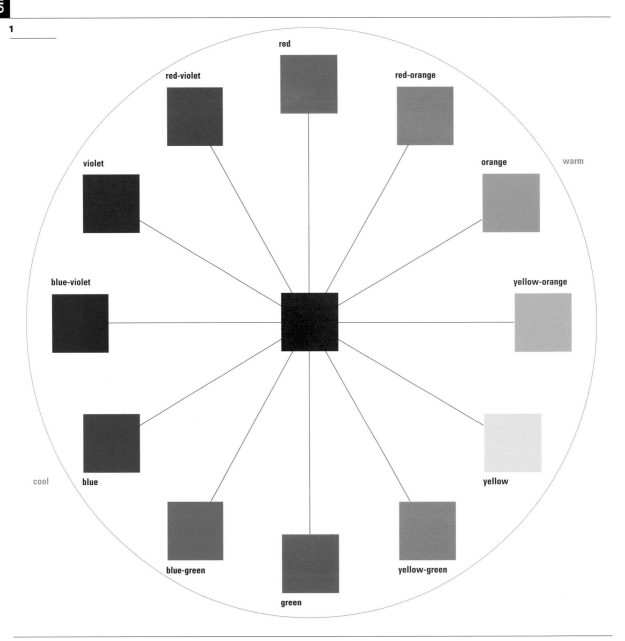

Properties of color

Three different sets of primary hues are accepted for use in different disciplines. The first set consists of red, yellow and blue and is used by artists and designers. Pigments of these colors can be mixed to obtain all other colors (top). The second set of primaries are red, green and blue. Called the additive primaries, these are the primaries of light and are used in science. These are also the colors found on the computer screen. When these colors are added together in different amounts they form all other colors; when added together equally they produce white light (middle). The third set consists of magenta, yellow, and cyan. These are the subtractive primaries and are used by printers. In printing, color separations are made by using filters to subtract light from the additive primaries, resulting in the subtractive process printing colors (bottom).

Hue

Hue is simply another name for color. The pure hues are identified by familiar names such as red, violet, green, purple, yellow. In the world of commercial products and pigments, hues have been given thousands of names. Desert Rose, Winter, Woodland Green, Apache Red, and African Violet may evoke romantic and exotic thoughts, but these names, aside from their marketing value, have little to do with the composition of the colors they represent. In reality, few legitimate names exist for hues. The basic twelve-color wheel pictured on the opposite page features the primary hues red, yellow, and blue; the secondary hues orange, green, and violet; and the six tertiary hues red-orange, orange-yellow, yellow-green, blue-green, blue-violet, and red-violet (fig. 2). The secondary hues are obtained by mixing equal amounts of two primaries; the tertiary hues are acquired by mixing equal amounts of a primary and an adjacent secondary hue. Complementary colors are opposite hues on the color wheel, such as red and green, violet and yellow. Due to the vast range of reds, yellows, and blues, not all color wheels introduce the same primary hues (fig. 3). Primaries are considered absolute colors and cannot be created by mixing other colors together. However, mixing the primaries into various combinations creates an infinite number of colors.

2

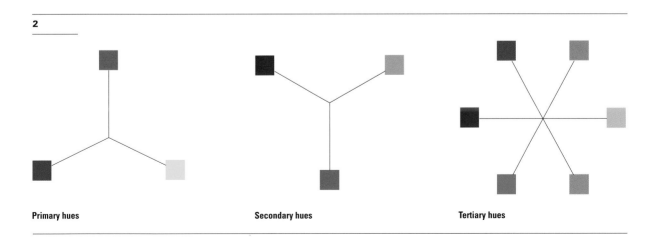

Primary hues Secondary hues Tertiary hues

Value

Value refers to the lightness or darkness of a color. It is a variable that can substantially alter a color's appearance, and as we will see in the next chapter, it is also an important factor in achieving legibility with type and color. A hue changes in value when either white or black are added to it. A color with added white is called a tint (fig. 4); a color with added black is called a shade (fig. 5). Generally speaking, pure hues that are normally light in value (yellow, orange, green) make the best tints, while pure hues that are normally dark in value (red, blue, violet) make the most desirable shades. The palette of colors below shows a spectrum of tints and shades based on the hues from the color wheel (fig. 6). Looking at these colors clearly shows that changes in value greatly expand color possibilities. The bottom row (fig. 7), consisting of the achromatic colors white, black, and gray, is presented in increments of 10%.

1 2 3 4 5 6 7 8 9 10 11 12

Twelve basic hues

6

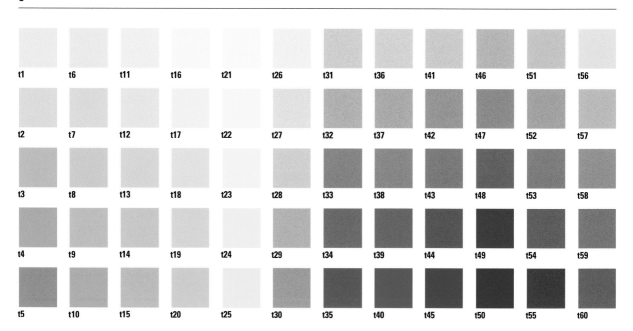

t1 t6 t11 t16 t21 t26 t31 t36 t41 t46 t51 t56

t2 t7 t12 t17 t22 t27 t32 t37 t42 t47 t52 t57

t3 t8 t13 t18 t23 t28 t33 t38 t43 t48 t53 t58

t4 t9 t14 t19 t24 t29 t34 t39 t44 t49 t54 t59

t5 t10 t15 t20 t25 t30 t35 t40 t45 t50 t55 t60

Tints

4

A note about the color used in this book.
The process colors below include five tints of each pure hue on the color wheel, five shades, and the achromatic hues for a total of 143 colors. The colors are numbered for reference to the type and color combinations in chapter 4, and the case studies in chapter 5. This color palette could be expanded to include the most subtle variations, but quantity of colors is not the most important consideration. While in fact this palette offers hundreds of color possibilities, it is far more critical to learn to control color as it is used for typographic applications, and to develop a sensitive eye. When it comes to working with color and type, less is more. A CMYK conversion chart for the colors is located on page 156.

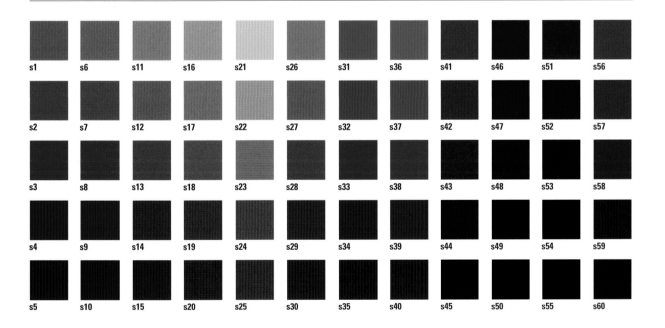

s1 s6 s11 s16 s21 s26 s31 s36 s41 s46 s51 s56
s2 s7 s12 s17 s22 s27 s32 s37 s42 s47 s52 s57
s3 s8 s13 s18 s23 s28 s33 s38 s43 s48 s53 s58
s4 s9 s14 s19 s24 s29 s34 s39 s44 s49 s54 s59
s5 s10 s15 s20 s25 s30 s35 s40 s45 s50 s55 s60

Shades

5

w k1 k2 k3 k4 k5 k6 k7 k8 k9 k10

Achromatic colors

Saturation

Also called chroma or intensity, saturation refers to the brightness of a hue. The highest saturation occurs in colors that are pure and unmixed. Any color mixture will diminish intensity. However, adding white, gray, black, or a complementary color most radically compromises intensity (fig. **8**). Variations of a single hue dulled in intensity by different amounts of an added complement are often referred to as tones. When complementary colors are placed in close proximity, the intensity of each is increased. This vibrant condition is referred to as simultaneous contrast (fig. **9**).

Color temperature

The terms "warm" and "cool" are used to express those hues that connote these respective qualities. In general, reds, oranges, and yellows "feel" warm, while blues, greens, and purples "feel" cool. Distinctions between warm and cool colors can be very subtle. For example, white paper can appear either warmer or cooler depending upon the slight influence of red or blue. The same applies to gray and black (fig. **10**).

a a a a a

These five letters demonstrate the principle of color saturation. The first letter is fully saturated and is the brightest. The second letter has added black and is darker; the third letter has white added to it and is lighter; the fourth contains red, the complement of green, and is darker and duller; the fifth letter has added blue and appears duller than the fully saturated color.

8

Two fully saturated and complementary colors vibrate as a result of simultaneous contrast.

9

warm
warmer
hot

Red, orange, and yellow are colors that suggest warmth. Colors appear hotter as yellow decreases and as red increases.

cool
cooler
cold

Blue, turquoise, and green are cool colors; blue is very cold. Green is slightly warmer due to the addition of yellow.

warm gray
cool gray

Warm gray contains a small percentage of red while cool gray casts a slight blue.

10

Seeing color

Perhaps the most important concept to realize about color is that it is conditional. No single color can be judged outside of its environment. Colors physically affect one another. We owe a debt to Josef Albers, an influential artist, designer, and educator who first developed a theory based on his observations about the relativity of color. His writings have pivotally influenced artists and designers for half a century. In his book *Interaction of Color* he states, "First, it should be learned that one and the same color evokes innumerable readings." He demonstrates that the same color can appear very different when placed on different backgrounds, and that different colors can appear nearly the same when juxtaposed with different backgrounds. In addition to changes in hue, colors are influenced in terms of lightness and darkness, warmness and coolness, and brightness and dullness, depending upon surrounding colors. When working with color and type, it is important to be aware of all the ways in which color contrasts can be accomplished. Albers advocated an active, experimental approach to color, one of practice before theory. The only way to truly see and understand a color is to observe it in relationship to its environment. In this sense, color can be "read" by designers and applied with sensitivity and sound judgment. The examples on this page reveal the interdependent nature of color (fig. **11**).

The two letters to the left are identical in color. Placing them on two different backgrounds makes them appear different in both hue and value. The dark green background absorbs green from the left *a*, leaving it lighter and more yellow. Conversely, the bright yellow background absorbs yellow from the right *a*, leaving it darker and bluer.

Two identical warm red letters appear very different on different backgrounds. The warm background makes the left letter *a* appear cooler, while the cool background of the right letter *a* accentuates the letter's warmth.

Though these two letters are the same color, a light background makes the letter *a* on the left appear less bright than the letter *a* on the right, which has a dark background.

Color transparency

When working with color and type, it is impor-
tant to establish color harmony, a condition
resulting both from the choice of colors and
their order in the visual field. Black, white, and
gray always form a harmonious relationship
because they resemble each other. Harmony is
enhanced, however, when the sequence
progresses naturally from black to gray to white
(fig. **12**). Just as artists mix paints to create new
colors, designers working with a computer can
"mix" colors by selecting mixtures from
available color palettes. Color mixing is simply
finding relationships among colors. Mixing two
colors to form a third, for example, creates a
visual bridge between the first two colors. The
third color is an offspring hue resembling both
parents. Placing a mixed color between two
parent colors is not only a harmonious ordering
of the hues, it creates the surprising illusion of
transparency. The original two colors appear as
sheets of colored acetate that overlap and form
a third color (fig. **13**). The ability to find
similarities among colors is an important part
of the color selection process, for it provides a
way of achieving harmony and concordance
among all the colors in a design.

**Black to gray to white forms
a natural and harmonious
sequence.**

12

**One is able to see just a
subtle hint of the red-violet
as the rather opaque light
yellow overlaps it.**

**A dark and light version of a
hue combine to form a
medium version of the hue.**

**The intense red is just
transparent enough to allow
the light yellow to peek
through it.**

**The green appears to overlap
and darken the blue.**

13

The color triangle

The color triangle is a diagram that shows the interrelationships of hue, black, and white, and the intermediate tints, shades, and gray (fig. **14**). Selecting colors along any axis of the triangle will generally result in harmonious combinations. It is important to realize that black, white, and hue are absolute, and that tints, shades, and grays possess innumerable variations. The axes shown with bold lines represent combinations that are very effective for use with type and background. Below, a few examples of the color triangle illustrate harmonious color combinations (fig. **15**).

14

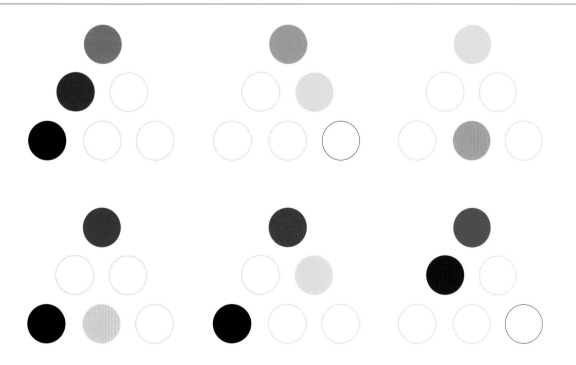

15

The basic color schemes

The color schemes below provide models for the exploration of harmonious, inventive, and communicative color combinations (fig. **16**). All of these schemes are based upon the physical laws, relationships, and inherent structure of the color wheel. It is significant that these color formulations are at the heart of the chromatic displays found in nature: red desert sandstone glowing against a deep indigo sky; the variegated green perennial garden, accented with crimson blooms. The basic color schemes are at the root of most effective color combinations and may be used alone or combined into more elaborate combinations. An understanding of these schemes is essential when working with color and type, for they provide a departure point for further color investigation. When used

Primary
A combination of the primary hues, red, yellow, and blue, these colors are elemental and pure.

Secondary
Any combination of the secondary colors violet, orange, and green, and their tints and shades.

Tertiary
Any combination of the eight tertiary colors: red-orange, yellow-green, blue-violet, blue-green, yellow-orange, and red-violet. These hybrid colors fall between the primaries and secondaries on the color wheel.

Monochromatic
Consists of any single hue and its tints and shades

Achromatic
Combinations of black, white, and gray hues.

16

with type, color should always be chosen for its visual appeal as well as for its ability to communicate and promote typographic legibility. With the aid of these basic schemes, you can venture daringly into uncharted terrain to create color combinations that are both functional and emotionally charged. Color is bold, soft, energetic, somber, feminine, masculine, trendy, and traditional. A limitless

communicator, color is capable of expressing the richness of culture, or portraying something as exciting as a calypso dance or as musty as a smoky restaurant. The case studies found in chapter 5 demonstrate how the basic color schemes can be expanded and adapted in creative typographic designs.

To provide a mental picture of the relative locations of colors on the color wheel, small color wheel diagrams, such as the one pictured here, accompany the schemes on this spread and in the color combinations in chapter 4. Compare these to the actual color wheel on page 20.

Complementary
A scheme comprising any two colors and their tints and shades that are directly opposite one another on the color wheel.

Split complementary
A juxtaposition of any hue and the two colors located on either side of its complement.

Analogous
Consists of a combination of colors that are adjacent to one another on the color wheel.

Neutral
A hue combined with a percentage of its complement or black.

Incongruous
Offbeat combinations consisting of a hue and a color to the right or left of its complement.

When color and type are combined, the visual as well as the emotional attributes of type are enhanced. At the same time, changing the color of type or its back- ground can signifi- cantly affect legibility.

Color and type

When color and type are combined, the visual as well as the emotional attributes of type are enhanced. At the same time, changing the color of type or its background can significantly affect legibility. How readable you decide type should be depends upon the intent of your message. When working with color and type, remember that the following guidelines are just that . . . *guidelines* to be tested and adapted to suit the unique needs of the typographic message.

A matter of contrast

Bodoni is a refined, crisp typeface designed in the 18th century. It is at its best when presented in black on white. The extreme thick and thin relationship of its strokes are compromised when printed in any other color combination. Compare Bodoni set in three different color combinations.

Bodoni

Bodoni

Bodoni

1

Black type on a white background is easiest to read. Notice how the gray background diminishes legibility. Reversing type to appear white on black inverts the contrast relationship, making the type less legible. Although reversing type is common practice, it is not advisable to set large amounts of text in this manner.

Black type on a white background is easiest to read. Notice how as backgrounds become darker in tone, legibility diminishes.

Black type on a white background is easiest to read. Notice how as backgrounds become darker in tone, legibility diminishes.

Black type on a white background is easiest to read. Notice how as backgrounds become darker in tone, legibility diminishes.

2

The impact of hue, value, and saturation on legibility

Legible typography possesses attributes that make it readable, and if attaining typographic readability is a priority, as most often it should be, a number of important factors must be juggled. These include the choice of typeface; type size; type weight; and letter, word, and line spacing (see chapter 1). When color is applied to type, the interplay of hue, value, and saturation must be considered.

Most typefaces are designed to be read as black letters on a white ground, and they achieve optimum legibility printed in this manner (fig. 1). There is nothing ambiguous about black and white. They are completely balanced opposites, offering exquisite contrast. When reading large amounts of type, the contrast of black on white is what readers are most accustomed to (fig. 2).

The most important thing you can do to achieve optimum legibility when working with color and type is to carefully weigh the three color properties to establish appropriate contrast between letters and their background. All colors possess a definable hue, value, and intensity by their very nature. When combining color and type, balancing these characteristics is critical.

Let us look at a couple of examples. The fully saturated, complementary colors blue and orange offer plenty of hue contrast, but when applied to type and background the edges of letterforms tend to vibrate, creating a disturbing kinetic effect that quickly numbs the eyes and tires the reader. Both of these colors possess a competing brightness, fighting for attention. If one of these hues is "softened" or "pushed back" by making it lighter or darker in value (selecting a tint or shade of the hue), the type becomes much more legible (fig. **3**). In a different example, two saturated, analogous colors such as blue and green provide sufficient contrast without a disturbing, dizzying effect. Because the green appears both lighter and brighter than the blue, there may be no need for further adjustment (fig. **4**). If analogous colors are too close to each other on the color wheel and if they do not provide enough hue or value contrast, adjustments should be made to sharpen the contrast (fig. **5**).

Type presented in the highly saturated blue and orange combination is very difficult to read. Adjusting the value of either the type or the background greatly improves legibility.

Type presented in the highly saturated blue and orange combination is very difficult to read. Adjusting the value of either the type or the background greatly improves legibility.

Type presented in the highly saturated blue and orange combination is very difficult to read. Adjusting the value of either the type or the background greatly improves legibility.

Type presented in the highly saturated blue and orange combination is very difficult to read. Adjusting the value of either the type or the background greatly improves legibility.

3

Type presented in the highly saturated blue and orange combination is very difficult to read. Adjusting the value of either the type or the background greatly improves legibility. Compare the legibility of the two top and the two bottom text blocks.

Blue and yellow-green hues seem to work well here. Even so, if the value of the yellow-green is tweaked slightly, legibility improves.

Blue and yellow-green hues seem to work well here. Even so, if the value of the yellow-green is tweaked slightly, legibility improves.

4

Blue and yellow-green hues seem to work well here. Even so, if the value of the yellow-green is tweaked slightly, legibility improves.

Red and orange, analogous colors close to each other on the color wheel, do not provide sufficient contrast for adequate legibility. Using a tint of the orange greatly improves the situation.

Red and orange, analogous colors close to each other on the color wheel, do not provide sufficient contrast for adequate legibility. Using a tint of the orange greatly improves the situation.

5

Red and orange, analogous colors close to each other on the color wheel, do not provide sufficient contrast for good legibility. Using a tint of the orange greatly improves the situation.

Of all the contrasts of color, value can be used to enhance legibility most significantly. Value contrasts effectively preserve the shapes and integrity of letters, making them more easily recognizable.

A good rule of thumb is to choose colors not directly across from one another, nor too close to one another on the color wheel. There will, of course, always be exceptions. Look for compatible colors but colors which also differ in value and intensity. If you must use a combination of hues that for some reason do not meet legibility standards, try improving them by turning value or intensity up or down.

Typeface and color

Every typeface possesses unique qualities that should be taken into consideration when choosing color. These qualities include proportion, weight, width, presence or absence

Some typefaces are less legible than others, even when printed in black on white and with optimum sizing and spacing. This is due to differences in design. Letters with extreme proportions (heavy, light, wide, or thin) or letters with visually challenging shapes are more difficult to read when color is added. Choose color combinations that preserve the integity of such typefaces. Compare the problematic examples on the left with examples on the right that incorporate proper color adjustments.

Some typefaces are less legible than others, even when printed in black on white and with optimum sizing and spacing. This is due to differences in design.

Some typefaces are less legible than others, even when printed in black on white and with optimum sizing and spacing. This is due to differences in design.

Some typefaces are less legible than others, even when printed in black on white and with optimum sizing and spacing. This is due to differences in design.

Some typefaces are less legible than others, even when printed in black on white and with optimum sizing and spacing. This is due to differences in design.

Some typefaces are less legible than others, even when printed in black on white and with optimum sizing and spacing. This is due to differences in design.

Some typefaces are less legible than others, even when printed in black on white and with optimum sizing and spacing. This is due to differences in design.

Some typefaces are less legible than others, even when printed in black on white and with optimum sizing and spacing. This is due to differences in design.

Some typefaces are less legible than others, even when printed in black on white and with optimum sizing and spacing. This is due to differences in design.

Some typefaces are less legible than others, even when printed in black on white and with optimum sizing and spacing. This is due to differences in design.

Some typefaces are less legible than others, even when printed in black on white and with optimum sizing and spacing. This is due to differences in design.

6

of serifs, and eccentricities in typeface design. A very thin or narrow typeface, a peculiar or ornamental face, or a script may appear very weak and illegible if hues are too similar or if values are too close. Enough contrast must exist to preserve the fidelity of the letterforms (fig. **6**).

Typographic "color"

Black and white are neutral colors. When type is printed in black or any other color, each separate type design possesses a different tone (figs. **7, 8**). This effect is sometimes referred to as typographic "color." Creating different tones for different parts of a text is important, for it is in this way that hierarchical order and emphasis are achieved. This principle is demonstrated in the text that you are now reading; the main text appears lighter, and the subheads appear darker though both are printed in black.

Notice the differences in the "color" of these ten text blocks. Though only two actual colors are used (black and red), each block of text appears different from every other block.

Notice the differences in the "color" of these ten text blocks. Though only two actual colors are used (black and red), each block of text appears different from every other block.

Notice the differences in the "color" of these ten text blocks. Though only two actual colors are used (black and red), each block of text appears different from every other block.

Notice the differences in the "color" of these ten text blocks. Though only two actual colors are used (black and red), each block of text appears different from every other block.

Notice the differences in the "color" of these ten text blocks. Though only two actual colors are used (black and red), each block of text appears different from every other block.

Notice the differences in the "color" of these ten text blocks. Though only two actual colors are used (black and red), each block of text appears different from every other block.

Notice the differences in the "color" of these ten text blocks. Though only two actual colors are used (black and red), each block of text appears different from every other block.

Notice the differences in the "color" of these ten text blocks. Though only two actual colors are used (black and red), each block of text appears different from every other block.

NOTICE THE DIFFERENCES IN THE "COLOR" OF THESE TEN TEXT BLOCKS. THOUGH ONLY TWO ACTUAL COLORS ARE USED (BLACK AND RED), EACH BLOCK OF TEXT APPEARS DIFFERENT FROM EVERY OTHER BLOCK.

NOTICE THE DIFFERENCES IN THE "COLOR" OF THESE TEN TEXT BLOCKS. THOUGH ONLY TWO ACTUAL COLORS ARE USED (BLACK AND RED), EACH BLOCK OF TEXT APPEARS DIFFERENT FROM EVERY OTHER BLOCK.

Notice the differences in the "color" of these ten text blocks. Though only two actual colors are used (black and red), each block of text appears different in color from every other block. This effect is a visual illusion created by the proportions and shapes of the typeface designs.

color

color

color

The principle of typographic "color" is also true of larger display type. Though these three words are all printed in black, each possesses a different tone due to the unique characteristics of the individual typeface designs.

Type spacing and color

Letter, word, and line spacing also affect type color. Words appear lighter in tone if letters are positioned further apart (fig. **9**). Likewise, as word and line spacing increase, type appears lighter in value (fig. **10**). Paying attention to the spacing needs of type as discussed in chapter 1 can greatly improve legibility when color contrasts are marginal or when large amounts of text must be set in color (fig. **11**).

Type size and color

Small type, type that is light in weight, and delicately proportioned type with serifs suffer greatly when contrast in hue or value is insufficient (fig. **12**). As type decreases in size, color contrast must increase in strength.

As letter spacing increases, words appear lighter in tone.

color color

color color

color color

9

You can achieve the illusion of darker or lighter text blocks as you decrease or increase interline spacing. Even if you are limited to the use of one color, you can create the appearance of several colors.

You can achieve the illusion of darker or lighter text blocks as you decrease or increase interline spacing. Even if limited to the use of one color, you can create the appearance of several colors.

You can achieve the illusion of darker or lighter text blocks as you decrease or increase interline spacing. Even if limited to the use of one color, you can create the appearance of several colors.

You can achieve the illusion of darker or lighter text blocks as you decrease or increase interline spacing. Even if limited to the use of one color, you can create the appearance of several colors.

10

If you find it necessary to present large amounts of text type in color, try increasing slightly the amount of space between lines. Even an additional point of space can make a significant difference, and a reader might be encouraged to continue rather than stop.

If you find it necessary to present large amounts of text type in color, try increasing slightly the amount of space between lines. Even an additional point of space can make a significant difference, and a reader might be encouraged to continue rather than stop.

If you find it necessary to present large amounts of text type in an elaborate color setting, try increasing slightly the amount of space between lines. Even an additional point of space can make a significant difference, helping a reader to more easily find the next line while reading.

11

The smaller and more delicate the type, the more value and intensity contrast is needed to ensure adequate legibility.

The smaller and more delicate the type, the more value and intensity contrast is needed to ensure adequate legibility.

The smaller and more delicate the type, the more value and intensity contrast is needed to ensure adequate legibility.

The smaller and more delicate the type, the more value and intensity contrast is needed to ensure adequate legibility.

12

Type on busy backgrounds

Busy backgrounds or textured backgrounds compete with the legibility of type. When placing type onto or reversing type from textured backgrounds, make certain there is plenty of contrast to maintain legibility (fig. **13**). When combining type with photographs, find a quiet place within the photo that will not compromise the type, or insert the type within a separate overlapping background.

A background texture can interfere with the type if it is too busy, loud, and abrasive. Make a color adjustment, if necessary, to uphold the type's integrity.

A background texture can interfere with the type if it is too busy, loud, and abrasive. Make a color adjustment, if necessary, to uphold the type's integrity.

A background texture can interfere with the type if it is too busy, loud, and abrasive. Make a color adjustment, if necessary, to uphold the type's integrity.

13

Screening type

Screening type is a way to expand color options without actually having to pay for additional colors. Screens are particularly effective for one- and two-color printing jobs. Type can be printed as a screen or reversed from a screened background. The percentage of the screen affects the legibility of the type (fig. **14**).

10% 20% 30% 40% 50% 60% 70% 80% 90% 100%

10% 20% 30% 40% 50% 60% 70% 80% 90% 100%

The choice of screen percentage is usually a matter of intuition. What are you trying to achieve with the type, and how legible must it be? Screens are traditionally specified in 5% increments, although computers enable you to input any percentage.

Working with process colors entails working with screens, for the wide ranging colors available for use are created with halftone dots of the process colors laid over one another (screen mixes). If type is printed in a combination of process screens – as it usually is – any inaccuracy in printing registration can result in soft, blurred, or ragged type due to straying dots. The problem is often compounded when both type and its background are printed with screen mixes. This problem is alleviated or eliminated when one or more of the process colors is 100%, when a high resolution halftone screen is used, when registration is accurate, and when type is not too small.

Type may safely be reversed from a four-color photograph to appear as white, or printed in color if there is enough contrast between the type and the photo. However, if type is too small or thin, there is an excellent chance the dots of the four-color image will invade the type characters and compromise their legibility (fig. **15**).

Outlines and shadows

If color contrast alone is not enough to make type stand out from its background, outlines and shadows can be useful. Since these treatments can be clumsy, trendy, and gimmicky, they should be used sparingly. Purpose and good judgment should guide their use. It is not advisable to use these effects with text type, for in terms of legibility they will do more harm than good. They are more successfully used with display type (fig. **16**).

A variety of outline and shadow effects.

16

Compare the placement of type in this photograph. In the left example, it is difficult to read because of **the competing background. The right example shows a much more effective positioning.**

15

Working with color
and type on the desktop

Know about color

Before you can get the most out of working with color and type, you shouk become completely familiar with the basic color and type topics presented in chapters 1-3 of this book. Seek other sources as well to gain as much knowledge as you can. But reading is only the first step; confidence and competence come only through dedicated, hands-on practice.

Define your objectives

What colors to add to type is never an arbitrary decision. Know your purpose and audience, and then choose color and type combinations that best represent them. With effective combinations of color and type, you can convey the intent of the message and set just the right mood. Always make typographic legibility your primary concern, departing from it only when appropriate.

Choose color for type and background

Remember that working with color and type is always a matter of both type *and* its background. You arrive at the most legible combinations when you strive for strong contrasts of hue (warm vs. cool), value (light vs. dark), saturation (vivid vs. dull), and combinations of these. But of these contrasts, value is the most critical. Think tints and shades before hues.

Choose dark on light combinations first

Type always reads better when letters are light and backgrounds are dark. But if light type on dark backgrounds works better for your purposes, go for it. Ultimately, the most important concept to remember is that contrast in value is essential.

Strive for color harmony

Though color harmony means many things to many people, a few suggestions will provide guidance: 1) Limit the number of colors to just a few, and select one to serve as the dominant color. 2) When considering hues, choose those with common characteristics such as analogous colors, or colors opposite one another on the color wheel. Harmony can result in both similar and dissimilar colors. 3) Don't use too many vivid colors; mix it up with shades and tints of well chosen pure hues. This will also provide your design with depth. 4) Use achromatic colors with pure hues, tints, and shades, as these combinations are always harmonious. 5) Begin with the basic color schemes shown on pages 28 and 29, and elaborate upon them as necessary.

Refer to color swatchbooks

When you are working on the computer desktop and you are selecting colors that will be printed, be aware that the computer screen does not accurately represent color. Always make color selections from printed swatchbooks, and then apply these selections to elements on the screen. You will then have an accurate idea about what the chosen colors will look like on press.

Select a color library

Whether working with spot or process (CMYK) color, choose a color-matching library and use it exclusively for each design job. Each library is based on a specific color system that will aid you in achieving consistency in your color selections. Color libraries include Pantone, Toyo, Trumatch, and Focoltone.

The color properties of hue, value, and saturation are important concerns when choosing color for type and its background. Carefully balancing these three color attributes leads to legible color and type combinations.

Color and type combinations

4

The color properties of hue, value, and saturation are critical concerns when choosing color for type and its background. Carefully balancing these three color attributes leads to legible color and type combinations. Color is an expression of light on the computer screen, and because of its brightness and glow, it appears significantly different than ink on paper. The combinations on the following pages will aid you in making selections based upon the appearance of color and type on the printed page. These specimens will also help you to assess the relative legibility of color and type combinations and to venture into more daring and expressive color terrain. Though these specimens do not exhaust all color and type possibilities (no single source can), you will nonetheless find a practical collection based upon an interaction of hues within five basic color schemes: primary, secondary, tertiary, monochromatic, and achromatic. The color palette used is presented on pages 22 and 23. It represents a thorough range of hues, values, and saturations. Each combination is numerically keyed to the process color conversion chart on page 146 for easy reference.

Since primary colors are equidistant on the color wheel, they offer significant hue contrasts. The primaries red and blue represent color temperature extremes. An interesting by-product of warm and cool colors is that warm colors appear to advance from the background, while cool colors recede. Make note of how the red type hovers above the blue backgrounds. Altering the saturation of the blue background aids legibility; compare the legibility of *1* and *5*.

color and type	color and type
1 type **1** background **t41**	10 type **t1** background **9**
color and type	color and type
2 type **1** background **t42**	11 type **t2** background **9**
color and type	color and type
3 type **1** background **t43**	12 type **t3** background **9**
color and type	color and type
4 type **1** background **t44**	13 type **t4** background **9**
color and type	color and type
5 type **1** background **9**	14 type **t5** background **9**
color and type	color and type
6 type **1** background **s41**	15 type **s1** background **9**
color and type	color and type
7 type **1** background **s42**	16 type **s2** background **9**
color and type	color and type
8 type **1** background **s43**	17 type **s3** background **9**
color and type	color and type
9 type **1** background **s44**	18 type **s4** background **9**

19 type **9** background **t1**

20 type **9** background **t2**

21 type **9** background **t3**

22 type **9** background **t4**

23 type **9** background **1**

24 type **9** background **s1**

25 type **9** background **s2**

26 type **9** background **s3**

27 type **9** background **s4**

28 type **t41** background **1**

29 type **t42** background **1**

30 type **t43** background **1**

31 type **t44** background **1**

32 type **t45** background **1**

33 type **s41** background **1**

34 type **s42** background **1**

35 type **s43** background **1**

36 type **s44** background **1**

Because they are so vivid, the hot and saturated red backgrounds engulf blue type, making it difficult to read. Legibility improves immensely with lighter red backgrounds, but these backgrounds appear more pink than red (19-22).

Yellow is the most luminous of the primary colors. Shades of yellow cast a green tint, creating the illusion of a complementary color relationship (42-45). Darker shades of red appear burgundy, and provide a contrast to the yellow backgrounds that greatly enhances legibility (51-54).

color and **type**

color and **type**

37 | type **1** background **t21**

color and **type**

color and **type**

38 | type **1** background **t22**

color and **type**

color and **type**

39 | type **1** background **t23**

color and **type**

color and **type**

40 | type **1** background **t24**

color and **type**

color and **type**

41 | type **1** background **5**

color and **type**

color and **type**

42 | type **1** background **s21**

color and **type**

color and **type**

43 | type **1** background **s22**

color and **type**

color and **type**

44 | type **1** background **s23**

color and **type**

color and **type**

45 | type **1** background **s24**

color and type

color and type

46 | type **t1** background **5**

color and type

color and type

47 | type **t2** background **5**

color and type

color and type

48 | type **t3** background **5**

color and type

color and type

49 | type **t4** background **5**

color and **type**

color and **type**

50 | type **t5** background **5**

color and **type**

color and **type**

51 | type **s1** background **5**

color and **type**

color and **type**

52 | type **s2** background **5**

color and **type**

color and **type**

53 | type **s3** background **5**

color and **type**

color and **type**

54 | type **s4** background **5**

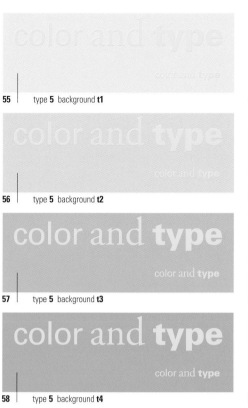

55 | type **5** background **t1**

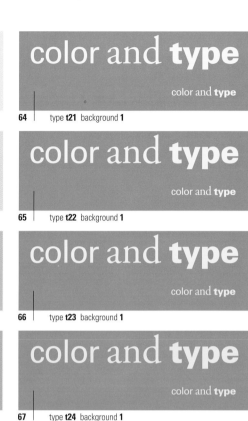

64 | type **t21** background **1**

56 | type **5** background **t2**

65 | type **t22** background **1**

57 | type **5** background **t3**

66 | type **t23** background **1**

58 | type **5** background **t4**

67 | type **t24** background **1**

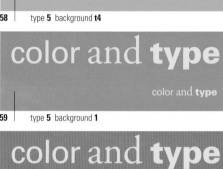

59 | type **5** background **1**

68 | type **t25** background **1**

Yellow type on a light red background appears jaundiced and difficult to read (55), while on darker shades of red, it is much more legible (60-63). The fully saturated combination of red and yellow also produces satisfying results since the two hues already differ greatly in value (59).

60 | type **5** background **s1**

69 | type **s21** background **1**

61 | type **5** background **s2**

70 | type **s22** background **1**

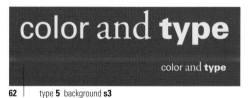

62 | type **5** background **s3**

71 | type **s23** background **1**

63 | type **5** background **s4**

72 | type **s24** background **1**

Primary

The inherent value contrast of the pure hues yellow and blue provides excellent legibility (77). Blue type on tints of the yellow background (73-76) and shades of blue type on yellow backgrounds (87-90) further improve legibility. Darker shades of yellow begin to approximate the value of the blue type, leading to a reduction in legibility (79-81).

color and **type**

color and **type**

73 type **9** background **t21**

color and **type**

color and **type**

74 type **9** background **t22**

color and **type**

color and **type**

75 type **9** background **t23**

color and **type**

color and **type**

76 type **9** background **t24**

color and **type**

color and **type**

77 type **9** background **5**

color and **type**

color and **type**

78 type **9** background **s21**

color and **type**

color and **type**

79 type **9** background **s22**

color and type

color and type

80 type **9** background **s23**

color and type

color and type

81 type **9** background **s24**

color and type

color and type

82 type **t41** background **5**

color and type

color and type

83 type **t42** background **5**

color and type

color and type

84 type **t43** background **5**

color and **type**

color and **type**

85 type **t44** background **5**

color and **type**

color and **type**

86 type **t45** background **5**

color and **type**

color and **type**

87 type **s41** background **5**

color and **type**

color and **type**

88 type **s42** background **5**

color and **type**

color and **type**

89 type **s43** background **5**

color and **type**

color and **type**

90 type **s44** background **5**

91 | type **5** background **t41**

92 | type **5** background **t42**

93 | type **5** background **t43**

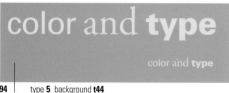

94 | type **5** background **t44**

95 | type **5** background **9**

96 | type **5** background **s41**

97 | type **5** background **s42**

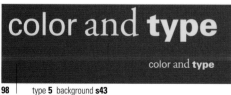

98 | type **5** background **s43**

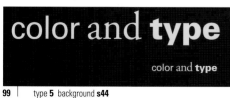

99 | type **5** background **s44**

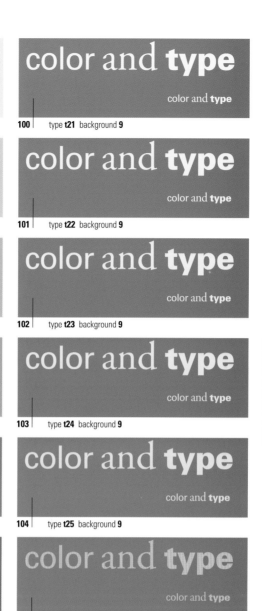

100 | type **t21** background **9**

101 | type **t22** background **9**

102 | type **t23** background **9**

103 | type **t24** background **9**

104 | type **t25** background **9**

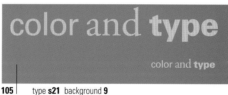

105 | type **s21** background **9**

106 | type **s22** background **9**

107 | type **s23** background **9**

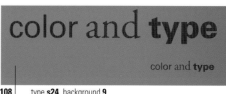

108 | type **s24** background **9**

Placing yellow type on a blue background can be a very effective color combination, though overall, this combination is harder to read than the reverse. Yellow type on darker shades of blue (96-99) or tints of yellow on saturated blue backgrounds (100-104) provide acceptable legibility.

109 | type **3** background **t31**

110 | type **3** background **t32**

Because they are similar in value, the fully saturated secondary hues green and orange are not distinctive enough for a legible palette (113). Orange type on a light green background (109) appears more legible than orange type on a dark green background (117).

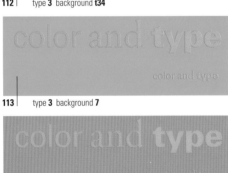

111 | type **3** background **t33**

112 | type **3** background **t34**

113 | type **3** background **7**

114 | type **3** background **s31**

115 | type **3** background **s32**

116 | type **3** background **s33**

117 | type **3** background **s34**

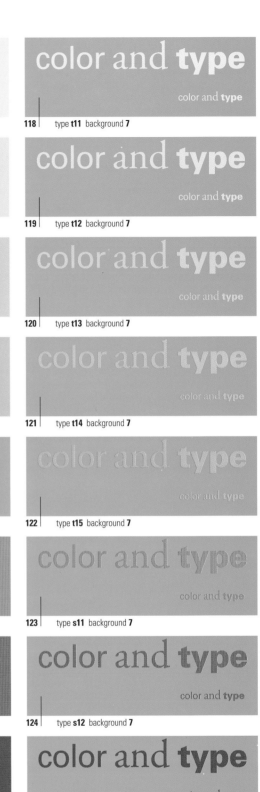

118 | type **t11** background **7**

119 | type **t12** background **7**

120 | type **t13** background **7**

121 | type **t14** background **7**

122 | type **t15** background **7**

123 | type **s11** background **7**

124 | type **s12** background **7**

125 | type **s13** background **7**

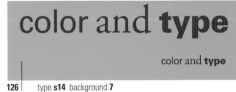

126 | type **s14** background **7**

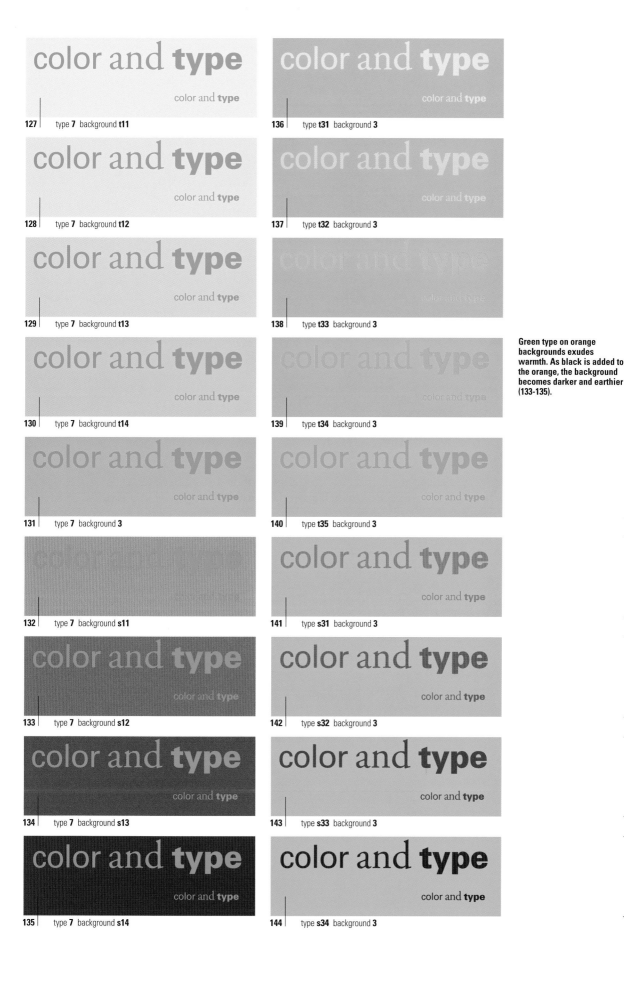

127 type **7** background **t11**

128 type **7** background **t12**

129 type **7** background **t13**

130 type **7** background **t14**

131 type **7** background **3**

132 type **7** background **s11**

133 type **7** background **s12**

134 type **7** background **s13**

135 type **7** background **s14**

136 type **t31** background **3**

137 type **t32** background **3**

138 type **t33** background **3**

139 type **t34** background **3**

140 type **t35** background **3**

141 type **s31** background **3**

142 type **s32** background **3**

143 type **s33** background **3**

144 type **s34** background **3**

Green type on orange backgrounds exudes warmth. As black is added to the orange, the background becomes darker and earthier (133-135).

color and type

color and type

145 | type **3** background **t51**

color and type

color and type

154 | type **t11** background **11**

color and type

color and type

146 | type **3** background **t52**

color and type

color and type

155 | type **t12** background **11**

color and type

color and type

147 | type **3** background **t53**

color and type

color and type

156 | type **t13** background **11**

Sufficient contrast between orange and violet translates into a readable color combination (149). As the shades of violet become darker, the orange type becomes more luminescent (150-153). The least readable combinations shown here are *147* and *162*. Violet is a regal color – pompous, sophisticated, and serious.

color and type

color and type

148 | type **3** background **t54**

color and type

color and type

157 | type **t14** background **11**

color and type

color and type

149 | type **3** background **11**

color and type

color and type

158 | type **t15** background **11**

color and type

color and type

150 | type **3** background **s51**

color and type

color and type

159 | type **s11** background **11**

color and type

color and type

151 | type **3** background **s52**

color and type

color and type

160 | type **s12** background **11**

color and type

color and type

152 | type **3** background **s53**

color and type

color and type

161 | type **s13** background **11**

color and type

color and type

153 | type **3** background **s54**

color and type

color and type

162 | type **s14** background **11**

163 type **11** background **t11**

164 type **11** background **t12**

165 type **11** background **t13**

166 type **11** background **t14**

167 type **11** background **3**

168 type **11** background **s11**

169 type **11** background **s12**

170 type **11** background **s13**

171 type **11** background **s14**

172 type **t51** background **3**

173 type **t52** background **3**

174 type **t53** background **3**

175 type **t54** background **3**

176 type **t55** background **3**

177 type **s51** background **3**

178 type **s52** background **3**

179 type **s53** background **3**

180 type **s54** background **3**

These color combinations become less legible as the orange background grows progressively darker. *163* is the most effective combination; *171* is nearly impossible to read.

181 | type **7** background **t51**

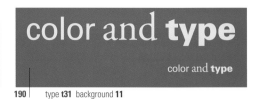

190 | type **t31** background **11**

182 | type **7** background **t52**

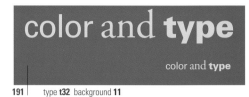

191 | type **t32** background **11**

The fully saturated hues of green and violet offer enough contrast for reasonable legibility (185). Most difficult to read are *183* and *198*, where value and intensity are almost identical.

183 | type **7** background **t53**

192 | type **t33** background **11**

184 | type **7** background **t54**

193 | type **t34** background **11**

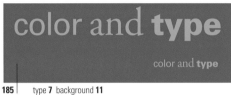

185 | type **7** background **11**

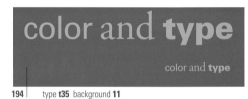

194 | type **t35** background **11**

186 | type **7** background **s51**

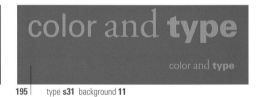

195 | type **s31** background **11**

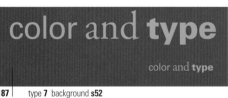

187 | type **7** background **s52**

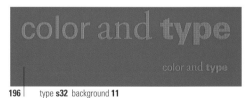

196 | type **s32** background **11**

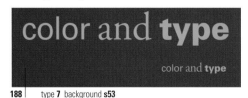

188 | type **7** background **s53**

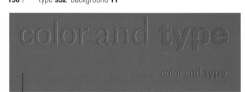

197 | type **s33** background **11**

189 | type **7** background **s54**

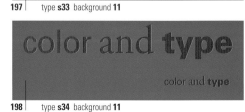

198 | type **s34** background **11**

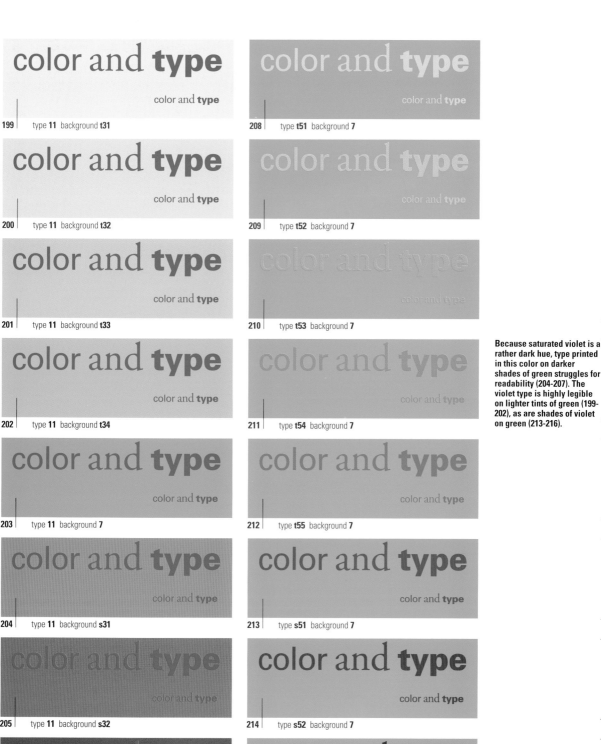

color and type
color and **type**

199 | type **11** background **t31**

color and type
color and **type**

200 | type **11** background **t32**

color and type
color and **type**

201 | type **11** background **t33**

color and type
color and **type**

202 | type **11** background **t34**

color and type
color and **type**

203 | type **11** background **7**

color and type
color and **type**

204 | type **11** background **s31**

color and type
color and **type**

205 | type **11** background **s32**

color and type
color and **type**

206 | type **11** background **s33**

color and type
color and **type**

207 | type **11** background **s34**

color and type
color and **type**

208 | type **t51** background **7**

color and type
color and **type**

209 | type **t52** background **7**

color and type
color and **type**

210 | type **t53** background **7**

color and type
color and **type**

211 | type **t54** background **7**

color and type
color and **type**

212 | type **t55** background **7**

color and type
color and **type**

213 | type **s51** background **7**

color and type
color and **type**

214 | type **s52** background **7**

color and type
color and **type**

215 | type **s53** background **7**

color and type
color and **type**

216 | type **s54** background **7**

Because saturated violet is a rather dark hue, type printed in this color on darker shades of green struggles for readability (204-207). The violet type is highly legible on lighter tints of green (199-202), as are shades of violet on green (213-216).

The two tertiary hues red-orange and yellow-orange lie close to one another on the color wheel. Since they are so similar, the most effective way to create sufficient contrast for type and background is through value. The red-orange type in full saturation reads best on lighter tints of yellow-orange (217-220); darker shades of red-orange type on yellow-orange backgrounds are also quite easy to negotiate with the eye (232-234). *223, 228, and 229* are nearly impossible to read.

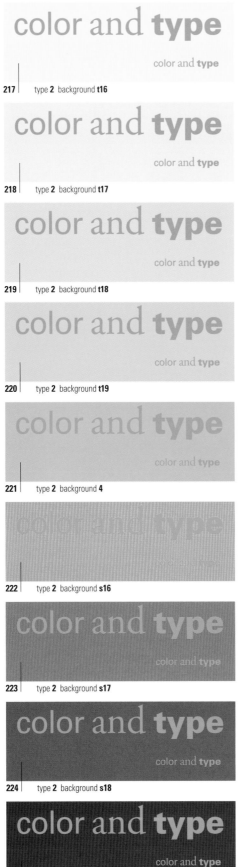

217 type **2** background **t16**

218 type **2** background **t17**

219 type **2** background **t18**

220 type **2** background **t19**

221 type **2** background **4**

222 type **2** background **s16**

223 type **2** background **s17**

224 type **2** background **s18**

225 type **2** background **s19**

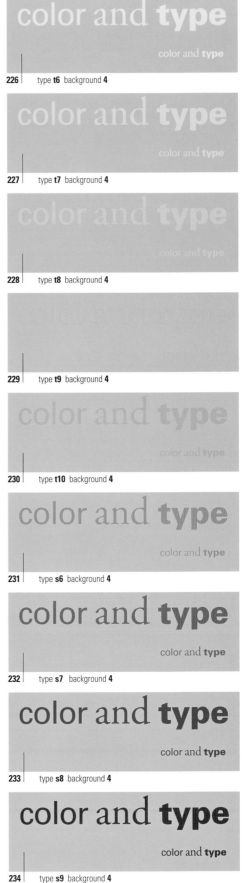

226 type **t6** background **4**

227 type **t7** background **4**

228 type **t8** background **4**

229 type **t9** background **4**

230 type **t10** background **4**

231 type **s6** background **4**

232 type **s7** background **4**

233 type **s8** background **4**

234 type **s9** background **4**

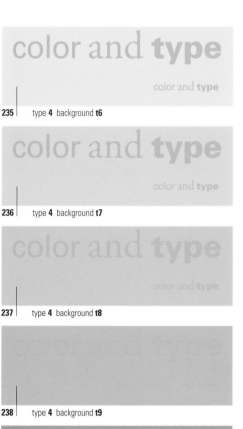

235 type **4** background **t6**

236 type **4** background **t7**

237 type **4** background **t8**

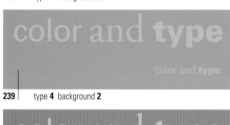

238 type **4** background **t9**

239 type **4** background **2**

240 type **4** background **s6**

241 type **4** background **s7**

242 type **4** background **s8**

243 type **4** background **s9**

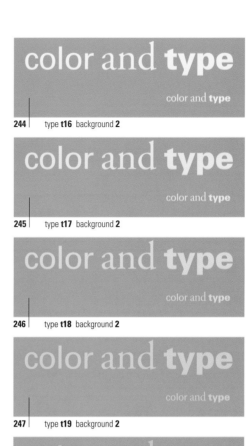

244 type **t16** background **2**

245 type **t17** background **2**

246 type **t18** background **2**

247 type **t19** background **2**

248 type **t20** background **2**

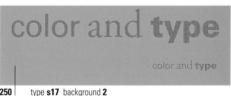

249 type **s16** background **2**

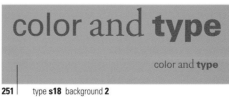

250 type **s17** background **2**

251 type **s18** background **2**

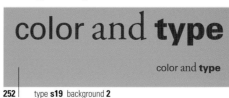

252 type **s19** background **2**

In reverse, this color combination lends better legibility with yellow-orange type placed on dark shades of the red-orange background (241-243), or with tints of yellow-orange type placed on red-orange backgrounds (244-246). These warm combinations are energetic and spontaneous.

Dissimilar hues are three colors apart on the color wheel. These combinations can appear quite harmonious and readable. Red-orange type on tints of yellow-green are highly readable (253-256), as are dark shades of yellow-orange type on yellow-green backgrounds (269, 270). On a somber, dark shade of yellow-green, the red-orange type reveals a glowing phosphorescence (261).

color and **type**

color and **type**

253 | type **2** background **t26**

color and **type**

color and **type**

254 | type **2** background **t27**

color and **type**

color and **type**

255 | type **2** background **t28**

color and **type**

color and **type**

256 | type **2** background **t29**

color and type

color and type

257 | type **2** background **6**

color and **type**

color and type

258 | type **2** background **s26**

color and **type**

color and **type**

259 | type **2** background **s27**

color and **type**

color and **type**

260 | type **2** background **s28**

color and **type**

color and **type**

261 | type **2** background **s29**

color and **type**

color and **type**

262 | type **t6** background **6**

color and **type**

color and **type**

263 | type **t7** background **6**

color and **type**

color and **type**

264 | type **t8** background **6**

color and **type**

color and **type**

265 | type **t9** background **6**

color and **type**

color and type

266 | type **t10** background **6**

color and **type**

color and **type**

267 | type **s6** background **6**

color and **type**

color and **type**

268 | type **s7** background **6**

color and **type**

color and **type**

269 | type **s8** background **6**

color and **type**

color and **type**

270 | type **s9** background **6**

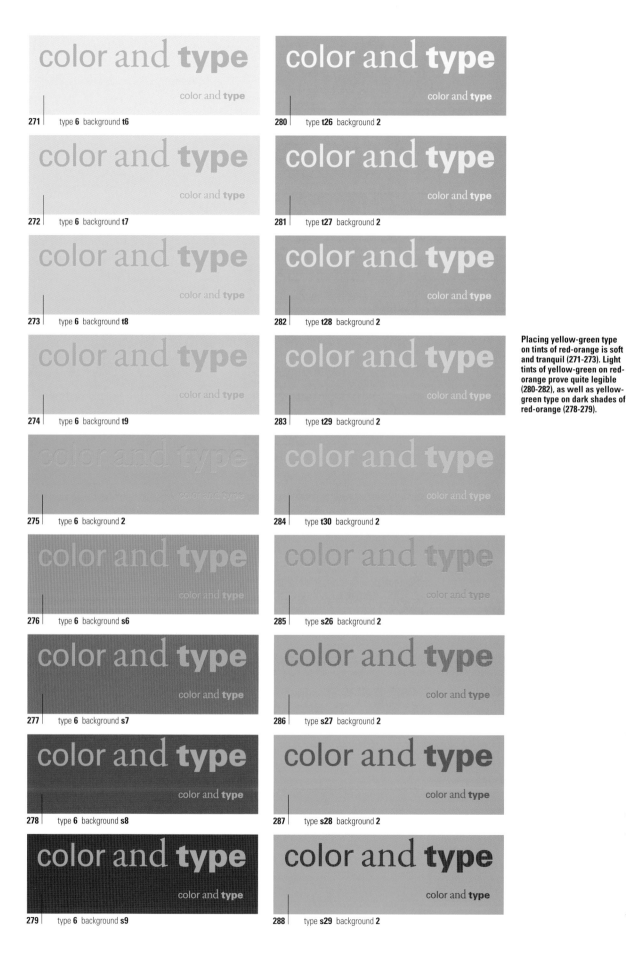

271 | type **6** background **t6**

272 | type **6** background **t7**

273 | type **6** background **t8**

274 | type **6** background **t9**

275 | type **6** background **2**

276 | type **6** background **s6**

277 | type **6** background **s7**

278 | type **6** background **s8**

279 | type **6** background **s9**

280 | type **t26** background **2**

281 | type **t27** background **2**

282 | type **t28** background **2**

283 | type **t29** background **2**

284 | type **t30** background **2**

285 | type **s26** background **2**

286 | type **s27** background **2**

287 | type **s28** background **2**

288 | type **s29** background **2**

Placing yellow-green type on tints of red-orange is soft and tranquil (271-273). Light tints of yellow-green on red-orange prove quite legible (280-282), as well as yellow-green type on dark shades of red-orange (278-279).

Blue-green and red-orange are complementary colors, and when used at full saturation for type and background, the two colors vibrate and vie for attention (293). However, using red-orange type with turquoise (any of the lighter tints of blue-green) creates a harmonious, serene, and legible color combination (289-292). Straight red-orange type placed on darker shades of blue-green advances dynamically forward in space to create acceptable combinations (296, 297).

289 | type **2** background **t36**

298 | type **t6** background **8**

290 | type **2** background **t37**

299 | type **t7** background **8**

291 | type **2** background **t38**

300 | type **t8** background **8**

292 | type **2** background **t39**

301 | type **t9** background **8**

293 | type **2** background **8**

302 | type **t10** background **8**

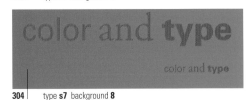

294 | type **2** background **s36**

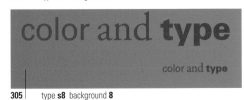

303 | type **s6** background **8**

295 | type **2** background **s37**

304 | type **s7** background **8**

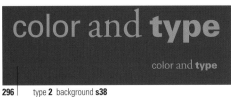

296 | type **2** background **s38**

305 | type **s8** background **8**

297 | type **2** background **s39**

306 | type **s9** background **8**

307 type **8** background **t6**

316 type **t36** background **2**

308 type **8** background **t7**

317 type **t37** background **2**

309 type **8** background **t8**

318 type **t38** background **2**

310 type **8** background **t9**

319 type **t39** background **2**

311 type **8** background **2**

320 type **t40** background **2**

312 type **8** background **s6**

321 type **s36** background **2**

313 type **8** background **s7**

322 type **s37** background **2**

314 type **8** background **s8**

323 type **s38** background **2**

315 type **8** background **s9**

324 type **s39** background **2**

The simultaneous contrast effect (see chapter 2) is more pronounced when blue-green type is placed upon a red-orange background (311). This combination is best avoided unless you are seeking this vibrant effect. Using combinations of lighter tints and darker shades of these hues will encourage the reader to continue reading.

Red-orange and blue-violet produce a friendly, kinetic color combination. However, setting large amounts of type in this manner inhibits the reading process. Using this combination for display type can yield fresh and exciting results.

325 | type **2** background **t46**

326 | type **2** background **t47**

327 | type **2** background **t48**

328 | type **2** background **t49**

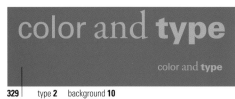

329 | type **2** background **10**

330 | type **2** background **s46**

331 | type **2** background **s47**

332 | type **2** background **s48**

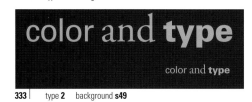

333 | type **2** background **s49**

334 | type **t6** background **10**

335 | type **t7** background **10**

336 | type **t8** background **10**

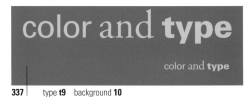

337 | type **t9** background **10**

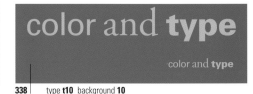

338 | type **t10** background **10**

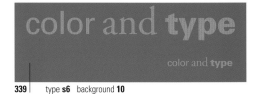

339 | type **s6** background **10**

340 | type **s7** background **10**

341 | type **s8** background **10**

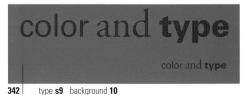

342 | type **s9** background **10**

343 | type **10** background **t6**

344 | type **10** background **t7**

345 | type **10** background **t8**

346 | type **10** background **t9**

347 | type **10** background **2**

348 | type **10** background **s6**

349 | type **10** background **s7**

350 | type **10** background **s8**

351 | type **10** background **s9**

352 | type **t46** background **2**

353 | type **t47** background **2**

354 | type **t48** background **2**

355 | type **t49** background **2**

356 | type **t50** background **2**

357 | type **s46** background **2**

358 | type **s47** background **2**

359 | type **s48** background **2**

360 | type **s49** background **2**

The simmering red-orange background is softened by the use of blue-violet for the type. Due to the relative darkness of blue-violet, legibility is compromised with the use of darker background shades of red-orange (349-351).

Tertiary

Neighbors on the color
wheel, red-orange and red-
violet have much in common.
Combining them produces
harmonious results, but
because these hues are sim-
ilar in value, it is advisable
to use contrasting tints and
shades. Compare the legi-
bility of *361* with *365*.

361 | type **2** background **t56**

362 | type **2** background **t57**

363 | type **2** background **t58**

364 | type **2** background **t59**

365 | type **2** background **12**

366 | type **2** background **s56**

367 | type **2** background **s57**

368 | type **2** background **s58**

369 | type **2** background **s59**

370 | type **t6** background **12**

371 | type **t7** background **12**

372 | type **t8** background **12**

373 | type **t9** background **12**

374 | type **t10** background **12**

375 | type **s6** background **12**

376 | type **s7** background **12**

377 | type **s8** background **12**

378 | type **s9** background **12**

color and **type**

color and **type**

379 | type **12** background **t6**

color and **type**

color and **type**

388 | type **t56** background **2**

color and **type**

color and **type**

380 | type **12** background **t7**

color and **type**

color and **type**

389 | type **t57** background **2**

color and **type**

color and **type**

381 | type **12** background **t8**

color and type

color and type

390 | type **t58** background **2**

color and **type**

color and **type**

382 | type **12** background **t9**

color and type

color and type

391 | type **t59** background **2**

color and **type**

color and **type**

383 | type **12** background **2**

color and **type**

color and type

392 | type **t60** background **2**

color and **type**

color and **type**

384 | type **12** background **s6**

color and **type**

color and **type**

393 | type **s56** background **2**

color and type

color and type

385 | type **12** background **s7**

color and **type**

color and **type**

394 | type **s57** background **2**

color and type

color and type

386 | type **12** background **s8**

color and **type**

color and **type**

395 | type **s58** background **2**

color and **type**

color and **type**

387 | type **12** background **s9**

color and **type**

color and **type**

396 | type **s59** background **2**

Notice how the value of red-violet and the shade of red-orange in *385* and *391* are nearly identical. For optimum legibility, it is far better to select a background that differs more significantly in value, such as *379-381*. Of course, the appearance of a more legible color combination may not offer the desired color effect. Balancing the needs of legibility and color effect is always a challenging undertaking that necessitates careful consideration.

397 | type **4** background **t26**

398 | type **4** background **t27**

399 | type **4** background **t28**

400 | type **4** background **t29**

401 | type **4** background **6**

402 | type **4** background **s26**

403 | type **4** background **s27**

404 | type **4** background **s28**

405 | type **4** background **s29**

Yellow-orange and yellow-green are both light in value and very intense (401). It is best to combine extreme tints and shades as in *397, 405, 406,* and *414* for acceptable legibility. The yellow-green, which is accented with yellow-orange type, possesses a warmth and freshness that might remind you of a balmy summer day.

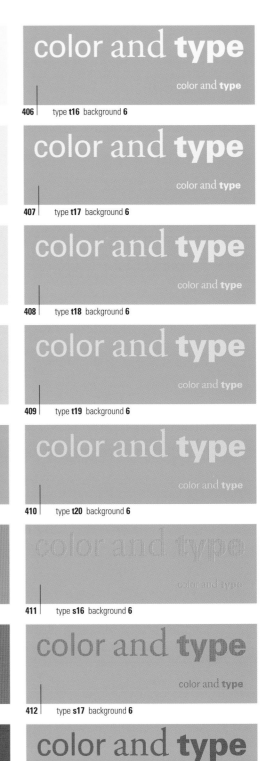

406 | type **t16** background **6**

407 | type **t17** background **6**

408 | type **t18** background **6**

409 | type **t19** background **6**

410 | type **t20** background **6**

411 | type **s16** background **6**

412 | type **s17** background **6**

413 | type **s18** background **6**

414 | type **s19** background **6**

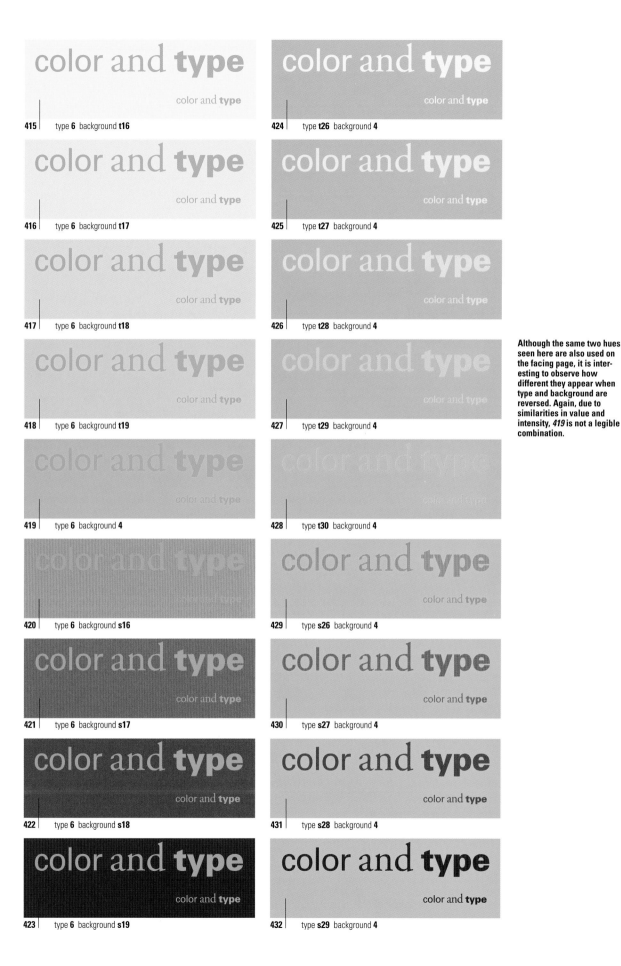

415 type **6** background **t16**

424 type **t26** background **4**

416 type **6** background **t17**

425 type **t27** background **4**

417 type **6** background **t18**

426 type **t28** background **4**

418 type **6** background **t19**

427 type **t29** background **4**

419 type **6** background **4**

428 type **t30** background **4**

420 type **6** background **s16**

429 type **s26** background **4**

421 type **6** background **s17**

430 type **s27** background **4**

422 type **6** background **s18**

431 type **s28** background **4**

423 type **6** background **s19**

432 type **s29** background **4**

Although the same two hues seen here are also used on the facing page, it is interesting to observe how different they appear when type and background are reversed. Again, due to similarities in value and intensity, *419* is not a legible combination.

433 | type **4** background **t36**

434 | type **4** background **t37**

435 | type **4** background **t38**

The yellow-orange type warms the cool, aquatic blue-green and they form a harmonious color alliance. The golden hue of the type provides enough body and strength to be quite readable when placed upon lighter tints of the background (433, 434). Placed upon darker shades of the background, the type casts an elegant glow (441).

436 | type **4** background **t39**

437 | type **4** background **8**

438 | type **4** background **s36**

439 | type **4** background **s37**

440 | type **4** background **s38**

441 | type **4** background **s39**

442 | type **t16** background **8**

443 | type **t17** background **8**

444 | type **t18** background **8**

445 | type **t19** background **8**

446 | type **t20** background **8**

447 | type **s16** background **8**

448 | type **s17** background **8**

449 | type **s18** background **8**

450 | type **s19** background **8**

color and type

451 type **8** background **t16**

color and type

452 type **8** background **t17**

color and type

453 type **8** background **t18**

color and type

454 type **8** background **t19**

color and type

455 type **8** background **4**

color and type

456 type **8** background **s16**

color and type

457 type **8** background **s17**

color and type

458 type **8** background **s18**

color and type

459 type **8** background **s19**

color and type

460 type **t36** background **4**

color and type

461 type **t37** background **4**

color and type

462 type **t38** background **4**

color and type

463 type **t39** background **4**

color and type

464 type **t40** background **4**

color and type

465 type **s36** background **4**

color and type

466 type **s37** background **4**

color and type

467 type **s38** background **4**

color and type

468 type **s39** background **4**

Shades of yellow-orange are rich, warm, and earthy (458, 459). Adding blue-green type cools the palette, much as a stream brings relief to the heat of a desert. Obviously, *456, 457, 462,* and *463* do not provide enough contrast between type and background for sound legibility.

| 469 | type **4** background **t46** |

| 478 | type **t16** background **10** |

| 470 | type **4** background **t47** |

| 479 | type **t17** background **10** |

| 471 | type **4** background **t48** |

| 480 | type **t18** background **10** |

This color combination, a union of the complementary colors blue-violet and yellow-orange, connotes royalty, lavishness, and pomp and ceremony. Yellow-orange type stands out best and is most easy to read on darker shades of blue-violet (474-477).

| 472 | type **4** background **t49** |

| 481 | type **t19** background **10** |

| 473 | type **4** background **10** |

| 482 | type **20** background **10** |

| 474 | type **4** background **s46** |

| 483 | type **s16** background **10** |

| 475 | type **4** background **s47** |

| 484 | type **s17** background **10** |

| 476 | type **4** background **s48** |

| 485 | type **s18** background **10** |

| 477 | type **4** background **s49** |

| 486 | type **s19** background **10** |

487 type **10** background **t16**

488 type **10** background **t17**

489 type **10** background **t18**

490 type **10** background **t19**

491 type **10** background **4**

492 type **10** background **s16**

493 type **10** background **s17**

494 type **10** background **s18**

495 type **10** background **s19**

496 type **t46** background **4**

497 type **t47** background **4**

498 type **t48** background **4**

499 type **t49** background **4**

500 type **t50** background **4**

501 type **s46** background **4**

502 type **s47** background **4**

503 type **s48** background **4**

504 type **s49** background **4**

The inverse is true when yellow-orange type appears on blue-violet backgrounds; the lighter backgrounds give definition to the blue-violet type, which is quite dark at full saturation (487-490).

Lavenders – the lighter tints of red-violet – are nostalgic and romantic hues. When used as a background for yellow-orange type, however, it is advantageous to use darker values of yellow-orange (not shown). Another way to maintain legibility is to use either darker values of red-violet for the background rather than lighter values (510-513), or lighter values of yellow-orange type on saturated red-violet (514-516).

505 | type **4** background **t56**

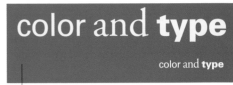

514 | type **t16** background **12**

506 | type **4** background **t57**

515 | type **t17** background **12**

507 | type **4** background **t58**

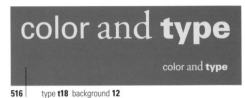

516 | type **t18** background **12**

508 | type **4** background **t59**

517 | type **t19** background **12**

509 | type **4** background **12**

518 | type **t20** background **12**

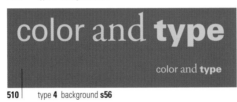

510 | type **4** background **s56**

519 | type **s16** background **12**

511 | type **4** background **s57**

520 | type **s17** background **12**

512 | type **4** background **s58**

521 | type **s18** background **12**

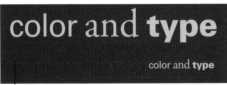

513 | type **4** background **s59**

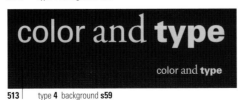

522 | type **s19** background **12**

color and **type**

color and **type**

523 type **12** background **t16**

color and **type**

color and **type**

524 type **12** background **t17**

color and **type**

color and **type**

525 type **12** background **t18**

color and **type**

color and **type**

526 type **12** background **t19**

color and **type**

color and **type**

527 type **12** background **4**

color and **type**

color and **type**

528 type **12** background **s16**

color and type

color and type

529 type **12** background **s17**

color and type

color and type

530 type **12** background **s18**

color and **type**

color and **type**

531 type **12** background **s19**

color and **type**

color and **type**

532 type **t56** background **4**

color and type

color and type

533 type **t57** background **4**

color and type

color and type

534 type **t58** background **4**

color and type

color and type

535 type **t59** background **4**

color and **type**

color and **type**

536 type **t60** background **4**

color and **type**

color and **type**

537 type **s56** background **4**

color and **type**

color and **type**

538 type **s57** background **4**

color and **type**

color and **type**

539 type **s58** background **4**

color and **type**

color and **type**

540 type **s59** background **4**

Using fully saturated red-violet type on a fully saturated yellow-orange background is quite legible due to the contrasting characteristics of these basic hues (527).

This analogous combination is mellow, cool, and refreshing. Compare *549, 550,* and *558,* which are acceptably legible, with the marginally legible *544, 555,* and *556.*

541 | type **6** background **t36**

542 | type **6** background **t37**

543 | type **6** background **t38**

544 | type **6** background **t39**

545 | type **6** background **8**

546 | type **6** background **s36**

547 | type **6** background **s37**

548 | type **6** background **s38**

549 | type **6** background **s39**

550 | type **t26** background **8**

551 | type **t27** background **8**

552 | type **t28** background **8**

553 | type **t29** background **8**

554 | type **t30** background **8**

555 | type **s26** background **8**

556 | type **s27** background **8**

557 | type **s28** background **8**

558 | type **s29** background **8**

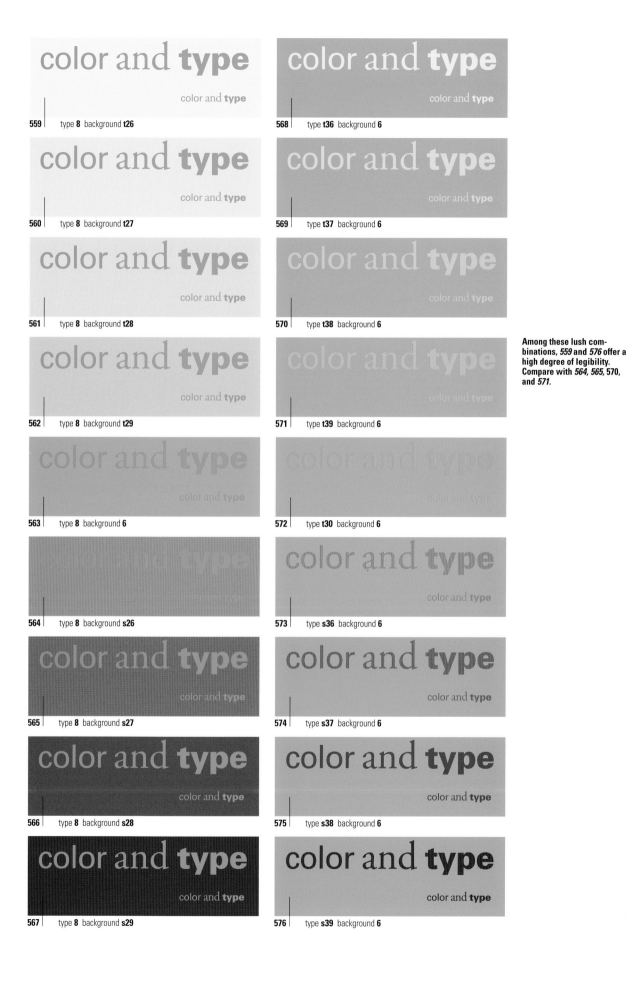

559 type **8** background **t26**

560 type **8** background **t27**

561 type **8** background **t28**

562 type **8** background **t29**

563 type **8** background **6**

564 type **8** background **s26**

565 type **8** background **s27**

566 type **8** background **s28**

567 type **8** background **s29**

568 type **t36** background **6**

569 type **t37** background **6**

570 type **t38** background **6**

571 type **t39** background **6**

572 type **t30** background **6**

573 type **s36** background **6**

574 type **s37** background **6**

575 type **s38** background **6**

576 type **s39** background **6**

Among these lush combinations, *559* and *576* offer a high degree of legibility. Compare with *564, 565,* 570, and *571.*

It is interesting to note the wide variety of color effects that can be achieved with colors belonging to the same families of hue. Variations in value and saturation make this possible. Compare, for example, the startling differences between *577, 581,* and *585*. While the type's hue remains constant, a shift in the value and saturation of the backgrounds gives each a unique appearance.

577 | type **6** background **t46**

578 | type **6** background **t47**

579 | type **6** background **t48**

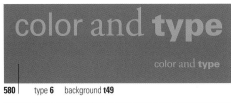

580 | type **6** background **t49**

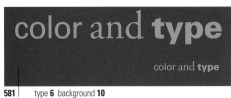

581 | type **6** background **10**

582 | type **6** background **s46**

583 | type **6** background **s47**

584 | type **6** background **s48**

585 | type **6** background **s49**

586 | type **t26** background **10**

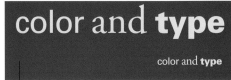

587 | type **t27** background **10**

588 | type **t28** background **10**

589 | type **t29** background **10**

590 | type **t30** background **10**

591 | type **s26** background **10**

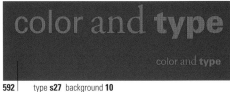

592 | type **s27** background **10**

593 | type **s28** background **10**

594 | type **s29** background **10**

595 type **10** background **t26**

596 type **10** background **t27**

597 type **10** background **t28**

598 type **10** background **t29**

599 type **10** background **6**

600 type **10** background **s26**

601 type **10** background **s27**

602 type **10** background **s28**

603 type **10** background **s29**

604 type **t46** background **6**

605 type **t47** background **6**

606 type **t48** background **6**

607 type **t49** background **6**

608 type **t50** background **6**

609 type **s46** background **6**

610 type **s47** background **6**

611 type **s48** background **6**

612 type **s49** background **6**

Adequate value and saturation contrast such as in *597* makes it possible to distinguish the shapes of the letters and the spaces between them (counter-forms). When such definition and contrast are at a minimum, such as in *605*, legibility breaks down.

613 | type **6** background **t56**

622 | type **t26** background **12**

614 | type **6** background **t57**

623 | type **t27** background **12**

615 | type **6** background **t58**

624 | type **t28** background **12**

Combinations of the comple-
mentary hues red-violet and
yellow-green are slightly off
beat and whimsical. Darker
shades of red-violet acquire
an air of mystery and magic
(620, 621).

616 | type **6** background **t59**

625 | type **t29** background **12**

617 | type **6** background **12**

626 | type **t30** background **12**

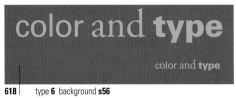

618 | type **6** background **s56**

627 | type **s26** background **12**

619 | type **6** background **s57**

628 | type **s27** background **12**

620 | type **6** background **s58**

629 | type **s28** background **12**

621 | type **6** background **s59**

630 | type **s29** background **12**

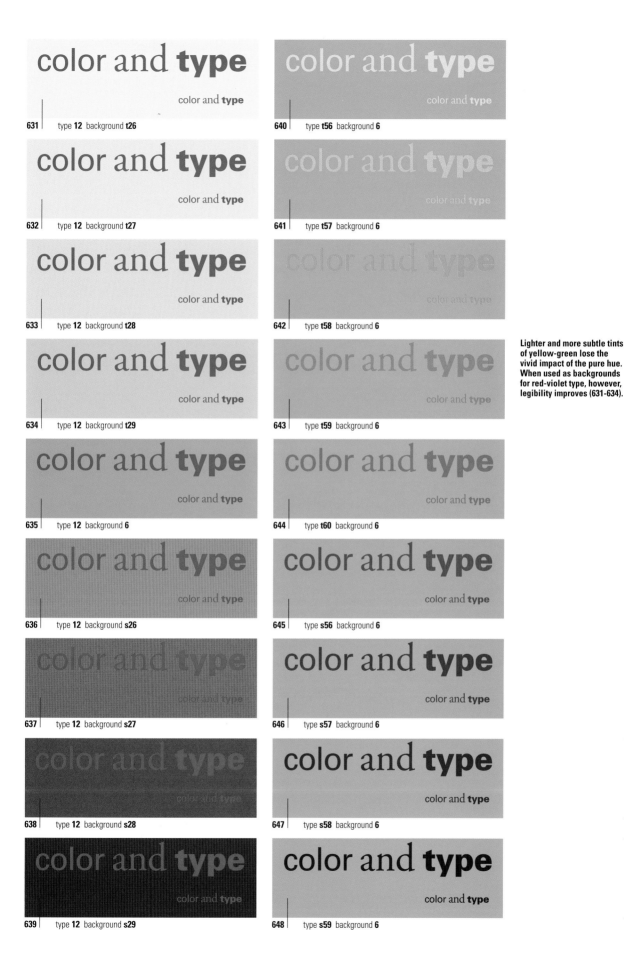

631 type **12** background **t26**

632 type **12** background **t27**

633 type **12** background **t28**

634 type **12** background **t29**

635 type **12** background **6**

636 type **12** background **s26**

637 type **12** background **s27**

638 type **12** background **s28**

639 type **12** background **s29**

640 type **t56** background **6**

641 type **t57** background **6**

642 type **t58** background **6**

643 type **t59** background **6**

644 type **t60** background **6**

645 type **s56** background **6**

646 type **s57** background **6**

647 type **s58** background **6**

648 type **s59** background **6**

Lighter and more subtle tints of yellow-green lose the vivid impact of the pure hue. When used as backgrounds for red-violet type, however, legibility improves (631-634).

Tertiary

In partnership, blue-green and blue-violet appear calm and restful. These analogous hues remind us perhaps of a peaceful and tranquil sea. Plenty of value contrast is needed to ensure legibility when these colors are used for type and background. Compare *658* and *666*.

color and **type** color and **type** **649** type **8** background **t46**	color and **type** color and **type** **658** type **t36** background **10**
color and **type** color and **type** **650** type **8** background **t47**	color and **type** color and **type** **659** type **t37** background **10**
color and **type** color and **type** **651** type **8** background **t48**	color and **type** color and **type** **660** type **t38** background **10**
color and **type** color and **type** **652** type **8** background **t49**	color and **type** color and **type** **661** type **t39** background **10**
color and **type** color and **type** **653** type **8** background **10**	color and **type** color and **type** **662** type **t40** background **10**
color and **type** color and **type** **654** type **8** background **s46**	color and **type** color and **type** **663** type **s36** background **10**
color and **type** color and **type** **655** type **8** background **s47**	color and **type** color and **type** **664** type **s37** background **10**
color and **type** color and **type** **656** type **8** background **s48**	color and **type** color and **type** **665** type **s38** background **10**
color and **type** color and **type** **657** type **8** background **s49**	color and **type** color and **type** **666** type **s39** background **10**

667 type **10** background **t36**

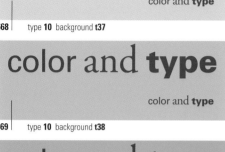

668 type **10** background **t37**

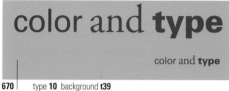

669 type **10** background **t38**

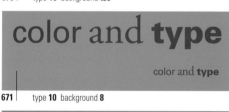

670 type **10** background **t39**

671 type **10** background **8**

672 type **10** background **s36**

673 type **10** background **s37**

674 type **10** background **s38**

675 type **10** background **s39**

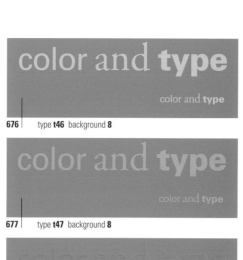

676 type **t46** background **8**

677 type **t47** background **8**

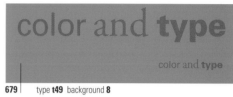

678 type **t48** background **8**

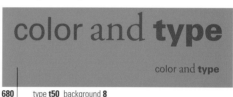

679 type **t49** background **8**

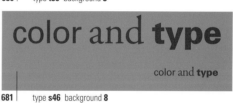

680 type **t50** background **8**

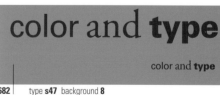

681 type **s46** background **8**

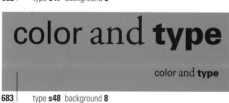

682 type **s47** background **8**

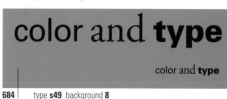

683 type **s48** background **8**

684 type **s49** background **8**

By reversing the type-background relationship, the effect is subtly warmer. When considering color for type, consider the content. Though two colors may be quite similar, the slight differ-ence between them can have an enormous impact upon the typographic message.

685 type **8** background **t56**

686 type **8** background **t57**

687 type **8** background **t58**

Color temperature affects the relationship between these two hues in a most subtle way, for red-violet leans towards red and the warm side of the color wheel. Approaching green on the color wheel, blue-green is cool. Color temperature distinctions, regardless of their subtlety, are important to keep in mind when choosing colors.

688 type **8** background **t59**

689 type **8** background **12**

690 type **8** background **s56**

691 type **8** background **s57**

692 type **8** background **s58**

693 type **8** background **s59**

694 type **t36** background **12**

695 type **t37** background **12**

696 type **t38** background **12**

697 type **t39** background **12**

698 type **t40** background **12**

699 type **s36** background **12**

700 type **s37** background **12**

701 type **s38** background **12**

702 type **s39** background **12**

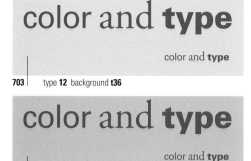

703 type **12** background **t36**

color and **type**
color and **type**

704 type **12** background **t37**

color and **type**
color and **type**

705 type **12** background **t38**

color and **type**
color and **type**

706 type **12** background **t39**

color and **type**
color and **type**

707 type **12** background **8**

color and **type**
color and **type**

708 type **12** background **s36**

color and **type**
color and **type**

709 type **12** background **s37**

color and type
color and type

710 type **12** background **s38**

color and type
color and type

711 type **12** background **s39**

color and **type**
color and **type**

712 type **t56** background **8**

color and **type**
color and **type**

713 type **t57** background **8**

color and **type**
color and **type**

714 type **t58** background **8**

color and type
color and type

715 type **t59** background **8**

color and type
color and type

716 type **t60** background **8**

color and **type**
color and **type**

717 type **s56** background **8**

color and **type**
color and **type**

718 type **s57** background **8**

color and **type**
color and **type**

719 type **s58** background **8**

color and **type**
color and **type**

720 type **s59** background **8**

703-706 and *717-720* are the most legible as well as the safest combinations shown here. However, *711* offers a more dramatic possibility that might be appropriate for use with display type. Compare the legibility of the display type and the text type in this combination. When a color combination might be marginal, try enlarging the type for better results.

Blue-violet and red-violet are cousins on the color wheel, and they possess extraordinary richness. Fully saturated hues, such as *725,* are always more vivid than tints and shades. When white is added, such as in the background tints of *721-724,* the hues become softer and more pastelle in appearance.

721 | type **10** background **t56**

730 | type **t46** background **12**

722 | type **10** background **t57**

731 | type **t47** background **12**

723 | type **10** background **t58**

732 | type **t48** background **12**

724 | type **10** background **t59**

733 | type **t49** background **12**

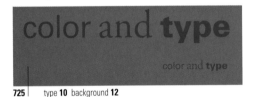

725 | type **10** background **12**

734 | type **t50** background **12**

726 | type **10** background **s56**

735 | type **s46** background **12**

727 | type **10** background **s57**

736 | type **s47** background **12**

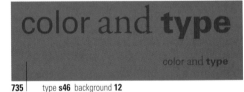

728 | type **10** background **s58**

737 | type **s48** background **12**

729 | type **10** background **s59**

738 | type **s49** background **12**

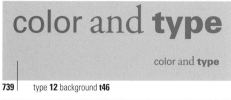

739 type **12** background **t46**

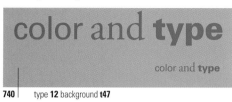

740 type **12** background **t47**

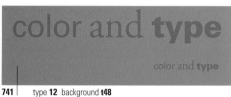

741 type **12** background **t48**

742 type **12** background **t49**

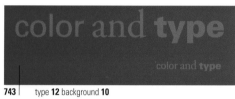

743 type **12** background **10**

744 type **12** background **s46**

745 type **12** background **s47**

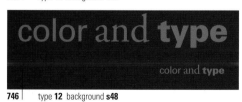

746 type **12** background **s48**

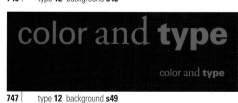

747 type **12** background **s49**

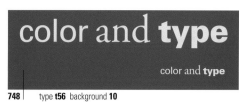

748 type **t56** background **10**

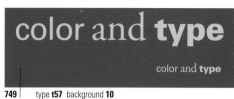

749 type **t57** background **10**

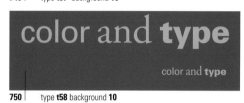

750 type **t58** background **10**

751 type **t59** background **10**

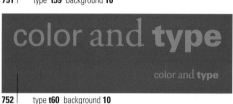

752 type **t60** background **10**

753 type **s56** background **10**

754 type **s57** background **10**

755 type **s58** background **10**

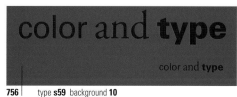

756 type **s59** background **10**

A color becomes duller as black or its complement is added to it (compare the type in *753-756*). If you wish to tone down vivid type, try adding black. If the type's background is dark, you may have to lighten it to preserve legibility.

Monochromatic

When the same hue is used for both type and background, the only way to establish contrast is through value. As type and background approach the same value, legibility diminishes. Compare *757* with *761*.

757 | type **1** background **t1**

758 | type **1** background **t2**

759 | type **1** background **t3**

760 | type **1** background **t4**

761 | type **1** background **t5**

762 | type **1** background **s1**

763 | type **1** background **s2**

764 | type **1** background **s3**

765 | type **1** background **s4**

766 | type **t1** background **1**

767 | type **t2** background **1**

768 | type **t3** background **1**

769 | type **t4** background **1**

770 | type **t5** background **1**

771 | type **s1** background **1**

772 | type **s2** background **1**

773 | type **s3** background **1**

774 | type **s4** background **1**

color and **type**

color and **type**

color and **type**

color and **type**

color and type

color and **type**

775 type **9** background **t41**

color and type

color and **type**

776 type **9** background **t42**

color and type

color and **type**

777 type **9** background **t43**

color and type

color and **type**

778 type **9** background **t44**

color and type

color and **type**

779 type **9** background **t45**

color and type

color and **type**

780 type **9** background **s41**

color and type

color and **type**

781 type **9** background **s42**

color and type

color and **type**

782 type **9** background **s43**

color and type

color and **type**

783 type **9** background **s44**

color and type

color and **type**

784 type **t41** background **9**

color and type

color and **type**

785 type **t42** background **9**

color and type

color and **type**

786 type **t43** background **9**

color and type

color and **type**

787 type **t44** background **9**

color and type

color and **type**

788 type **t45** background **9**

color and type

color and **type**

789 type **s41** background **9**

color and type

color and **type**

790 type **s42** background **9**

color and type

color and **type**

791 type **s43** background **9**

color and type

color and **type**

792 type **s44** background **9**

Even though you may be limited to the use of a single color, you can achieve a great deal of chromatic variety by juxtaposing different values of the color.

When working with type, the achromatic colors black, white, and gray are extremely useful. Because of their absolute neutrality, they are highly versatile. This is a no-nonsense palette: resolute, serious, and businesslike.

color and type

color and type

793 | type **k10** background **k1**

color and type

color and type

794 | type **k10** background **k2**

color and type

color and type

795 | type **k10** background **k3**

color and type

color and type

796 | type **k10** background **k4**

color and type

color and type

797 | type **k10** background **k5**

color and type

color and type

798 | type **k10** background **k6**

color and type

color and type

799 | type **k10** background **k7**

color and type

color and type

800 | type **k10** background **k8**

801 | type **k10** background **k9**

color and type

color and type

802 | type **k1** background **k10**

color and type

color and type

803 | type **k2** background **k10**

color and type

color and type

804 | type **k3** background **k10**

color and type

color and type

805 | type **k4** background **k10**

color and type

color and type

806 | type **k5** background **k10**

color and type

color and type

807 | type **k6** background **k10**

color and type

color and type

808 | type **k7** background **k10**

color and type

color and type

809 | type **k8** background **k10**

color and type

color and type

810 | type **k9** background **k10**

811	type **k0** background **k1**
812	type **k0** background **k2**
813	type **k0** background **k3**
814	type **k0** background **k4**
815	type **k0** background **k5**
816	type **k0** background **k6**
817	type **k0** background **k7**
818	type **k0** background **k8**
819	type **k0** background **k9**

820	type **k1** background **k0**
821	type **k2** background **k0**
822	type **k3** background **k0**
823	type **k4** background **k0**
824	type **k5** background **k0**
825	type **k6** background **k0**
826	type **k7** background **k0**
827	type **k8** background **k0**
828	type **k9** background **k0**

Grays, which can be created from screen tints of black, are customarily presented in 10% increments. Progressing from 10% to 90% black, type becomes increasingly more legible (820-828). Solid black type proves most legible.

The next six pages display type in the 12 basic hues of the color wheel on white, gray, and black backgrounds. You will find that each hue responds differently to the achromatic palette and that legibility differs enormously depending upon the value and intensity of each hue. Legibility is at its worst when the values of the background and the type become too similar. For example, the red type in *834* approximates the gray background, leading to a decrease in legibility.

color and **type** color and **type**	color and **type** color and **type**
829 type **1** background **k0**	838 type **2** background **k0**

830 type **1** background **k2** 839 type **2** background **k2**

831 type **1** background **k3** 840 type **2** background **k3**

832 type **1** background **k4** 841 type **2** background **k4**

833 type **1** background **k5** 842 type **2** background **k5**

834 type **1** background **k6** 843 type **2** background **k6**

835 type **1** background **k7** 844 type **2** background **k7**

836 type **1** background **k8** 845 type **2** background **k8**

837 type **1** background **k10** 846 type **2** background **k10**

color and **type**

color and **type**

847 | type **3** background **k0**

color and **type**

color and **type**

856 | type **4** background **k0**

color and **type**

color and **type**

848 | type **3** background **k2**

color and **type**

color and **type**

857 | type **4** background **k2**

color and **type**

color and **type**

849 | type **3** background **k3**

color and type

color and type

858 | type **4** background **k3**

color and type

color and type

850 | type **3** background **k4**

color and **type**

color and **type**

859 | type **4** background **k4**

Regardless of which hue is combined with white, black, or gray, the result is almost always harmonious and beautiful. The achromatic hues enhance the chromatic hues, never competing with their essential qualities.

color and **type**

color and **type**

851 | type **3** background **k5**

color and **type**

color and **type**

860 | type **4** background **k5**

color and **type**

color and **type**

852 | type **3** background **k6**

color and **type**

color and **type**

861 | type **4** background **k6**

color and **type**

color and **type**

853 | type **3** background **k7**

color and **type**

color and **type**

862 | type **4** background **k7**

color and **type**

color and **type**

854 | type **3** background **k8**

color and **type**

color and **type**

863 | type **4** background **k8**

color and **type**

color and **type**

855 | type **3** background **k10**

color and **type**

color and **type**

864 | type **4** background **k10**

865 type **5** background **k0**	874 type **6** background **k0**
866 type **5** background **k2**	875 type **6** background **k2**
867 type **5** background **k3**	876 type **6** background **k3**
868 type **5** background **k4**	877 type **6** background **k4**
869 type **5** background **k5**	878 type **6** background **k5**
870 type **5** background **k6**	879 type **6** background **k6**
871 type **5** background **k7**	880 type **6** background **k7**
872 type **5** background **k8**	881 type **6** background **k8**
873 type **5** background **k10**	882 type **6** background **k10**

On a white background, yellow type lacks definition (865). As backgrounds grow darker, type becomes more vivid (866-872). Too much contrast can also affect legibility. On black, for example, yellow type creates a dazzle that can tire a reader if used for large quantities of text type (873).

color and **type**

color and **type**

883 | type **7** background **k0**

color and **type**

color and **type**

884 | type **7** background **k2**

color and **type**

color and **type**

885 | type **7** background **k3**

color and **type**

color and **type**

886 | type **7** background **k4**

color and **type**

color and **type**

887 | type **7** background **k5**

color and **type**

color and **type**

888 | type **7** background **k6**

color and type

color and type

889 | type **7** background **k7**

color and type

color and type

890 | type **7** background **k8**

color and **type**

color and **type**

891 | type **7** background **k10**

color and **type**

color and **type**

892 | type **8** background **k0**

color and **type**

color and **type**

893 | type **8** background **k2**

color and **type**

color and **type**

894 | type **8** background **k3**

color and **type**

color and **type**

895 | type **8** background **k4**

color and **type**

color and **type**

896 | type **8** background **k5**

color and type

color and type

897 | type **8** background **k6**

color and type

color and type

898 | type **8** background **k7**

color and **type**

color and type

899 | type **8** background **k8**

color and **type**

color and **type**

900 | type **8** background **k10**

Type in each hue appears to change colors as it interacts differently with each achromatic background. Notice how the green and blue-green type nearly disappears on the 50% gray background (887, 896).

Blue type is peaceful and soothing on gray. It reads best on white and the lighter shades of gray (901-904). Legibility suffers on the darker shades of gray and black (905-909). This is generally true of all of the darker hues.

color and **type**
color and **type**

901 | type **9** background **k0**

color and **type**
color and **type**

910 | type **10** background **k0**

color and **type**
color and **type**

902 | type **9** background **k2**

color and **type**
color and **type**

911 | type **10** background **k2**

color and **type**
color and **type**

903 | type **9** background **k3**

color and **type**
color and **type**

912 | type **10** background **k3**

color and **type**
color and **type**

904 | type **9** background **k4**

color and **type**
color and **type**

913 | type **10** background **k4**

color and **type**
color and **type**

905 | type **9** background **k5**

color and **type**
color and **type**

914 | type **10** background **k5**

color and **type**
color and **type**

906 | type **9** background **k6**

color and **type**
color and **type**

915 | type **10** background **k6**

color and **type**
color and **type**

907 | type **9** background **k7**

color and **type**
color and **type**

916 | type **10** background **k7**

color and **type**
color and **type**

908 | type **9** background **k8**

color and **type**
color and **type**

917 | type **10** background **k8**

color and **type**
color and **type**

909 | type **9** background **k10**

color and **type**
color and **type**

918 | type **10** background **k10**

color and type

color and **type**

919 | type **11** background **k0**

color and type

color and **type**

920 | type **11** background **k2**

color and type

color and **type**

921 | type **11** background **k3**

color and type

color and **type**

922 | type **11** background **k4**

color and type

color and **type**

923 | type **11** background **k5**

color and type

color and **type**

924 | type **11** background **k6**

color and type

color and **type**

925 | type **11** background **k7**

color and type

color and **type**

926 | type **11** background **k8**

color and type

color and type

927 | type **11** background **k10**

color and **type**

color and **type**

928 | type **12** background **k0**

color and **type**

color and **type**

929 | type **12** background **k2**

color and **type**

color and **type**

930 | type **12** background **k3**

color and **type**

color and **type**

931 | type **12** background **k4**

color and **type**

color and **type**

932 | type **12** background **k5**

color and **type**

color and **type**

933 | type **12** background **k6**

color and **type**

color and **type**

934 | type **12** background **k7**

color and type

color and type

935 | type **12** background **k8**

color and **type**

color and **type**

936 | type **12** background **k10**

Because white reflects more light than any other color, it is generally an effective background choice for type. The intrinsic properties of any hue are best preserved when paired with white.

Observing how others solve the mysteries of color and type can be informative as well as inspiring, and it can open doors to new and exciting possibilities in your own work.

Using color and type

Observing how others solve the mysteries of color and type can be instructional as well as inspiring, and it can open doors to new and exciting possibilities in your own work. Everyone possesses different color sensibilities and opinions, and a color scheme that works for one person is not necessarily acceptable to another. No formula or single "right" answer to any color and type problem exists. Subsequently, you have to make decisions based upon the timeless principle of *appropriateness*. This is to say that the solution to a problem should always arise from within the problem and not outside of it. The following 30 case studies represent a wide range of printed applications and reveal how top designers address the problems of color and type. You will find helpful tips throughout that will shed light on your own work.

Borrowing from the collection of colors on pages 22 and 23, color swatches on the left-hand pages provide an approximation of the colors used in the examples, as well as the quantity and relative location of the colors within the design. The purpose of these color swatches is to illustrate the general properties of the colors used in the projects. No attempt is made to exactly duplicate the color schemes. These color combinations are keyed to the color conversion chart on page 146 for reference.

Trident Microsystems designs, develops, and markets multimedia video processing chipsets, GUI accelerators, and graphics controllers. The annual report presented here communicates the company's achievements in this technology and in the marketplace. An animated message imitating a video screen changes from *FOLLOW* to *LEAD* as the reader shifts the cover from one position to another. The technologies that position the company for success are featured inside the annual report through an array of video images and an intensely bright palette of colors.

Annual report

Color harmony can be achieved by juxtaposing analogous colors as demonstrated by the dominant use of the yellow, light yellow, and green in this publication. Accenting these hues with opposite colors on the color wheel adds to visual stimulation.

T I P :

1
The word *LEAD* is repeated again on the first page of the report to reiterate the company's position as a leader. The word consists of orange letters with red outlines, a technique that creates emphasis and visual prominence.

LEAD

2
The three elements of the company's success – capabilities, relationships, and design – are presented in three interior spreads. A detail from one of these spreads shows a unique use of color and type. Appearing on top of a video image, the numeral *3* appears in three variations. These include the *3* with a black shadow, a red outline, and outlined in white. These numerals are stacked on top of one another but offset slightly for an energetic and vibrating appearance.

3
The letter to stockholders uses color to emphasize key information. Heads appear in black type of a bold weight, while highlighted information appears in red. The rest of the letter is printed in black type of a regular weight.

LETTER TO STOCKHOLDERS

4
For financial charts, yellow ruled lines offer a subtle but effective alternative to commonly used black ruled lines.

exercisable and vest cumulatively in 25% increments upon the anniversary of the date of grant.
The following table summarizes the option activities for the years ended June 30, 1993, 1994 and 1995.

(IN THOUSANDS, EXCEPT PER SHARE DATA)	OPTIONS AVAILABLE FOR GRANT	OPTIONS OUTSTANDING NUMBER OF OPTIONS	PRICE PER OPTION
Balance, June 30, 1992	307	692	$0.77–$ 5.00
Additional shares reserved	1,300	—	
Options granted	(841)	841	$5.00–$17.00
Options exercised	—	(78)	$0.77–$ 5.00
Options expired or canceled	189	(199)	$0.77–$ 7.00
Balance, June 30, 1993	955	1,256	$0.77–$17.00
Options granted	(1,665)	1,665	$4.63–$ 7.00
Options exercised	—	(197)	$0.77–$ 5.00
Options expired or canceled	860	(860)	$1.88–$14.75
Balance, June 30, 1994	150	1,864	$0.77–$ 7.00
Additional shares reserved	800	—	
Options granted	(1,008)	1,008	$1.55–$20.06
Options exercised	—	(221)	$0.80–$ 5.00
Options expired or canceled	335	(335)	$0.80–$15.75
Balance, June 30, 1995	277	2,316	$0.77–$20.06

At June 30, 1995, 1994 and 1993, options for 691,000, 819,000 and 275,000 shares of Common Stock were vested but not exercised. In July 1993, the Company canceled 630,000 options outstanding under the Option Plan with exercise prices

	t42
	9
	1
	t23
	6
	5

Typefaces: Din Schriften, Univers

TRIDENT MICROSYSTEMS 1995 ANNUAL REPORT

The cover, printed in a dazzlingly saturated yellow, cannot be ignored. This color combined with the lead/follow message entices the reader into the pages of the annual report.

CAPABILITIES

Design:
Stephen Doyle
Gary Tooth
Drenttel Doyle Partners

Typography 16, the annual of the Type Directors Club, seduces the reader into its pages with risky typography and color. The designers state: "We wanted anyone interested in type to zoom in on this in a bookstore. . .not being able to figure it out, they would then pick it up." Indeed, at first glance the jacket appears to be an unruly hodgepodge of letterforms stacked indiscriminately on top of one another. But closer examination reveals a masterfully articulated structure and a lyrical dialogue between warm and cool hues of varying values and intensities.

Book

TIP: To create energy and dimensionality in your publication, use a combination of warm and cool colors for type and background.

1

A detail taken from the jacket reveals the subtle transparent effect created by overlapping transparent inks. Colors become darker and more neutral at the point of intersection.

2

A detail from the flap of the book's jacket reveals a single block of text type printed over three different background colors. The pastel text, appearing to float delicately above the surface of the paper, is darker or lighter in value depending on which of the colors it overlaps.

3

This sample page reveals text blocks of different shapes and colors pieced tightly together like a puzzle. The illusion of depth is created by warm and cool, advancing and receding colors. Each block features biographical information about the judges of the competition, and the varying shapes and colors of the blocks provide each with a unique personality. In the spirit of risk-taking, some of the text blocks offer challenging reading due to the colors assigned to them.

The only annual devoted exclusively to typographic design, Typography 16 presents the finest work in this field from 1994. Selected from 2,894 international submissions to the forty-first Type Directors Club competition (TDC41), the 239 winning designs are models of excellence and innovation in contemporary type design.

This year's selection encompasses a wide range of categories, among them posters, logotypes, packaging, promotions, books, stationery, magazines, television graphics, annual reports, videos, and corporate identities. Entries are displayed in full color and are accompanied by informative captions listing the designer, client, typography, and more.

The Judge's Choice section features the winning entries from the year's competition that have been singled out by each of the seven judges as his or her

k	
s21	
k2	
s6	
t38	
s48	

4

The typographic forms found on the cover are reintroduced in a new variation on the title spread.

Typefaces: Didot, Matrix Script, Orator, Rockwell, Scala

TYPOGRAPHY

16

1995

THE
ANNUAL
OF THE

TYPE DIRECTORS CLUB

41

EXHIBITION

The typography on the jacket is simultaneously chaotic and orderly, a blend of intentions that raises the reader's curiosity. While the letterforms are precisely arranged, sized, and aligned, their overlap creates a complex maze, a varied garden of shape and color through which the eye wanders.

Design:
Scott Allison

Piet Mondrian was an abstract painter whose theories about color and space were the basis of an art and design movement called de Stijl – an important movement that originated in Holland in 1917. Mondrian's paintings were reduced to straight lines, squares, rectangles, and the colors red, yellow, green, blue, black, white, and gray. This booklet, which features the work of Mondrian, explores and emulates the visual vocabulary of the artist.

Booklet

TIP: Primary colors are the purest of hues; they cannot be formed by any other combination of colors. Use them when your design calls for a pure, elemental, and straightforward tone.

1

On the cover, alternating primary hues suggest the color cadence of a Mondrian painting. Title typography possesses a similar rhythmic structure.

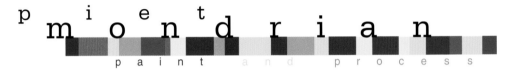

p i e t
m o n d r i a n
p a i n t a n d p r o c e s s

2

A detail from the contents page reveals a playground of type and color. Words are transformed into an intriguing visual pattern by the strategic insertion of red and yellow letters. We are reminded of the careful articulation of Mondrian's own forms.

c o n t e n t s

1	youth + education
2	process
3	abstract on
4	time line
5	maturity
6	bibliography
7	colophon

3

In a detail from a timeline within the booklet, words assigned primary colors emphasize the content.

1940 — 44 continues to develop paintings; compositions reach an unrivaled intensity in composition of line, plane, and color

w
k
k7
9
5
1

Typefaces: Helvetica, Serifa

A collection of spreads reveals Mondrian's preference for pure hues, especially the primaries red, yellow, and blue. Typography is placed horizontally and vertically, a formal trait characterizing the rectilinear energy of Mondrian's paintings.

TIP: Place type and images on black backgrounds if you wish to create visual drama. Most any color harmonizes with black.

ARTNOW is a series of exhibitions sponsored by the Montgomery Museum of Fine Arts. Brochures are designed to tie events together as a series and to provide a consistent visual look. Design elements for the brochures include an identifying logotype used for the series title, a vertical bar containing the name of the featured artist, and a four-color reproduction of the artist's work. Colors for each brochure reflect those used by the artist. This approach not only helps to distinguish each of the brochures, it also informs the reader about the specific color palettes.

1

The red *T* in the *ARTNOW* logotype emulates the red in the cover painting. The color also provides the mark with visual distinction and makes the word *ART* more readable. Compare the logotype with and without the red *T*.

2

While only a hint of red exists on the cover, a full-bleed sea of the hue on the back cover dazzles the reader. Compare the white headline and caption on the back cover to the rest of the text, which is set in black. A heightened contrast between the white letters and the red background projects these elements forward in space, giving them hierarchical prominence.

3

In the process of determining which colors should be used for the logotype, several combinations were tested. A few of the possibilities are exhibited here. The version with a red *T* was chosen for its visual impact.

t43

1

k

Typefaces: Franklin Gothic, Helvetica

A vertical bar containing the artist's name casts the same hue as in the painting. Extracting color from the cover painting and applying it to various typographic elements provides visual unity. Simultaneously, the juxtaposition of hot red and cool blue hues provides a resonant contrast.

When type and photographs containing light hues are placed upon black backgrounds – as in this cover – the entire space glows.

ART NOW

Montgomery
Museum
of Fine Arts

March 23 – June 2, 1996

John L. Moore

Design:
Jack Anderson
David Bates
Mary Hermes
John Anicker
Mary Chin Hutchison
Hornall Anderson Design
Works, Inc.
Art Direction:
Jack Anderson
Illustration:
Yutaka Sasaki
Photography:
Tom Collicott

T I P :

To emphasize elements such as
words and phrases within text,
try using colors that contrast
with the main body of the text.
For more emphasis use
stronger contrast and for less
emphasis use weaker contrast.

NEXTLINK specializes in the next wave of telecommunications services, focusing specifically upon local phone service customers who desire telecommunications reliability and up-to-date technology. Distinctive typography, custom lettering, and bold colors provide the company with a visual identity program that projects a highly progressive image. The company operates flexibly. . . one foot in the future.

1

The logotype suggests the futuristic outlook of the company. A gradation beginning with red-violet and ending with yellow-orange travels through the space age letters of NEXTLINK. The letter *X* – a metaphor for a communications link – casts a shadow as it rises into new technological realms. Unlike the rest of the letters of the logotype, the *X* is carved from a curved plane of rainbow color.

2

The *X* is most dramatic as it appears on the cover. Diecut through each page of the brochure, it forms a window from front to back. As the brochure is held to light, the *X* glows brilliantly. The background is silent and black, a deep space through which the *X* travels.

3

Within the brochure, black text type is punctuated with yellow-orange call-outs that stress important points.

4

The style and weight of text type reversed from photographs help to maintain legibility.

9
12
4
k

Typefaces: Eagle Book, Gill Sans

OUR PROMISE

To provide our customers
with real choices,
total solutions, and superior
telecommunications service.

NETLINK

IF YOU COULD CREATE A TELECOMMUNICA-
TIONS COMPANY FROM THE GROUND UP,
YOU WOULD MAKE CUSTOMER SERVICE
AS IMPORTANT AS TELEPHONE SERVICE.
YOU'D TREAT YOUR CUSTOMERS AS
AUDIENCE, NOT JUST SOMEONE YOU SEND
BILLS TO. YOU'D PROVIDE SOLUTIONS, NOT

JUST SERVICES. YOU'D OFFER EXCEL-
LENT VALUE, NOT JUST COMPETITIVE
PRICES. YOU'D BUILD A SYSTEM YOU
COULD UPDATE EASILY, SO YOUR
CUSTOMERS WOULD ALWAYS HAVE THE
LATEST TECHNOLOGY AND GREATEST
RELIABILITY. WE'RE NEXTLINK. AND
THAT'S EXACTLY WHAT WE'RE DOING.

WE PROVIDE TOTAL TELECOMMUNICATIONS SOLUTIONS

- Customers Define Our
 Working Relationship
- Services and Pricing
 Tailored to Your Needs
- True Single Source
 Telecommunications

- Real Partnership, Long-
 term Business Approach
- We Create and Identify
 Business Opportunities

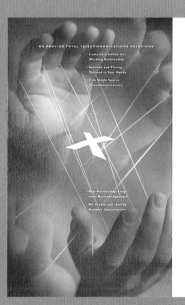

NEXTLINK is dedicated to the proposition that not all customers
are created equal. That each one has UNIQUE NEEDS that
require individual solutions. And that the right combination of
telecommunications products and services provides a BUSINESS
ADVANTAGE. You're probably not used to this approach. That's
understandable – traditional phone companies provide telephone
service. We provide TELECOMMUNICATIONS SOLUTIONS.

Our way of working is anything but traditional. In fact, we're out to
redefine the entire customer-telecommunications company relation-
ship. We start by working to understand not just your telecommunica-
tions needs, but also your TOTAL BUSINESS. Then we develop
a complete solution that can include local exchange service, long
distance service, voice messaging, and high-speed data networks. All
from a SINGLE SOURCE. And we work around your schedule.
Your requirements. Your definition of success. Refreshing, isn't it?

OUR CUSTOMER COMMITMENT

- 24-hour Customer
 Service
- Dedicated Personal
 Service Representatives
- Meeting and Exceeding
 Customer Expectations
- Round-the-Clock
 Teleconferencing Centers

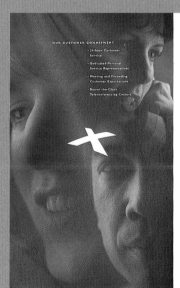

It takes a lot more than self-healing fiber networks to provide
reliable telecommunications service. It takes PEOPLE. People
who understand what it means to truly SERVE customers,
not just simply respond to them. People who take the time to
UNDERSTAND YOUR BUSINESS, so they can help you
run it better. People who turn technology into a COMPETITIVE
ADVANTAGE for you. The very people you'll find at NEXTLINK.

History teaches us that BUSINESS is full of surprises. But it
doesn't have to be. When you're a NEXTLINK customer, your problems
are our problems. Our success is directly tied to YOUR SUCCESS.
We're committed to building our business systems around your needs,
not ours. And the biggest surprise is discovering how pleasant life is
without unpleasant surprises. That's our approach. Because that's what
it takes to move telecommunications into the NEXT CENTURY.

Each spread of the brochure contains a photograph casting a specific tertiary hue. The *X* whose background reflects the hues contained within the photographs is on the right-hand page, adjacent the photographs.

The purpose of this three-fold brochure is to demonstrate the capabilities of Dupli-graphic as a high-quality, two-color printer. Colors used for the brochure are a primary metallic blue (the corporate color) and black. Ink is applied to only one side of a translucent sheet, and when folded, the type and images peer through to the other side as well. A smiling woman wearing sun glasses encourages the reader to "take a look" at the capabilities of the printer. Together, the type, images, color, translucent paper, and folds create an intriguing and mirror-like message.

1

As demonstrated by the typographic configuration on the inside of the brochure, a tremendous variety of type and color effects is possible using only two colors. Here we see type printed in two different solid colors, reversed from these colors to appear as white, and printed with screen mixes of the two colors to create a variety of tones.

type type
type type
type type
type type

2

When reversing type from solid color backgrounds, a number of factors affect legibility. Among these is the weight of type. Letter strokes, serifs, and punctuation of overly light type can appear too light; the counters (spaces within letters, such as in the lowercase e) of letters in heavy type may appear too small for adequate letter definition. Aggravating this problem is the printing phenomenon known as ink squeeze, where ink oozes over the edges of letter strokes and further thins them. Generally, medium weight type is most legible when reversed from solid color backgrounds. Compare the legibility of light, medium, and bold type reversed from identical color backgrounds.

color and type

color and type

color and type

3

Creating outline and solid rectangular shapes in each of the two colors to enclose type blocks contributes to the variety of the brochure.

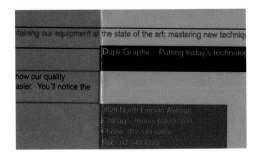

Typefaces: Akzidenz Grotesk, Akzidenz Grotesk Extended

Design:
William Kochi
Kode Associates, Inc.

Black and white and the achromatic grays can appear amazingly colorful when light and dark values are effectively utilized. Similar to walking in a winter garden, the bright colors of summer yield to subtle hues playing upon faded foliage. The LinoGraphics Capabilities brochure is printed entirely in black ink on translucent paper. Type and images converse through layers of pages for a highly textured and tactile reading experience.

1

Remarkable variety can be achieved in type by using screens of black in different combinations. Note the stimulating, shimmering effect of these variations. Typographic legibility depends upon the amount of value contrast incorporated into each combination.

color and type	color and type	color and type
color and type	color and type	color and type
color and type	color and type	color and type
color and type	color and type	color and type
color and type	color and type	color and type

2

For a chart on the last page of the brochure, black type, white type on black and gray backgrounds, overlapping type, and type with generous letter spacing combine to create an active, vibrant texture.

3

Outlined type, graphic icons, ruled lines, and photographs mingle in harmony and contribute to the brochure's appeal.

k

Typeface: Imago

The cover and inside cover reveal how type and images printed on both sides of the sheet can be viewed simultaneously. As viewed from the front, black elements printed on the opposite side appear gray, creating a rich tonality and a separation of elements.

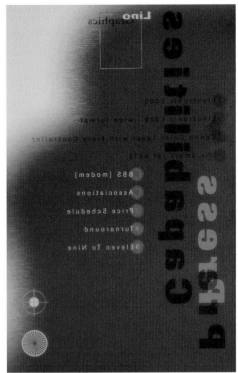

A selection of spreads from the brochure reveals a rich blend of black and white and grays. Despite the apparent complexity of the pages, type and images remain readable due to a careful orchestration of color values. At the same time, serendipity guides the interaction of color and type.

The intent of this retail catalog is to convey the elegance and style associated with the Saris products, which are roof rack systems for bicycles, skis, canoes, and other recreational equipment. The type is playful to allude to the sports of cycling, skiing, and paddling, but it also reflects the technical aspects of precision storage rack systems. The color palette consists of primary and secondary hues and is both sophisticated and funky.

Catalog

T I P : Triadic colors are separated by three other colors on the color wheel. As demonstrated by this catalog which utilizes triadic colors, you can use these hues to create both contrast and color harmony. Triadic colors are hues that differ from one another but also share common characteristics.

1

Each page of the Saris catalog features a different background color. These are presented as circular blends that "spotlight" the products from page to page. For this catalog only one color was needed for the circular blends, but it is possible to combine different colors for a variety of effects.

2

At the tops of pages, running heads consisting of type on black bars make it easy for the reader to navigate the catalog. The type is printed in the same color as the background, creating the dimensional effect that it is cut away from the black bar to expose the underlying background.

Saris hitch racks

3

On the back cover, an animated phrase is printed in both black and the yellow-green background color. Because the yellow-green letters appear over light areas of the same color blend, they remain readable; however, they are very subtle, receding quietly into space.

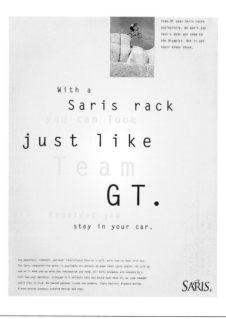

k
s21
4
t39
t38
t44

Typefaces: (need faces)

Saris
r a c k s .

a g u i d e

t o t h e

g e a r

SARIS.

Each page of the catalog is a kinetic and rather complex organization of elements. Product images and type appear in constant motion, swirling about one another in space. Despite the seeming randomness of the pages, the size and color of the type elements and images establish a clear hierarchy. Product information appears as light gray patches of text type, while product names appear in large, black type. Product numbers, also large in size, are printed in white for immediate recognition.

Design:
Clifford Stoltze
Tracy Schroder
Heather Kramer
Peter Farrell
Resa Blatman
Stoltze Design

Through design and color, the Massachusetts College of Art catalog emulates a highly charged and experimental learning environment. Both primary and secondary hues present images and type, and they are shifted in value and saturation for a most unusual palette.

Flipping through the pages reveals an intriguing kaleidoscope of shapes, colors, and typographic treatments. Never a dull moment, the catalog parts with convention yet remains accessible and informative.

1

Consisting of black and hot, red type, the title thrusts forward from the background, which is a photographic montage with a muted yellow cast. The catalog's spine is blue. A detail of the cover shows the distribution of the title colors. Appearing in red, *MASS ART* is separated from *Massachusetts College of Art* to reveal the abbreviated pronunciation of the college's name.

2

Many risks are taken with color and type that defy legibility standards, but given the experimental nature of the institution, this is quite acceptable. The left example shows small, yellow-green text type printed over a red photograph. Though not easy to read, with effort the type is nonetheless readable. The context of a message and the intended audience are always important aspects to consider before testing the limits of typographic legibility. For the most part, the youthful audience of this catalog will have little trouble reading this text. The right example is a more normative page containing information that the reader must easily access.

3

In this detail we see how color and type are manipulated into a visual metaphor. The word *students* presents a kaleidoscope of colors, referring to the word *kaleidoscopic*.

4

Part of the charm of this publication is the tapestry of overlapping and layered type, color, and images.

k

s22

2

t45

Design:
Mark Minelli
Pete Minelli
Lesley Kunikis
Brad Rhodes
Casey Reas
minelli design
CD Packaging Design:
Brad Rhodes

CD packaging

An interactive CD package for the Art Institute of Boston is part of a greater identity system for the school. Bold typography, enhanced and articulated through a slightly offbeat color palette, characterizes each component of the system. A number of hybrid colors were created by overprinting red, green, and purple inks, a technique that also aided the designers in overcoming budget limitations. The approach to color and type suggests the creative and experimental nature of the art school without abandoning the clarity of factual information.

1

As shown in this example, two solid colors can be combined to generate a third hybrid hue that provides richness and depth.

2

The colors used for the CD packaging are the same ones used for the interactive "buttons" featured in the CD itself. These buttons are selected with the mouse to navigate information about the school. Enough contrast exists between the hues to easily distinguish one from another.

3

A sleeve within the cover holds the CD. On this panel, violet is used for highly legible type; yellow-green is used for the image.

5

A darker color is used for the CD itself. This somber hue relates to poetic images encountered while interacting with the program.

4

Color is distributed among the letterforms in a manner reminiscent of an abstract painting. Though only three colors are actually used in the printing, reversing some letters to appear as white and printing others over a color background achieves the appearance of several colors.

t30	
t59	
1	

Typefaces: Bodoni, Rockwell

The CD cover shown front
and back reveals a
cacophonic mixture of
typographic forms and
emotive, passionate color.

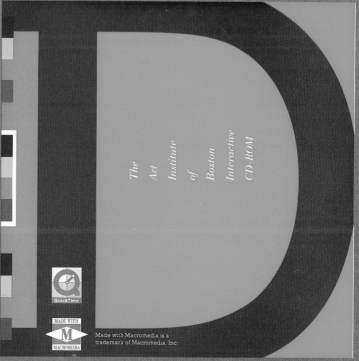

Design:
Clifford Stoltze
Stoltze Design
Design Assistance:
Peter Farrell
Heather Kramer
Illustrators:
Various

TIP : Remember that the color of the paper upon which you print adds to the total color palette. Also, since most printing inks are transparent, paper color always affects the color of the inks.

Anon, a limited-edition compilation of art and music, includes two music CDs and a collection of 30 full-color postcards that are packaged in a natural cardboard container. Themes for the CDs are solar and lunar, which are introduced on the cover in the form of a diagram of the solar system. The two main colors used for the packaging are yellow for solar, silver for lunar, and black for text. The yellow and silver appear soft and delicate on their earthy background, an effect accentuated by flourishes of gently curving calligraphy.

1

On the cover, type and images printed in yellow, silver, and black overlap to create a complex and delicate motif. *Anon* is printed in black to clearly identify the title. Despite the complexity of the layers, each is clearly distinguished from the next.

2

A red-orange band binding the package together repeats the title, introduces the contents of the package, and brings warmth to the entire presentation.

t30

t59

1

3

Enlarged portions of the solar system diagram found on the cover and the title *Anon* in calligraphic letters are reversed from white to reveal the inherent silver cast of the CD.

Typefaces: Calvino, Gangly

The packaging is a statement of contrasting forms, materials, and colors: the square shape of the container and the round diecut flaps representing the sun and moon; the raw neutrality of the packaging material and the elegance of the yellow and silver inks; and the title *Anon* presented in both curvilinear calligraphy and rectilinear type.

Design:
Jack Anderson
Lisa Cerveny
Jana Wilson
Suzanne Haddon
Hornall Anderson Design
Works, Inc.
Art Direction:
Jack Anderson
Copy Writer:
Karen Wilson

TIP : Dynamic color relationships can be achieved by using colors nearly opposite one another on the color wheel, and then using a full range of tints and shades of those colors. In this way, the color palette is simultaneously congruent and incongruent.

For GNA Power Annuities, bold colors are used to depict the concept of "power." In fact, the design staff refers to specialty color mixes as Power Red, Power Orange, Power Gold, etc. These colors are forceful because of their intensity and slightly dark value. Also contributing to their strength is the extent to which they are used. Large, overlapping letters and numerals appearing in the power colors dynamically engage large areas of space within printed materials.

1

The large letters and numerals overlap one another with precision, subdividing the space into elegant, abstract shapes. The overlapping letters appear transparent as color changes in value at points of intersection.

2

While the same colors are used throughout the program, they are applied differently to each piece of communication. This technique not only establishes variety within the system, it helps to distinguish the various materials as well.

3

On the inside of a brochure, letters alternate in color to emphasize the word *POWER*.

4

For optimum readability, black text always appears on lighter values of the colors.

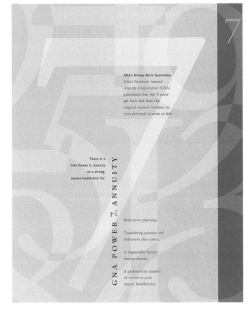

	k
	s28
	t54
	t20
	s3
	3

Typefaces: MS Gothic, Sabon

The cover of a folder containing information about the company typifies the use of the power colors and the monumental letters and numbers that expand beyond the borders. This palette consists of the tertiary hues red-orange, yellow-orange, and red-violet.

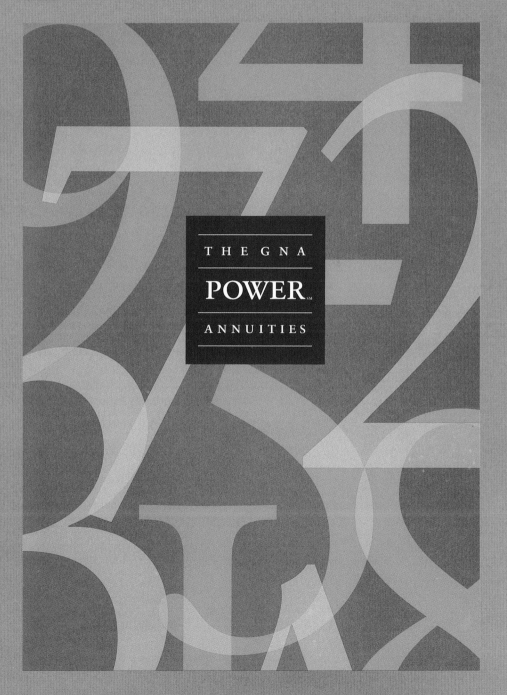

THE GNA

POWER sm

ANNUITIES

Using transparent color provides an effective way of synthesizing type and photographs. However, be aware that an increase in transparency usually translates into a decrease in legibility. This technique works best for display rather than text type.

A photograph of sky and clouds serves as a poetic backdrop for this cover of *exp.* magazine. The sun establishes a dramatic focal point that draws attention to the magazine's vivid red title. The cottony appearance of the clouds provokes a strong contrast with rectilinear shapes that provide an organizational framework for the typography. The shapes appear as tinted glass panes with hues that intensify areas of the achromatic photograph. Juxtaposed with the sky, the color intensifies the illusion of three-dimensionality and creates a mood of contemplation and mystery.

1

The computer enabled the designer to precisely adjust the color opacity in the rectangular shapes and letterforms. More opacity results in less transparency, while less opacity results in more transparency.

2

When reversing type from a background photograph, it is essential that the background is dark enough to ensure readability. This is a matter of contrast: if the background is too light, the type will appear too faint and therefore less readable.

3

Many different typographic manipulations can be used to separate and emphasize information, including the use of different typefaces and type weights. Assigning different colors to typographic parts is also an effective means to emphasize one element over another. Here, the word *Three* and the date *1996* achieve prominence through color.

4

A spread from the magazine's feature story utilizes the sky photograph, linking the cover and magazine interior. An image of a woman with the word *psychology* overlapping her forehead illustrates the topic of Gestalt psychology. The use of transparent color keeps the look of the magazine consistent.

5

9

1

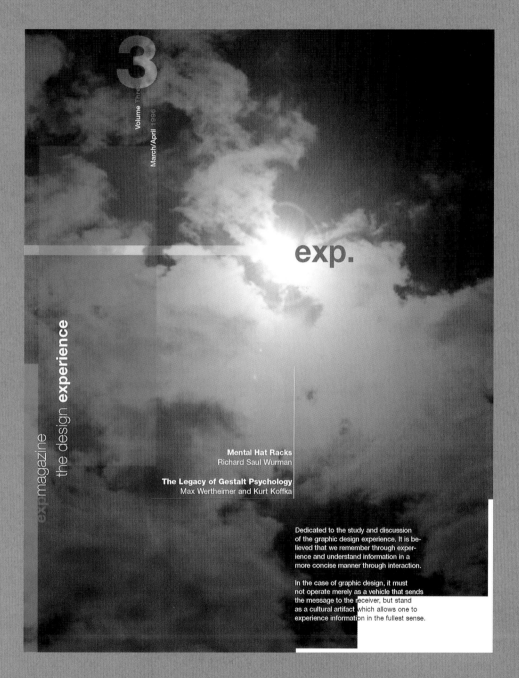

3

Volume Three

March/April 1996

exp.

exp·magazine

the design experience

Mental Hat Racks
Richard Saul Wurman

The Legacy of Gestalt Psychology
Max Wertheimer and Kurt Koffka

Dedicated to the study and discussion
of the graphic design experience. It is be-
lieved that we remember through exper-
ience and understand information in a
more concise manner through interaction.

In the case of graphic design, it must
not operate merely as a vehicle that sends
the message to the receiver, but stand
as a cultural artifact which allows one to
experience information in the fullest sense.

Design:
Clifford Stoltze
Brett Snyder
Heather Kramer
Peter Farrell
Rebecca Fagan
Stoltze Design

TIP:

When appropriate, choose color for type that mirrors the implied emotional and symbolic content of a message.

Postcards designed by Stoltze Design express the meanings of significant words through the poetic use of color and type. Entitled *Presents of Mind,* the cards are sent to friends and clients. The series offers a marvelous collection of creative color and type effects generated on the computer.

Content used for the cards are dictionary definitions of the selected words. The three colors used for the postcards include a glowing, phosphorescent orange; a subtle, metallic bronze; and a deep, oceanic blue-green. These colors possess rare qualities and join with type in a lively, chromatic concert.

1

One sees a "spark" in over-lapping letters and frag-mented oblique shapes. The definition of spark as "some-thing set off by a sudden force" is emphasized over other definitions by appear-ing in bright orange instead of blue-green.

2

The word *passion* looks pas-sionate through an emphatic layering of two contrasting typefaces and colors. "Flames" of passion appear-ing in the hot color flicker through a rectangular text block in cool blue-green.

3

The concept of purity ("free from what vitiates, weakens, or pollutes") is established by extracting the word from its environment and placing it upon a different color within a new environment.

w

k2

s39

t9

harmony

har·mo·ny \ˈhär-mə-nē\ *n pl* -nies [ME *armony*, fr. MF *armonie*, fr. L *harmonia*, fr. Gk, joint, har-mony, fr. *harmos* joint — more at ARM] (14c) 1 *archaic* : tuneful sound : MELODY 2 a : the combination of simultaneous musical notes in a chord b : the structure of music with respect to the composition and progression of chords c : the science and the structure, rela-tion, and progression of chords

3 a : pleasing or congruent arrangement of parts <a painting exhibiting ~ of color and line> b : CORRESPONDENCE, ACCORD <lives in ~ with her neigh-bors> c : internal calm : TRANQUILLITY

4 a : an interweaving of different accounts into a single narrative b : a systematic arrangement of parallel literary passages (as of the Gospels) for the purpose of showing agree-ment or harmony

Consider using warm colors when you wish to create impact. Most people respond emotionally to these hues of high intensity. There exists a fairly balanced distribution of warm and cool colors on the color wheel; however, people can physically see far more warm colors than cool ones.

The *A* stamp is the official priority mail stamp of the Swiss Post Office. Typically, expensive priority stamps are given warm colors while less expensive stamps are assigned cooler colors. For this stamp, Jean-Benoît Lévy decided to primarily employ warm colors but also to introduce cool colors for contrast. The edges of three interlocking shapes suggest an uppercase A. Stripes placed at the edges of the planes clearly define the letterform. The trilogy of shapes forming the letter *A* represents the three co-dependent parts of the mailing process: message, sender, and receiver.

1

The pinwheel shapes of the stamp appear substantially warmer and luminescent as they hover over a complementary cool blue sky. Within two of the shapes, linear color blends of red and yellow provide a shimmering effect.

2

Color blends and fades are effectively used in the stamp design. Easily achieved with a computer, this device modulates the surface of a form, providing a sense of three-dimensionality. As shown here, blends and fades come in several varieties, including linear, mid-linear, diamond, and rectangular.

3

Printed on an envelope is a simplified variation of the *A* form. Here, the structure of the stamp is clearly revealed. Moving clockwise, the shapes appear in an analogous gradation of red, orange, and yellow. This logical gradation provides cohesiveness and unity among the colors. The three functions of the mailing process are presented in converging upper-case letters printed over the three rectilinear shapes. These terms, presented in three languages, appear as three different but closely related hues.

4

The vivid warm colors and crisp geometric design of the *A* stamp give it distinction among other stamps.

If you are limited to the use of black, white, and gray, remember that these neutral colors work best when type and background contrast significantly in value, and that type set as a darker value on a lighter value works better than the inverse.

An opera poster for *Ariadne auf Naxos* comes to life in a rhythmic orchestration of type and color. This poster demonstrates how color may serve both as a means to emphasize and de-emphasize parts of information and to symbolically portray content. The poster is divided into two zones: a top zone consisting of a warm gray rectangle and robust typography that introduces the event; and a bottom zone with additional information set in text type and a painting by Titian called *Bacchus and Ariadne*. The painting portrays the classical myth surrounding the content of the opera.

1

The name *Richard Strauss* and the title *Ariadne auf Naxos* appear together on the warm gray rectangle in approximately the same size. Making one of these elements white and the other black creates a subtle distinction in emphasis. As the black unit advances in space, the white unit recedes (top). When both elements are assigned the same color, they are nearly equal in emphasis (bottom).

Richard Strauss
Ariadne auf Naxos

Richard Strauss
Ariadne auf Naxos

2

This example demonstrates how as the background changes in value, the type elements change in emphasis.

Richard Strauss
Ariadne auf Naxos

Richard Strauss
Ariadne auf Naxos

Richard Strauss
Ariadne auf Naxos

3

Below the gray rectangle, a painting by Titian entitled *Bacchus and Ariadne* portrays the classical myth upon which the opera is based. The painting is split horizontally into halves with the top half printed in black and white, and the bottom half printed in full color. This device represents the two distinct acts of the opera – two related but separate parts. The first act is a discussion among the actors about writing and producing an opera; the second act is a performance by the actors of the opera discussed in the first act. The black and white division of the painting signifies the unrealized production; the full-color component suggests the operatic event in real time.

k3

k

w

Typefaces: Garamond, Univers

Sinfonia
da Camera
Ian Hobson, music director

Ian Hobson, *conductor*
Nicholas DiVirgilio, *director*

Richard Strauss
Ariadne auf Naxos
A comic, chamber opera

Saturday March 30 1996 at 8:00pm
Foellinger Great Hall
Krannert Center for the Performing Arts
University of Illinois at Urbana-Champaign
Ticket information: 217 333-6280

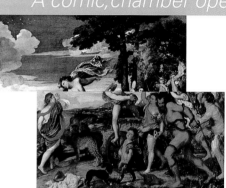

This performance is made possible through the generosity of Richard and Rosann Noel.

Sinfonia da Camera appears under the auspices of the University of Illinois at Urbana-Champaign in association with the School of Music and the College of Fine and Applied Arts.

painting: Titian: *Bacchus and Ariadne*, 1520-23, National Gallery, London
design: David Colley
printing: Dupli-Graphic/Chicago

Design:
David Colley

A poster for color studies in the Department of Design at Ohio State University demonstrates an interaction of two colors through color blends. The background progresses from red to blue, with the transition occurring at the center of the poster. A second, smaller field of color inverts the relationship, progressing from blue to red. The transition of this blend occurs also at the center. Through this color exercise, the essence of the poster's content is stated.

TIP: Use only the number of colors in a design that are absolutely necessary. If in doubt about the number, use as few as possible. A three-ring circus of color may entertain, but it will unlikely do little to enhance and augment the intended message.

1

Because it is neutral, the white type on the background does not interfere with the rest of the color on the poster. Any other color would have changed the intended effect, which is to emphasize the red and blue blend. Compare the two examples shown here.

Notice how the addition of type in a third hue changes the effect and perception of the two background colors and therefore changes the entire color statement.

2

Perhaps the most intriguing aspect of the poster is the simultaneous interaction of the color blends and the new hue resulting from their mix. Aside from the pure delight of color blends, they can (given an appropriate context) signify change, transition, time, and movement. An array of blends are pictured here; study the hue resulting from the interaction of the first two hues.

Typeface: Helvetica

Deeper Into Color

simultaneous contrast **vibration** **transparency**

programmed color **medial color**

studies in complex color relationships in the Department of Design at the Ohio State University

Design:
Willi Kunz
Willi Kunz
Associates, Inc.

For this poster announcing a summer program in architecture at Columbia University, designer Willi Kunz uses color to organize and structure the poster's space. Suggesting architectural spaces, yellow and black geometric forms asymmetrically frame the poster and house information related to the program. Resting above an image of New York City, a circular sphere suggesting the sun signifies the season in which the program is offered. The overall effect of the color is warm and optimistic.

1

Although the black shape functions as a container for text type, it has a life and purpose of its own due to the strength of the black and the character of the shape. The boldness of the shape also calls attention to the information contained within it. Type can be placed into shapes of all kinds. Never, however, should the shapes distract from the message; they should in fact relate to it in some way. This shape refers to the architectural theme of the poster.

2

The juxtaposing arrangement of the black and yellow shapes (shown only as black shapes in the diagram) creates a third white shape. Together these interlocking forms establish the poster's organizational structure.

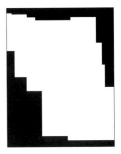

3

An effective transition from yellow to white is made in the poster by means of an intermediate series of yellow and white stripes. These alternating stripes read as a lighter yellow and soften the contrast between the yellow and white parts of the poster. Such transitions are often needed to bridge one color to another.

4

A light gray plane thrusting diagonally through the poster overlaps the sun motif and yellow shapes at the borders. This gives the plane a film-like, transparent quality.

York

W

k1

k

Columbia University
Graduate School of Architecture
Planning and Preservation

Introduction to Architecture

A Summer Studio in New York

A summer program giving university credit which introduces the student to aspects of the design, history, theory, and practice of architecture. The program is intended both for those without previous academic experience in design who are interested in architecture as a potential career, and for those with previous experience in architectural design who would like to develop additional studio design skills, perhaps in preparation for application to graduate school.

Courses are given in the studios of Avery Hall, home of Columbia University's world-renowned Graduate School of Architecture, Planning, and Preservation, on the Morningside Heights campus in New York City. Studios and seminar courses are taught by experienced architects and designers, coordinated and supervised by members of the faculty of the Graduate School. For those who may require it, housing is available on the University campus, with direct access to Avery Hall.

Students attend classes four days a week for five weeks, both morning and afternoon sessions. In the morning session, students are introduced to the fundamentals of architectural history and theory, structures, technology, and professional practice. Also, this course will introduce the student to the extraordinary city of New York, with its world famous collection of museums, cultural institutions, and architectural monuments. Lectures, seminar presentations, tours of architect's offices, and field-trips to solve building sites, museums, and famous works of architecture in New York City are led by the instructors.

In addition, students will attend a series of special lectures to be given by distinguished and renowned architects, including the following:

Kenneth Frampton
Architect; professor; author of "Modern Architecture: A Critical History".

Steven Holl
Architect; professor; winner of numerous Progressive Architecture Awards.

James Stewart Polshek
Architect; professor; designer for the renovation of Carnegie Hall.

Robert A. M. Stern
Architect; professor; author of "Pride of Place".

Bernard Tschumi
Architect; Dean, Columbia University; designer of the park "La Villette", Paris.

In the afternoon, the students attend the design studio – an educational method unique to architecture – a place where students are given an intensive training in the skills and critical thinking involved in architectural design. Students, in small groups, work directly with studio instructors to develop their individual designs, which the students then present in periodic reviews or "juries", where they hear the comments and criticism of the invited architects and professors. The design projects given in studio are frequently situated in New York City, so that the student is able to apply the knowledge he or she has gained from the morning sessions. The development of supporting skills such as drawing and model-building is also included in the studio curriculum.

Together the studio and lectures present a comprehensive introduction to every aspect of architecture as it is practiced today. In addition, through the various field trips and tours, the student learns from the extraordinary examples of architectural and urban design in New York City, the world's preeminent center for architectural culture.

Program Director:
Thomas Hanrahan
Architect; professor.

Introduction to Architecture
July 6 to August 8
Monday, Tuesday, Wednesday, Thursday
10:00am-5:00pm
3 credits, studio and seminar
Tuition for 1992: $1650
Housing on the Columbia University campus (if required): approximately $600

Applications should include a transcript of the applicant's academic record, a resume summarizing education, employment, and other types of experience; and, where appropriate, examples of the applicant's design work. Also please include a $35 application fee (checks made out to Columbia University).

Applications are due by June 30.

For information and applications write or call:

Office of Admissions –
Introduction to
Architecture Program
Columbia University
Graduate School
of Architecture, Planning,
and Preservation
400 Avery Hall
New York, NY 10027
(212) 854-3414

Design:
John Malinoski

Poster

TIP: When limited to the use of only two colors, select a pure hue and black. Most hues go well with black, and by screening and mixing the colors, a wide range of chromatic effects can be achieved.

A poster for the Master of Fine Arts program at Virginia Commonwealth University defies the limitations of using only two colors. The basic palette – yellow and black – represents the school's colors. This color combination is always very attractive, an attribute that is further enhanced through inventive spacing, screening, and layering of typographic elements. Indeed, this poster displays a wealth of two-color possibilities, and in doing so expresses the seriousness, involvement, and energy of the educational program.

1

While many typographic conventions are pushed aside for the sake of playful experimentation, critical information is set in black to preserve legibility.

2

In spite of the textured layering of type and color, black retains fidelity on the yellow-orange. Make note of how the heavier type appears black, and how the the lighter type appears gray.

3

A pattern of horizontal lines creates the effect of a lighter value of yellow-orange and draws attention to the adjacent photograph.

Typeface: Univers

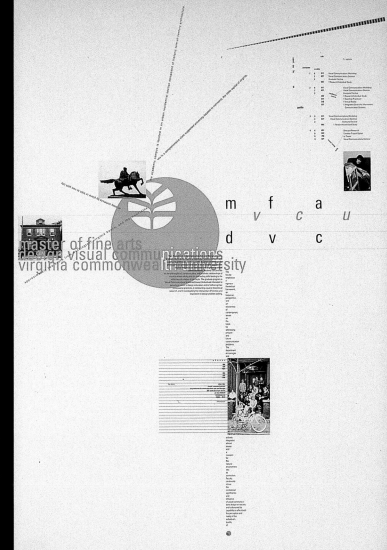

A large yellow dot provides a focal point for the poster. Lines of type radiate outward from the dot to encourage a search for information. While on the journey, color, type, and photographs give the reader a taste of the experiences offered by the program.

Design:
Nancy Skolos
Thomas Wedell
Skolos/Wedell
Photography:
Thomas Wedell

This poster announces an exhibition that documents all 85 major shows of Marcel Duchamp's work. Because Duchamp was obsessed with the game of chess, this topic became the theme of the poster. Each of the show openings are set into blocks of type suggesting chess pieces and placed strategically around a metaphorical chessboard. The poster's typographic border is a repeated pattern of the word *DADA* used by Duchamp for a poster design for one of his shows in 1953.

1

The show listings, placed at various angles throughout the poster, appear in various combinations of red, black, and white. Unique use of color and type activates the space and supports the DADA theme of the poster. This detail reveals some of these combinations.

2

The border of the poster demonstrates a stimulating use of color and type. The letters *D* and *A* in the name *DUCHAMP* are slightly enlarged and assigned the color red. As the letters are repeated along the edges of the poster, the term *DADA,* the name of an art movement of the early 20th century, emerges.

3

Placed at identical angles, tucked behind forms within the underlying photograph, and presented in red, two large *M*s provide drama and focal points within the poster.

4

The large white letters in the name *Marcel* are carefully placed within the photograph to establish visual prominence. Placing the letters in a lighter section of the photograph would weaken them and render them less legible (see page 36).

w

k

l

Typefaces: Keedy Sans, Matrix, Meta

Documenting Marcel

Reinhold-Brown Gallery

26 EAST 78TH STREET NEW YORK

IN ASSOCIATION WITH VIRGINIA L. GREEN

MARCH 5 – MAY 5 1996

Design:
Nancy Skolos
Thomas Wedell
Skolos/Wedell
Photography:
Thomas Wedell

Use color for typographic support elements such as ruled lines, bars, leaders, bullets, and other dingbats (assorted symbols used with a type font) to effectively flag and emphasize important information.

T I P :

The annual Lyceum Fellowship Competition is a travelling fellowship for undergraduate students in architecture. The 1996 program focuses on the house as a design problem, challenging students to think about the need to design a home rather than working with a generic set of developer's plans. A piece of yellow tracing paper with a site plan peels away from the skeletal structure of a home to visually reflect the architect's role in the design process. Yellow elevates the temperature of the poster, providing a mood of comfort and warmth.

1

The Lyceum logotype is superimposed onto yellow tracing paper. The transparent layers of the logotype represent the stages of conceptualization. Typefaces used for the logotype are Serifa and Futura. Serifa is collegiate in appearance; Futura refers to modern architecture. Folds in the tracing paper generate different values of yellow and create a distinct three-dimensionality related to architecture. The alternating yellow shapes in this example suggest a similar dimensionality and the illusion of a strong light source.

2

The general distribution of colors divides the poster into two interlocking shapes and creates a structural framework for type and images. The spatial divisions are active yet proportionally pleasing.

(diagram of space division)

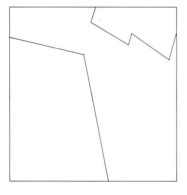

3

Yellow bars help to articulate the architectural structure and serve also as flags that mark typographic elements.

4

Black type on a yellow background proves highly visible and readable, a color combination frequently used in highway signage. In fact, black type reads well on any of the lighter warm hues. Black on red does not provide optimum legibility because these two colors are too close in value.

black on yellow	black on red-orange
black on orange	black on yellow-orange

w

k

t18

Typefaces: Futura, Meta, Serifa

Yellow and black effectively support the content. Adding other colors would only confuse the message or detract from the potency of just the black and yellow.

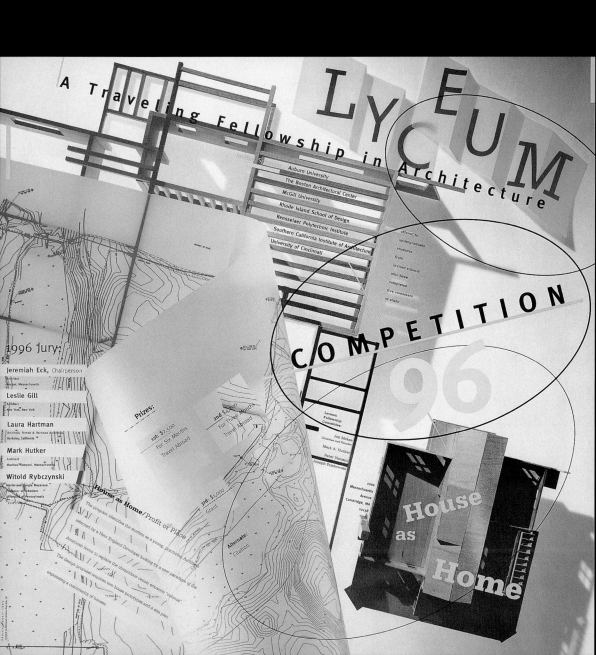

Design:
William Kochi
Kode Associates, Inc.
Photography:
William Kochi

When using color and type in publications, be consistent in the use of color for various typographic parts. For example, the small heads in this price guide are all presented in yellow.

T I P :

This small price guide provides a helpful resource for LinoGraphics customers, and it demonstrates the company's many capabilities. Each page offers a visual surprise with romantic, muted travel photographs and type mingling in a layered and textured conversation. The concept of "official" is parodied throughout the book: the cover is printed in an "official" cool gray; an "official" safety pattern delicately marks the left edge of each spread; and the "official" corporate seal, emblazoned in vivid red on the opening spread, is combined as a ghosted image in each of the interior photographs.

1

A stunning attribute of the book is the textures achieved by layering the photographs and typographic elements. Sufficient hue and value contrast preserves the integrity of each element.

2

Color can be used to link information from one page to another. These two pages reveal how letters of the word *GUIDE* appear on two different pages. *GU* (on the first page) and *IDE* (on the second page) are printed in black, linking them together. *IDE* is also cleverly integrated into the word *IDEN-TITY* on the second page.

3

The book reveals tremendous variety in form and color. Each page or spread features something unique, such as the overlapping red, green, and blue letters *RGB* on the RGB Scans page.

4

Used in tandem, the red ruled lines and the black type contribute to highly readable charts despite all the effusive visual activity of the pages.

Typefaces: OCR-B, Rockwell, Styvesant

The cover, printed in cool gray and simple in design, sets the reader up for a major sensory surprise. Upon opening the book, the pages bloom with activity and color. Juxtaposing neutral colors with highly chromatic colors can – when proportioned carefully – dazzle and delight the eye. A red colon at the right edge of the cover contrasts with the gray, appearing most luminescent because of its neutral surroundings. Though the smallest element on the cover, it is the most prominent. The mark is located in the same position and color on each spread, inviting the reader to turn to the next page (right).

Lino Graphics

kowloon-hong kong

Color Notes

rgb scans are closed-loop calibrated for output to fire 1000. all digital transparencies are imaged at res 50.

Digital Trans from postscript applications

	original	dupes
4"x5" ⑤	120	60
8"x10"	240	120

RGB

SCANS ⇒ FIRE 1000 :

Adobe PostScript

DrumScans

	300 dpi	1000 dpi
4"x5" ⑤	75	125
8"x10"	125	175

rabit: zerocb

Production Notes

image placements should include a laser proof noting size and positioning. complex silhouettes taking longer than 20 minutes are billed at $1.50 per minute.

Image Placement

original
PER IMAGE ⑤ 20

IMAGE
PLACEMENT

SILHOU-
ETTES :

original
PER IMAGE ⑤ 30

On each spread the ghostlike remnants of the company's seal are reflected in computer-manipulated photographs (left).

Design:
Jack Anderson
David Bates
Hornall Anderson Design
Works, Inc.
Art Direction:
Jack Anderson

Cf2GS is the acronym for the lengthy marketing communications firm's name Christiansen, Fritsch, Giersdorf, Grant, and Sperry, Inc. The creative use of the *2* for the two partners whose names begin with *G,* the innovative use of upper- and lower-case letters, and the incorporation of expressive color make this stationery system both unique and memorable. The elements of the logotype can appear in a serious and formal setting or in a more playful environment as purposes dictate.

Stationery

TIP: If you wish to accentuate and preserve the purity of hues within a typographic design, this can be accomplished by placing them upon white, black, and neutral gray backgrounds.

1

The colors used for the letters of the logotype consist of warm gray, cool gray, and bright yellow. The yellow glows in the midst of the more neutral hues, acquiring a strong presence and providing the mark with distinction. Without the contrasting yellow hue, the color would be lackluster at best.

2

Contrasts of hue, value, and intensity infuse a design with visual vitality. Shown from left to right is a composition that progresses from monochromatic elements to the addition of tints and finally to the addition of different hues and values. In the last example, color harmony is achieved through the juxtaposition of the two warm elements and the two cool elements.

3

Typically, letterforms lie upon a stage of black, each acting out assigned roles (left). Sometimes, however, the letters behave playfully. Compare the front and back of the business card. To emphasize each partner equally, the largest letter of the last name is accentuated through size and position.

MARKETING
COMMUNICATIONS

cf2GS

DAVID GIERSDORF

1008
WESTERN AVE
SUITE 201
SEATTLE, WA
98104

206 223-6464
FAX 223-2765

4

For variety, background colors for stationery items alternate between the three established hues. For example, on the back of the letterhead, the background shifts from black to cool gray. The numeral *2,* which is normally presented in white, now appears in black.

w
t20
k1
k4
k

140
141

Design:
Mark Meyer
Mark Oldach Design, Ltd.

The season program for the Steppenwolf Theatre Company reverberates with startling color and typographic virtuosity. Contrasting combinations of tertiary colors appear in great variety throughout the program, echoing the drama and excitement of the theatre. Typographic treatments are painstakingly resolved, appearing as a cast of well-rehearsed and talented characters. The reader is held captive by the energy and wit of this publication.

Program

TIP: As illustrated in this program, energy, rhythm, and variety can be achieved within a publication if the specific concentration and allocation of color varies and shifts from page to page.

1

Selected spreads reveal the eloquent variety of the color and type.

2

The typographic configuration introducing the play *Everyman* demonstrates a crafted unification of type, image, and color. Divided into two colors – white and blue-violet – the title is both resonant and readable. Note also the precise alignments of the type and image.

3

A subscription form on the last page of the program uses color to organize information. Zoning type with color in this way makes the form easier to complete.

4

Plays presented within the program are identified by a system of vertical bands. The bands, split into two colors, contain the number and dates of each play.

Typeface: Meta, Reactor

The Libertine

AMERICAN PREMIERE!
A PLAY BY STEPHEN JEFFREYS

Acclaimed Steppenwolf actor

John Malkovich

returns to the Chicago stage in this trenchant, witty portrait of the Earl of Rochester, the raconteur who inspired Etheridge's classic play "Man of Mode."

The Earl of Rochester delights in ravaging the noble fools of 1660's London with his rapier wit and merciless cynicism. His escapades with wine and women bring him celebrated notoriety, but he is not at all prepared to find truth and beauty in the world in the form of a young and talented actress—whose treachery may surpass even his own.

"I AM THE CYNIC OF OUR GOLDEN AGE. THIS BOUNTEOUS DISH WHICH OUR GREAT CHARLES AND OUR GREAT GOD HAVE PLACED BEFORE US SETS MY TEETH PERMANENTLY ON EDGE."

PHOTO: BRIGITTE LACOMBE

Yellow-green and blue-violet split an image of John Malkovich, intensifying the already provocative image. Typographic elements frame the eyes of the actor, calling attention to his piercing gaze.

Colorful wall graphics were designed to create public awareness of a historic site owned by The Council for America's First Freedom. This site will be the location of a reconstruction of Virginia's first capitol, a religious freedom study center, and a monument to religious freedom. At this location in 1786, Thomas Jefferson's Statute for Religious Freedom was approved by the Virginia General Assembly. This was the first time religious freedom was guaranteed to a people by law.

Wall graphics

TIP: If you wish to give selected typographic elements precedence over other elements in an environment of pure hues and shades, try dressing them in white. This will thrust them towards the viewer and imbue them with commanding visual strength.

1

The rectilinear shapes of the walls provide a structural framework for the organization of the color and typography. On this wall the most vivid element is a vertical red bar enclosing Thomas Jefferson's name. The words of the statute, set in justified Helvetica type with generous leading, are white against a blue-green background. This luminous typography commands attention and worthily presents the message's content.

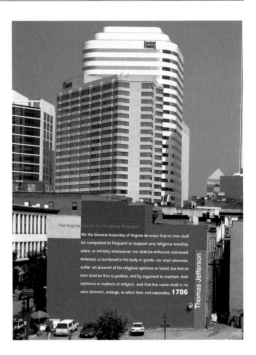

2

To avoid competition with the visual strength of the statute, the title typography is deliberately assigned less contrasting colors.

3

Commemorating the reconstruction of Virginia's first capitol at this site, a replica facade was built and placed upon a warehouse wall. An enormous initial capital *O,* set in yellow upon a deep blue-green background, rises like the sun to focus the reader's attention upon historic facts.

w
1
s46
5
s37

Typeface: Helvetica

Monumental typography set upon blazing walls separates historic site buildings from the surrounding city environment. The pure hues of yellow, red, blue-green, and blue-violet provide startling contrast to the somber tones of the cityscape.

	c	m	y	k
k				100
k9				90
k8				80
k7				70
k6				60
k5				50
k4				40
k3				30
k2				20
k1				10
w				0

	c	m	y	k
s5	100	100		80
s4	100	100		70
s3	100	100		50
s2	100	100		30
s1	100	100		10
1	100	100		
t5	90	80		
t4	70	65		
t3	55	50		
t2	30	30		
t1	20	15		
s10	80	100		80
s9	80	100		70
s8	80	100		50
s7	80	100		30
s6	80	100		10

	c	m	y	k
2	80	100		
t10	65	80		
t9	50	65		
t8	40	50		
t7	30	35		
t6	20	20		
s15	60	100		80
s14	60	100		70
s13	60	100		50
s12	60	100		30
s11	60	100		10
3	60	100		
t15	50	80		
t14	40	65		
t13	30	50		
t12	20	35		
t11	15	20		

	c	m	y	k
s20	40	100		80
s19	40	100		70
s18	40	100		50
s17	40	100		30
s16	40	100		10
4	40	100		
t20	30	80		
t19	25	65		
t18	20	50		
t17	10	35		
t16	5	25		
s25			100	80
s24			100	70
s23			100	50
s22			100	30
s21			100	10

	c	m	y	k
5				100
t25				80
t24				65
t23				50
t22				35
t21				25
s30	55		100	80
s29	55		100	70
s28	55		100	50
s27	55		100	30
s26	55		100	10
6	55		100	
t30	40		80	
t29	30		65	
t28	20		50	
t27	15		35	
t26	10		20	

	c	m	y	k
■ s35	85		85	80
■ s34	85		85	70
■ s33	85		85	50
■ s32	85		85	30
■ s31	85		85	10
■ 7	85		85	
■ t35	75		70	
■ t34	65		55	
■ t33	55		45	
■ t32	35		35	
■ t31	25		20	
■ s40	100		40	80
■ s39	100		40	70
■ s38	100		40	50
■ s37	100		40	30
■ s36	100		40	10

	c	m	y	k
■ 8	100		40	
■ t40	90		35	
■ t39	70		30	
■ t38	55		25	
■ t37	40		20	
■ t36	25		10	
■ s45	100	55		80
■ s44	100	55		70
■ s43	100	55		50
■ s42	100	55		30
■ s41	100	55		10
■ 9	100	50		
■ t45	85	45		
■ t44	65	40		
■ t43	50	35		
■ t42	40	25		
■ t41	25	10		

	c	m	y	k
■ s50	100	85		80
■ s49	100	85		70
■ s48	100	85		50
■ s47	100	85		30
■ s46	100	85		10
■ 10	100	85		
■ t50	90	75		
■ t49	70	65		
■ t48	55	50		
■ t47	40	35		
■ t46	25	25		
■ s55	75	100		80
■ s54	75	100		70
■ s53	75	100		50
■ s52	75	100		30
■ s51	75	100		10

	c	m	y	k
■ 11	75	100		
■ t55	60	85		
■ t54	45	70		
■ t53	35	55		
■ t52	25	40		
■ t51	15	30		
■ s60	40	100		80
■ s59	40	100		70
■ s58	40	100		50
■ s57	40	100		30
■ s56	40	100		10
■ 12	40	100		
■ t60	35	80		
■ t59	30	65		
■ t58	25	50		
■ t57	15	35		
■ t56	5	20		

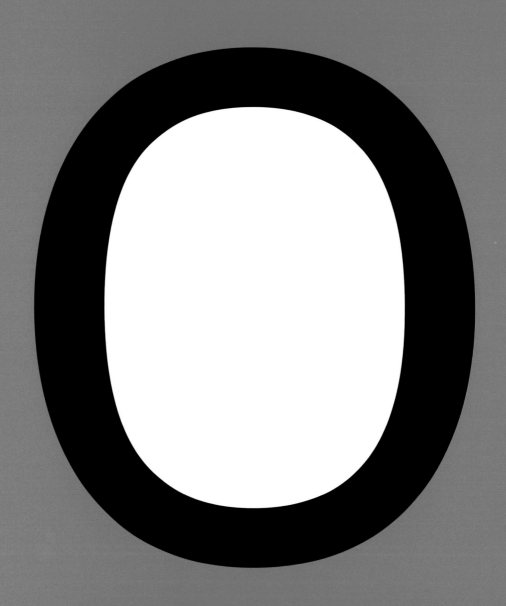

Obeying the rules

The division pages located at the beginning of
each chapter constitute a typographic experi-
ment by Erik Brandt. He comments: "Letter-
forms are the architectural elements of our
being-toward-reality. As such, they can be
treated as both syntactic and semantic vehicles.
These pages are simple attempts to isolate and
experiment. They are intended as quiet
moments to consider: How much experimenta-
tion is actually necessary? I urge that simpli-
city achieves both maximum clarity and
maximum entropy."

Obeying the rules

For optimum legibility, choose classical, time-tested typefaces with a proven track record.

Well-seasoned typographic designers can usually count their favorite typefaces on one hand. Most often, they are those typefaces that are drawn and crafted with consistency among characters, and those that exhibit highly legible proportions.

Over the centuries, typographic guidelines have been developed to provide consistency and competency within the profession, to preserve the beauty and legibility of typographic form, and to ensure that typography functions as often mandated: to clearly represent the thoughts of the author.

The guidelines presented in this chapter are not absolute or definitive, but they are representatives of a sturdy, time-tested collection of typographic "rules." They are presented here to provide a context for informed typographic exploration. In other words, rules must first be understood before they can be broken. Once it is known how to obey the rules, one can freely journey into unconventional terrain. For some readers, these guidelines offer a welcome review. For those new to the fascinating but often confusing world of typography, they provide a critical foundation for informed and responsible practice.

1
The book, *Typographic Specimens: The Great Typefaces,* co-authored by Philip Meggs and Rob Carter, presents 38 typefaces regarded as classical and timeless. The selection of these typefaces was based on the results of a survey sent to more than 100 prominent typographic designers. Admirable representatives of these classics are found here, and include both serif and sans serif faces. All of these typefaces are available for use on the electronic desktop.

Baskerville
Bembo
Bodoni
Caslon
Centaur
Franklin Gothic
Frutiger
Futura
Garamond
Gill Sans
Goudy Old Style
Helvetica
News Gothic
Palatino
Perpetua
Sabon
Times New Roman
Univers

1

Rule 2:
Be mindful not to use too many different typefaces at any one time.

Rule 3:
Avoid combining typefaces that are too similar in appearance.

The primary purpose for using more than one typeface is to create emphasis or to separate one part of the text from another. When too many different typefaces are used, the page becomes a three-ring circus, and the reader is unable to determine what is and what is not important.

If the reason for combining typefaces is to create emphasis, it is important to avoid the ambiguity caused by combining types that are too similar in appearance. When this occurs, it usually looks like a mistake, because not enough contrast exists between the typefaces.

The role of typographic experimentation is to extend the boundaries of language by freely probing visual and verbal syntax and the relationships between **WORD** and image. Syntactic exploration enables designers to discover among typographic **media** an enor-

2

The role of typographic experimentation is to extend the boundaries of language by freely probing visual and verbal syntax and the relationships between **word and image.** Syntactic exploration enables designers to discover among typographic media an enormous

The role of typographic experimentation is to extend the boundaries of language by freely probing visual and verbal syntax and the relationships between word and image. **Syntactic exploration enables designers to discover among typographic media an**

3

The role of typographic experimentation is to extend the boundaries of language by freely probing visual and verbal syntax and the relationships between word and image. Syntactic exploration enables designers to discover among typographic media an enormous poten-

The role of typographic experimentation is to extend the boundaries of language by freely probing visual and verbal syntax and the relationships between word and image. Syntactic exploration enables designers to discover among typographic media an enormous potential to

4

The role of typographic experimentation is to extend the boundaries of language by freely probing visual and verbal syntax and the relationships between *word and image.* Syntactic exploration enables designers to discover among typographic media an enormous

The role of typographic experimentation is to extend the boundaries of language by freely probing visual and verbal syntax and the relationships between ***word and image.*** Syntactic exploration enables designers to discover among typographic media an enormous

5

2
Using too many different typefaces on a page or within text is very distracting, and the reader's ability to discern what is and what is not important is compromised. Excellent results may be obtained by combining two or three different typefaces, as long as the role of each is carefully considered.
3
When mixing different typefaces, a good rule of thumb is to use typefaces that appear very different from one another. A serif typeface combined with a sans serif typeface can be effective (top), as can a lightweight typeface combined with a heavy-weight face (bottom).
4
Combining Helvetica with Univers (top), or Caslon with Goudy Old Style (bottom) makes absolutely no sense because the typeface pairings are too similar in appearance.
5
Why not use just one typeface and create emphasis by changing weight, width, or slant, or combine typefaces having more obvious contrasts.

Rule 4:
Text set in all capital letters severely retards reading. Use upper- and lower-case letters for optimum readability.

Lower-case letters provide the necessary visual cues to make text most readable. This is due to the presence of ascenders, descenders, and the varied internal patterns of lower-case letters. Using both upper- and lower-case letters is the most normative means for setting text type, and a convention to which readers are most accustomed. Upper-case letters can success-fully be used for display type, however.

Rule 5:
For text type, use sizes that according to legibility studies prove most readable.

These sizes generally range from 8 to 12 points (and all sizes in between) for text that is read from an average distance of 12 to 14 inches. However, it is important to be aware of the fact that typefaces of the same size may actually appear different in size depending upon the x-height of the letters (the distance between the baseline and meanline).

6
Lower-case letters have ascenders and descenders that give words distinct, memorable shapes. Words set entirely in upper-case letters form monotonous, rectangular shapes.
7
Text set entirely in upper-case letters lacks rhythmic variety and is therefore difficult to read (top). Text set entirely in lower-case letters is easier to read due to distinct visual patterns (bottom).
8
The most familiar means for setting text is to employ both upper- and lower-case letters. Capitals clearly mark the beginnings of sentences.
9
The most readable sizes of text type range from 8 to 12 points. These specimens are set in Minion Regular.
10
Compare the perceived sizes of Bodoni (top), Helvetica (middle), and Frutiger (bottom), each of which is set to 8 points in size.

6

THE ROLE OF TYPOGRAPHIC EXPERIMEN-TATION IS TO EXTEND THE BOUNDARIES OF LANGUAGE BY FREELY PROBING VISUAL AND VERBAL SYNTAX AND THE RELATIONSHIPS BETWEEN WORD AND IMAGE. SYNTACTIC EXPLORATION

the role of typographic experimentation is to extend the boundaries of language by freely probing visual and verbal syntax and the relationships between word and image. syntactic exploration enables designers to discover among typographic media an enormous poten-

7

The role of typographic experimentation is to extend the boundaries of language by freely probing visual and verbal syntax and the relationships between word and image. Syntactic exploration enables designers to discover among typographic media an enormous poten-

8

8 point
The role of typographic experimentation is to extend

9 point
The role of typographic experimentation is to

10 point
The role of typographic experimentation is

11 point
The role of typographic experimenta-

12 point
The role of typographic experimen-

9

The role of typographic experimentation is to extend the boundaries of language by freely probing visual and verbal syntax and the relationships between word and image. Syntactic exploration enables designers to discover among typographic media an enormous potential to edify, entertain, and surprise. As in other

The role of typographic experimentation is to extend the boundaries of language by freely probing visual and verbal syntax and the relationships between word and image. Syntactic exploration enables designers to discover among typographic media an enormous

The role of typographic experimentation is to extend the boundaries of language by freely probing visual and verbal syntax and the relationships between word and image. Syntactic exploration enables designers to discover among typographic media an enormous potential to

10

Rule 6:
Avoid using too many different type sizes and weights at the same time.

You only need to use as many different sizes and weights as needed to establish a clear hierarchy among parts of information. Josef Müller-Brockmann advocates using no more than two sizes, one for display titles and one for text type. Restraint in the number of sizes used leads to functional and attractive pages.

Rule 7:
Use text types of book weight. Avoid typefaces appearing too heavy or too light.

The weight of typefaces is determined by the thicknesses of the letter strokes. Text typefaces that are too light cannot easily be distinguished from their backgrounds. In typefaces that are too heavy, counterforms diminish in size, making them less legible. Book weights strike a happy medium, and are ideal for text.

Type and experiment

The role of typographic experimentation is to extend the boundaries of language by freely probing visual and verbal syntax and the relationships between word and image. Syntactic exploration enables designers to

11

Type and experiment

The role of typographic experimentation is to extend the boundaries of language by freely probing visual and verbal syntax and the relationships between word and image. Syntactic exploration enables designers to discover

12

Type **and** experiment

The role of typographic experimentation is to **extend** the boundaries of language by freely probing visual and verbal syntax and the relationships between word and image. Syntactic exploration enables designers to discover

13

The role of typographic experimentation is to extend the boundaries of language by freely probing visual and verbal syntax and the relationships between word and image. Syntactic exploration enables designers to

The role of typographic experimentation is to extend the boundaries of language by freely probing visual and verbal syntax and the relationships between word and image. Syntactic exploration enables designers to

14

The role of typographic experimentation is to extend the boundaries of language by freely probing visual and verbal syntax and the relationships between word and image. Syntactic exploration enables designers to discover among typographic media an enormous potential to edify, entertain, and surprise.

15

The role of typographic experimentation is to extend the boundaries of language by freely probing visual and verbal syntax and the relationships between word and image. Syntactic exploration enables designers to discover among typographic media an enormous

16

11
Using the same type size and weight for titles and text works fine, as long as the two elements are separated by an interval of space.
12
Using two sizes and weights of type for titles and text establishes a clear and simple hierarchy. It is important to create plenty of contrast. If elements are too close in size or weight, they lack contrast and their relationship is ambiguous.
13
Too many different sizes and weights give the page a haphazard look.
14
Two typefaces of extremely heavy weight are difficult to read due to an imbalance between the letter strokes and counterforms. These faces are best reserved for display type or small amounts of text. Note the extreme contrast in the strokes of the bottom example, a quality that also impedes readability.
15
This very thin typeface appears to almost fade into its background.
16
A typeface of book weight provides excellent readability.

Rule 8:
Use typefaces of medium width. Avoid typefaces that appear extremely wide or narrow in width.

Distorting text to make letters wider or narrower by stretching or squeezing them with a computer impedes the reading process. The proportions of such letters are no longer familiar to us. Well designed type families include condensed and extended faces that fall within accepted proportional norms.

Rule 9:
For text type, use consistent letter and word spacing to produce an even, uninterrupted texture.

Letters should flow gracefully and naturally into words, and words into lines. This means that word spacing should increase proportionally as letter spacing increases.

17

The typeface Trade Gothic Regular (top) can be compared with condensed (middle) and extended (bottom) versions. While the condensed and extended variations are useful and carefully designed additions to the Trade Gothic family, large amounts of text set in them prove difficult to read.

18

As you can see in this example, extreme stretching and squeezing of roman letterforms via computer renders text nearly illegible.

19

Excellent letter and word spacing. From top to bottom: letter and word spacing appearing too tight; letter spacing appearing too loose; letter spacing appearing too tight and word spacing too loose; letter and word spacing appearing too tight.

Letters abhor crowding, but they also wish not to lose sight of their neighbors.

Another important consideration is that lighter typefaces look best with more generous letter spacing, while the reverse is true of heavier faces.

The role of typographic experimentation is to extend the boundaries of language by freely probing visual and verbal syntax and the relationships between word and image. Syntactic exploration enables designers to discover among typographic media an enormous poten-

The role of typographic experimentation is to extend the boundaries of language by freely probing visual and verbal syntax and the relationships between word and image. Syntactic exploration enables designers to discover among typographic media an enormous potential to edify, entertain, and surprise. As in other forms of language typography is

The role of typographic experimentation is to extend the boundaries of language by freely probing visual and verbal syntax and the relationships between word and image. Syntactic exploration enables designers to dis-

17

The role of typographic experimentation is to extend the boundaries of language by freely probing visual and verbal syntax and the relationships between word and image. Syntactic exploration enables designers to discover among typographic media an enormous potential to edify, entertain, and surprise. As in other forms of language typography is capable of infinite expression. The only limits to typographic discovery are those imposed by the designer herself.

The role of typo-
graphic experimenta-
tion is to extend the
boundaries of lan-
guage by freely
probing visual and

18

The role of typographic experimentation is to extend the boundaries of language by freely probing visual and verbal syntax and the relationships between word and image. Syntactic exploration enables designers to discover among typographic media an enormous poten-

The role of typographic experimentation is to extend the boundaries of language by freely probing visual and verbal syntax and the relationships between word and image. Syntactic exploration enables designers to discover among typographic media an enormous potential to

The role of typographic experimenta-
tion is to extend the boundaries of
language by freely probing visual and
verbal syntax and the relationships
between word and image. Syntactic
exploration enables designers to

The role of typographic experimentation is to extend the boundaries of language by freely probing visual and verbal syntax and the relationships between word and image. Syntactic exploration enables designers to discover among typographic media an

The role of typographic experimentation is to extend the boundaries of language by freely probing visual and verbal syntax and the relationships between word and image. Syntactic exploration enables designers to discover among typographic media an enormous potential to edify, entertain,

19

Rule 10:
Use appropriate line lengths. Lines that are too short or too long disrupt the reading process.

When lines of type are either too long or too short, the reading process becomes tedious and wearisome. As the eye travels along overly long lines, negotiating the next line becomes difficult. Reading overly short lines creates choppy eye movements that tire and annoy the reader.

The role of typographic experimentation is to extend the boundaries of language by freely probing visual and verbal syntax and the relationships between word and image. Syntactic exploration enables designers to discover among typographic media an enormous potential to edify, entertain, and surprise. As in other forms of language typography is capable of infinite expression. The only limits to typographic discovery are those imposed by the designer herself.

The role of typographic experimentation is to extend the boundaries of language by freely probing visual and verbal syntax and the relationships between word and image. Syntactic exploration enables designers to discover among typographic media an enormous potential to edify, entertain, and surprise. As in other forms of language typography is capable of infinite expression. The only limits to typographic discovery are those imposed by the designer herself.

20

The role of typographic experimentation is to extend the boundaries of language by freely probing visual and verbal syntax and the relationships between word and image. Syntactic exploration enables designers to discover among typographic media an enormous potential to edify, entertain, and surprise. As in other forms of language typography is capable of infinite expression. The only limits to typographic discovery are those imposed by the

The role of typographic experimentation is to extend the boundaries of language by freely probing visual and verbal syntax and the relationships between word and image. Syntactic exploration enables designers to discover among typographic media an enormous potential to edify, entertain, and surprise. As in other forms of language typography is capable of infinite expression. The only limits to typographic discovery are those imposed by

The role of typographic experimentation is to extend the boundaries of language by freely probing visual and verbal syntax and the relationships between word and image. Syntactic exploration enables designers to discover among typographic media an enormous potential to edify,

20

When working with text type, a maximum of about 70 characters (ten to twelve words) per line is thought to be most acceptable. The top example far exceeds this recommendation. Though the measure is the same in the bottom example, an increase in the size of the type lessens the number of characters per line.

21

Text set into short lines produces rather choppy reading (left). Line length is of particular importance when setting justified type because space is distributed evenly among words. This results in awkward and irregular spaces between words (middle). While using longer lines lessens this problem, it does not eliminate it completely (right).

Rule 11:
For text type, use line spacing that easily carries the eye from one line to the next.

Lines of type with too little space between them slow the reading process; the eye is forced to take in several lines at once. By adding one to four points of space between lines of type – depending on the specific nature of the typeface – readability can be improved.

Rule 12:
For optimum readability, use a flush left, ragged right type alignment.

Although in special situations, other methods of type alignment (flush right, ragged left; centered, and justified) are acceptable, the tradeoff is always a loss – however slight – in readability.

22

Text blocks containing acceptable amounts of line spacing. As more space is introduced, lines appear more separate and the text block calmer.

23

Though the two text blocks in this example are technically identical in size and line spacing, the top block, due to a larger x-height, appears tighter in line spacing than the bottom block. Lines of text with large x-heights should be spaced appropriately to compensate for their larger appearance. Lines with no additional space between them are said to be set "solid."

24

With a computer, it is possible to establish negative line spacing. However, for optimum readability, this practice should be avoided. Note the overlapping ascenders and descenders.

25

The four primary methods for aligning text type.

1.5 points line spacing
The role of typographic experimentation is to extend the boundaries of language by freely probing visual and verbal syntax and the relationships between word and image. Syntactic exploration enables designers to discover among typographic media an enormous poten-

2 points line spacing
The role of typographic experimentation is to extend the boundaries of language by freely probing visual and verbal syntax and the relationships between word and image. Syntactic exploration enables designers to discover

3 points line spacing
The role of typographic experimentation is to extend the boundaries of language by freely probing visual and verbal syntax and the relationships between word and image. Syntactic exploration enables designers to discover

22

set solid
The role of typographic experimentation is to extend the boundaries of language by freely probing visual and verbal syntax and the relationships between word and image. Syntactic exploration enables designers to discover among typographic media an enormous poten-

set solid
The role of typographic experimentation is to extend the boundaries of language by freely probing visual and verbal syntax and the relationships between word and image. Syntactic exploration enables designers to discover among typographic media an enormous potential to edify, entertain, and

23

negative line spacing
The role of typographic experimentation is to extend the boundaries of language by freely probing visual and verbal syntax and the relationships between word and image. Syntactic exploration enables designers to discover among typographic media an enormous potential to edify, entertain, and surprise. As in other

24

flush left, ragged right
The role of typographic experimentation is to extend the boundaries of language by freely probing visual and verbal syntax and the relationships between word and image. Syntactic exploration enables designers to discover among typographic media an enormous poten-

flush right, ragged left
The role of typographic experimentation is to extend the boundaries of language by freely probing visual and verbal syntax and the relationships between word and image. Syntactic exploration enables designers to discover among typographic media an enormous

justified
The role of typographic experimentation is to extend the boundaries of language by freely probing visual and verbal syntax and the relationships between word and image. Syntactic exploration enables designers to discover among typographic media an enormous poten-

centered
The role of typographic experimentation is to extend the boundaries of language by freely probing visual and verbal syntax and the relationships between word and image. Syntactic exploration enables designers to discover among typographic media an

25

Rule 13:
Strive for consistent, rhythmic rags.

Avoid rags in which strange and awkward shapes are formed as a result of line terminations. Also avoid rags that produce a repetitious and predictable pattern of line endings.

Rule 14:
Clearly indicate paragraphs, but be careful not to upset the integrity and visual consistency of the text.

The two most common means of indicating paragraphs are by indenting and inserting additional space between paragraphs. It is not necessary to indent the first paragraph in a column of text.

The role of typographic experimentation is to extend the boundaries of language by freely probing visual and verbal syntax and the relationships between word and image. Syntactic exploration enables designers to discover among typographic media an enormous

26

The role of typographic experimentation is to extend the boundaries of language by freely probing visual and verbal syntax and the relationships between word and image. Syntactic exploration enables designers to discover in typographic media an enormous potential to

The role of typographic experimentation is to extend the boundaries of language by freely probing visual and verbal syntax and the relationships between word and image. Syntactic exploration enables designers to discover among typographic media an enor-

The role of typographic experimentation is to extend the boundaries of language by freely probing visual and verbal syntax and the relationships between word and image. Syntactic exploration enables designers to discover among typographic media an

27

The role of typographic experimentation is to extend the boundaries of language by freely probing visual and verbal syntax and the relationships between word and image. Syntactic exploration enables designers to discover among typographic media an enormous poten-

The role of typographic experimentation is to extend the boundaries of language by freely probing visual and verbal syntax and the relationships between word and image. Syntactic exploration enables designers to discover among typographic media an

The role of typographic experimentation is to extend the boundaries of language by freely probing visual and verbal syntax and the relationships between word and image.

Syntactic exploration enables designers to discover among typographic media an enormous potential to edify, entertain, and surprise. As in other forms of language typography is capable of infinite expression.

28

The purpose of effective rags is not only to achieve aesthetic beauty. When rags consist of line endings that are carefully articulated, rhythmic and consistent, they enable readers to move gently and effortlessly down a text column. Rags provide logical points of departure from one line to the next.
26
Effective rags consist of lines establishing an informal but consistent pattern of line endings. The rag edge should appear to fade off gradually.
27
Rags are less effective when line endings are not distinct enough from one another (top), when weird shapes and contours emerge (middle), or when long and short lines are so similar that they create a repetitive and predictable pattern (bottom).
28
Common paragraph indication by means of indenting (top), and intervals of space separating paragraphs (bottom).

Rule 15:
Avoid widows and orphans whenever possible.

A widow is a word or very short line at either the beginning or the end of a paragraph. An orphan is a single syllable at the end of a paragraph. Both of these lonely conditions should be avoided whenever possible, for they destroy the continuity of text blocks, create spotty pages, and interfere with concentration in reading.

29

Other methods of paragraph indication are plentiful; these, however, should be used with caution. In these examples, paragraphs are indicated (top to bottom) by the following means: bold type for the first letter, small squares, reverse indenting, small caps for the first word, and a large first letter placed into the margin.

30

When encountering widows and orphans, rework text as necessary to avoid them. This may require changing the spacing, altering the rag, or rewriting copy.

The role of typographic experimentation is to extend the boundaries of language by freely probing visual and verbal syntax and the relationships between word and image. **S**yntactic exploration enables designers to discover among typographic media an enormous potential to edify, entertain, and surprise. As in other forms of language typog-

■ The role of typographic experimentation is to extend the boundaries of language by freely probing visual and verbal syntax and the relationships between word and image.
■ Syntactic exploration enables designers to discover among typographic media an enormous potential to edify, entertain, and

The role of typographic experimentation is to extend the boundaries of language by freely probing visual and verbal syntax and the relationships between word and image.
Syntactic exploration enables designers to discover among typographic media an enormous potential to edify, entertain, and

THE role of typographic experimentation is to extend the boundaries of language by freely probing visual and verbal syntax and the relationships between word and image. SYNTACTIC exploration enables designers to discover among typographic media an enormous poten-

The role of typographic experimentation is to extend the boundaries of language by freely probing visual and verbal syntax and the relationships between word and image.
Syntactic exploration enables designers to discover among typographic media an

29

The role of typographic experimentation is to extend the boundaries of language by freely probing visual and verbal syntax and the relationships between word and image. Syntactic exploration enables designers to discover among typographic media an enormous potential to edify, entertain, and surprise. As in other forms of language typography is capable of infinite expression. The only limits to typographic discovery are those imposed by the designer herself.

herself.

The role of typographic experimentation is to extend the boundaries of language by freely probing visual and verbal syntax and the relationships between word and image. Syntactic exploration enables designers to discover among typographic media an enormous potential to edify, entertain, and surprise. As in other

The role of typographic experimentation is to extend the boundaries of language by freely probing visual and verbal syntax and the relationships between word and image. Syntactic exploration enables designers to discover among typographic media an enormous potential.

30

Rule 16:
Emphasize elements within text with discretion and without disturbing the flow of reading.

Never overdo it. Use minimum means for maximum results. The ultimate purposes for emphasizing elements within text are to clarify content and distinguish parts of information.

The role of typographic experimentation is to extend the boundaries of language by freely probing visual and verbal syntax and the relationships between *word and image.* Syntactic exploration enables designers to discover among typographic media an enormous poten-

The role of typographic experimentation is to extend the boundaries of language by freely probing visual and verbal syntax and the relationships between word and image. Syntactic exploration enables designers to discover among typographic media an enormous poten-

The role of typographic experimentation is to extend the boundaries of language by freely probing visual and verbal syntax and the relationships between word and image. Syntactic exploration enables designers to discover among typographic media an enormous poten-

The role of typographic experimentation is to extend the boundaries of language by freely probing visual and verbal syntax and the relationships between word and image. Syntactic exploration enables designers to discover among typographic media an enormous poten-

The role of typographic experimentation is to extend the boundaries of language by freely probing visual and verbal syntax and the relationships between WORD AND IMAGE. Syntactic exploration enables designers to discover among typographic media an enormous poten-

The role of typographic experimentation is to extend the boundaries of language by freely probing visual and verbal syntax and the relationships between WORD AND IMAGE. Syntactic exploration enables designers to discover among typographic media an

The role of typographic experimentation is to extend the boundaries of language by freely probing visual and verbal syntax and the relationships between **word and image.** Syntactic exploration enables designers to discover among typographic media an

The role of typographic experimentation is to extend the boundaries of language by freely probing visual and verbal syntax and the relationships between word and image. **Syntactic exploration enables designers to discover among**

The role of typographic experimentation is to extend the boundaries of language by freely probing visual and verbal syntax and the relationships between word and image. Syntactic exploration enables designers to discover among typographic media an enor-

The role of typographic experimentation is to extend the boundaries of language by freely probing visual and verbal syntax and the relationships between word and image. Syntactic exploration enables designers to discover among typographic media an enormous poten-

31
Several methods for emphasizing units of information within text are shown. These include using italics, underlined type, color type, different typeface, small capitals, capitals, bold type within light type, light type within bold type, larger type, and outline type (left to right, top to bottom). While none of these possibilities are invasive to the text, some are obviously more pronounced than others.

Rule 17:
Always maintain the integrity of type. Avoid arbitrarily stretching letters.

Well designed typefaces exhibit visual qualities that make them readable. Letters are painstakingly designed with specific proportional attributes in mind. Arbitrarily distorting them compromises their integrity.

Rule 18:
Always align letters and words on the baseline.

Letters are designed to coexist side-by-side on an invisible baseline. When they stray from this orientation, they appear to be out of control, their readability greatly compromised.

32

A Univers 65 *E* appears normal (top). The deliberate and refined proportions of this letter are entirely compromised in the two bottom examples. Here, letterforms have been vertically and horizontally scaled by the computer, resulting in an arbitrary and awkward proportional relationship between the thick and thin strokes of the letters.

33

If a more condensed or extended version of a typeface is desired, use a version designed specifically for that particular type family. In this example, Univers 67 Condensed and Univers Ultra Condensed letters are shown. Notice how the thick and thin relationships of the letter strokes correspond in intent to those of the Univers 65 letter.

34

Because letters are specifically designed to align side-by-side on a baseline for optimum readability, any deviation from this norm is highly questionable. Consider the three anomalies shown in this example. Never stack letters.

32

33

The role of typographic experimentation is to

The role of typographic experimentation

e
x
p
e
r
i
m
e
n
t
a
t
i
o
n

34

Rule 19:
When working with type and color, ensure that sufficient contrast exists between type and its background.

Too little contrast in hue, value, or saturation, or a combination of these factors, can result in type that is difficult, if not impossible, to read.

The role of typographic experimentation is to extend the boundaries of language by freely probing visual and verbal syntax and the relationships between word and image. Syntactic

The role of typographic experimentation is to extend the boundaries of language by freely probing visual and verbal syntax and the relationships between word and image. Syntactic

35

The role of typographic experimentation is to extend the boundaries of language by freely probing visual and verbal syntax and the relationships between word and image. Syntactic

The role of typographic experimentation is to extend the boundaries of language by freely probing visual and verbal syntax and the relationships between word and image. Syntactic

The role of typographic experimentation is to extend the boundaries of language by freely probing visual and verbal syntax and the relationships between word and image. Syntactic

The role of typographic experimentation is to extend the boundaries of language by freely probing visual and verbal syntax and the relationships between word and image. Syntactic

The role of typographic experimentation is to extend the boundaries of language by freely probing visual and verbal syntax and the relationships between word and image. Syntactic

The role of typographic experimentation is to extend the boundaries of language by freely probing visual and verbal syntax and the relationships between word and image. Syntactic

35

Black type on a white background is the most legible of color combinations, and this is what we are most accustomed to in reading. Any deviation from this norm compromises readability to a degree. White type on a black background reverses this color relationship, and is harder to read.

36

By considering the color contrast relationships between type and its background, type can be rendered more readable. The type and background color relationships in the left-hand column are problematic due to inadequate color contrasts. Compare these with the examples in the right-hand column where color adjustments are made in hue, value, saturation, or in a combination of these factors. These adjustments improve legibility.

Breaking the rules

Typography can function to dutifully deliver a message, just as a postman delivers a letter, but it can also provide the elements and inspiration for uninhibited play. Through play we experience the pure joy of typographic expression, and our eyes and minds are open to new ways of solving typographic problems. Old habits and formulas are replaced by a more active and vigorous way of working with type.

To effectively and freely explore typography, it is essential to eliminate all biases, preconceptions, and expectations regarding results. For the beginner, this is not such a problem. But for the experienced typographic designer, changing old habits can be a formidable challenge. Typographic experimentation can ultimately lend fresh insight to the designer, help break formulaic chains, and move projects into more challenging directions.

Putting the first marks on a piece of virgin paper when beginning a drawing is often very intimi-dating. Likewise, the initial stages of typo-graphic experimentation can leave you scratch-ing your head. This chapter is devoted to helping you overcome any fears associated with launching into the world of typographic experimentation.

Because type is viewed as well as read, it is governed by the principles of visual syntax. Whether you are consciously aware of it or not, you regularly use these principles when working with type. The first step in exploring type is to have an understanding of these factors and the ability to consciously apply them.

A morphology is a collection of factors that help us work with type. It can be used by designers as an effective tool to explore typographic possibilities and seek new alternatives. Often used in graphic design education, mor-phologies visibly and methodically provide students with a usable typographic vocabulary. Several precedents exist for the use of morphologies in design and typography, and they take many forms. The designer Karl Gerstner pioneered a logical morphology based on the formal language of type. Wolfgang Weingart's Morphological Typecase, consisting of categories such as sunshine, religious, typewriter, and stair typography, reflects his broad point of view. For Weingart, everything can potentially relate to and inspire typographic practice.

This chapter presents a morphology that can be used to usher you into a shameless flurry of typographic experimentation. Presented on the facing page, this morphology includes 25 typo-graphic factors or variables in four categories. These categories are 1) typographic, 2) form, 3) space, and 4) typographic support. *Typographic* factors relate specifically to the manipulation of letters and words. *Form* factors involve the alteration of existing typographic forms. *Space* factors address how elements are physically related to one another on a page. *Support* factors include nontypographic elements that augment typographic forms. The 25 factors are further subdivided into more specific factors. For example, distortion, which is a form factor, is subdivided into specific kinds of distortion, including fragmentation, skewing, bending, stretching, etc. In addition, each main factor includes a "combination" factor that serves to describe combinations of factors. Elements of the morphology are numbered and keyed for reference to examples and experiments found throughout the book.

In the pages that follow, the morphological factors are examined as they relate first to display type and second to text type. Be mindful that a morphology can provide nearly infinite possibilities for typographic experimentation. The examples shown in this chapter are intended to describe factors in most basic terms. They offer merely a departure point for your own typographic explorations.

Note: The boxes in this morphology filled with black represent other possibilities that may be added as needed.

Typographic factors

1.1 case	1.1.1 upper	1.1.2 lower	1.1.3 combination						
1.2 face	1.2.1 serif	1.2.2 sans serif	1.2.3 script	1.2.4 eccentric	1.2.5 combination				
1.3 size	1.3.1 small	1.3.2 medium	1.3.3 large	1.3.4 combination					
1.4 slant	1.4.1 slight	1.4.2 medium	1.4.3 extreme	1.4.4 combination					
1.5 weight	1.5.1 light	1.5.2 medium	1.5.3 heavy	1.5.4 combination					
1.6 width	1.6.1 narrow	1.6.2 medium	1.6.3 wide	1.6.4 combination					

Form factors

2.1 blending	2.1.1 linear	2.1.2 radial	2.1.3 combination						
2.2 distortion	2.2.1 fragmenting	2.2.2 skewing	2.2.3 bending	2.2.4 stretching	2.2.5 blurring	2.2.6 inverting	2.2.7 mutilating	2.2.8 combination	
2.3 elaboration	2.3.1 addition	2.3.2 subtraction	2.3.3 extension	2.3.4 combination					
2.4 outline	2.4.1 thin	2.4.2 medium	2.4.3 thick	2.4.4 broken	2.4.5 combination				
2.5 texture	2.5.1 fine	2.5.2 coarse	2.5.3 regular	2.5.4 irregular	2.5.5 combination				
2.6 dimensionality	2.6.1 volumetric	2.6.2 shadowing	2.6.3 combination						
2.7 tonality	2.7.1 light	2.7.2 medium	2.7.3 dark	2.7.4 combination					

Space factors

3.1 balance	3.1.1 symmetrical	3.1.2 asymmetrical	3.1.3 combination						
3.2 direction	3.2.1 horizontal	3.2.2 vertical	3.2.3 diagonal	3.2.4 circular	3.2.5 combination				
3.3 ground	3.3.1 advancing	3.3.2 receding	3.3.3 combination						
3.4 grouping	3.4.1 consonant	3.4.2 dissonant	3.4.3 combination						
3.5 proximity	3.5.1 overlapping	3.5.2 touching	3.5.3 separating	3.5.4 combination					
3.6 repetition	3.6.1 few	3.6.2 many	3.6.3 random	3.6.4 pattern	3.6.5 combination				
3.7 rhythm	3.7.1 regular	3.7.2 irregular	3.7.3 alternating	3.7.4 progressive	3.7.5 combination				
3.8 rotation	3.8.1 slight	3.8.2 moderate	3.8.3 extreme	3.8.4 combination					

Support factors

4.1 ruled lines	4.1.1 horizontal	4.1.2 vertical	4.1.3 diagonal	4.1.4 curved	4.1.5 stair-stepped	4.1.6 thin	4.1.7 medium	4.1.8 thick	4.1.9 combination
4.2 shapes	4.2.1 geometric	4.2.2 organic	4.2.3 background	4.2.4 adjacent	4.2.5 combination				
4.3 symbols	4.3.1 normal	4.3.2 manipulated	4.3.3 combination						
4.4 images	4.4.1 background	4.4.2 adjacent	4.4.3 contained	4.4.4 manipulated	4.4.5 combination				

1.1 Case

Most typefaces are designed to include both upper- and lower-case letters. Upper-case letters (figs. **1, 2**) stand straight and tall. They are more formal than lower-case letters (figs. **3, 4**), which appear more informal in posture. Traditionally, upper- and lower-case letters are used together in titles and text. The upper-case letters visually mark the beginnings of sentences (figs. **5, 6**), and this is the norm. But many possibilities exist for playful (and odd) combinations of upper- and lower-case letters in display and text settings (figs. **7, 8**).

TYPE

1 **1.1.1** upper

THE ROLE OF TYPOGRAPHIC EXPERI-MENTATION IS TO EXTEND THE BOUNDARIES OF LANGUAGE BY FREELY PROBING VISUAL AND VERBAL SYNTAX AND THE RELATIONSHIPS

2 **1.1.1** upper

type

3 **1.1.2** lower

the role of typographic experimenta-tion is to extend the boundaries of language by freely probing visual and verbal syntax and the relationships between word and image. syntactic

4 **1.1.2** lower

Type

5 **1.1.3** combination

The role of typographic experimenta-tion is to extend the boundaries of language by freely probing visual and verbal syntax and the relationships between word and image. Syntactic

6 **1.1.3** combination

tYpE

7 **1.1.3** combination

The role of typographic experimentation IS TO EXTEND THE BOUNDARIES OF language by freely probing visual and VERBAL SYNTAX AND THE RELATION-ships between word and image. Syntac-

8 **1.1.3** combination

When experimenting with type, one of the most important considerations is typeface selection. With many thousands of type designs available today, the task of selecting just the right typeface can be overwhelming. When experimenting, try sampling many different typefaces. Try some that you have never before used. Try them in different and obscure combinations, and try them without any preconceptions or expectations of outcome. While typefaces are generally lumped into two broad categories, serif (figs. **9-12**) and sans serif (figs. **13-16**), permutations exist in astounding variety. Every typeface possesses a unique visual texture when set into text. Compare the textures of the text settings below.

type

9 **1.2.1** serif, Matrix

The role of typographic experimentation is to extend the boundaries of language by freely probing visual and verbal syntax and the relationships between word and image. Syntactic exploration enables designers to

10 **1.2.1** serif, Matrix

type

11 **1.2.1** serif, Glypha

The role of typographic experimentation is to extend the boundaries of language by freely probing visual and verbal syntax and the relationships between word and image. Syntactic exploration enables

12 **1.2.1** serif, Glypha

type

13 **1.2.2** sans serif, Officina Sans

The role of typographic experimentation is to extend the boundaries of language by freely probing visual and verbal syntax and the relationships between word and image. Syntactic exploration enables designers to

14 **1.2.2** sans serif, Officina Sans

type

15 **1.2.2** sans serif, Gill Sans

The role of typographic experimentation is to extend the boundaries of language by freely probing visual and verbal syntax and the relationships between word and image. Syntactic exploration enables designers to

16 **1.2.2** sans serif, Gill Sans

Scripts and faces that simulate handwriting can be informal or formal, casual or snooty (figs. **17, 18**). As a result of desktop publishing, an entire generation of new typefaces (also incorrectly referred to as fonts) has surfaced. Having jumped on the bandwagon of eccentric faces are the established type foundries, as well as small, one-person shops that peddle their exotic type designs on the Internet. In peculiarity, the new eccentric typefaces far exceed their grandparents, the wood types of the 19th century. Eccentric faces, these grungy and disrespectful upstarts, defy and challenge the honored traditions of typeface design. They express emotions, attitudes, and opinions; they confront and challenge the reader (figs. **19-22**). These typefaces do not quietly and objectively represent the thoughts of the author; they deliberately emit their own messages by virtue of their visual characteristics. When experimenting with different typefaces, try to identify how their shapes and textures might relate to content and message. Used in combination, eccentric typefaces produce unexpected and surprising results (figs. **23, 24**).

17 | **1.2.3** script, Brush Script

18 | **1.2.3** script, Brush Script

19 | **1.2.4** eccentric, Template Gothic

20 | **1.2.4** eccentric, Template Gothic

21 | **1.2.4** eccentric, Amplifier

22 | **1.2.4** eccentric, Amplifier

23 | **1.2.5** combination; Democratica, Reporter Two

24 | **1.2.5** combination, Democratica, Reporter Two

Scale relationships greatly influence the way in which type is perceived, for they provide a means to either emphasize or de-emphasize elements. Relative to larger elements, small type whispers, is timid and shy (fig. **25, 26**); relative to smaller elements, large type screams, is forceful and adamant (fig. **29, 30**). Scale is always a relative condition; large is large only in relationship to small, and vice versa (figs. **31, 32**). The illusion of spatial depth can also be achieved by means of scale adjustments. Larger type appears to advance in space, while smaller type recedes.

25 **1.3.1** small

The role of typographic experimentation is to extend the boundaries of language by freely probing visual and verbal syntax and the relationships between word and image. Syntactic exploration enables designers to discover among typographic media an enormous potential to edify, entertain, and surprise. As in other forms of language typography is capable of infinite expression. The only limits to typographic discovery are those imposed by the

26 **1.3.1** small

type

27 **1.3.2** medium

The role of typographic experimentation is to extend the boundaries of language by freely probing visual and verbal syntax and the relationships between word and image. Syntactic exploration enables designers to discover

28 **1.3.2** medium

type

29 **1.3.3** large

The role of typographic experimentation is to extend the boundaries of language by freely probing visual and

30 **1.3.3** large

t ' pe

31 **1.3.4** combination

The role of typographic experimentation is to extend the boundaries of language by freely probing visual and verbal syntax and the relationships between word and image. Syntactic exploration enables designers to discover among typographic media an enormous potential to edify, entertain, and surprise. As in other forms of language typography is capable of infinite expression. The only limits to typographic discovery are those imposed by the designer herself.

32 **1.3.4** combination

When type is slanted, it assumes an active posture, is characteristically energetic and forceful, and appears to move forward in space. The more extreme the slant of type, the more kinetic and aggressive its appearance. Traditional italic type is usually slanted by approximately 13 to 16 degrees (figs. **33, 34**), but with the aid of the computer, roman letters can be slanted at any angle (figs. **37-40**). It is important to keep in mind that extremely slanted type is more difficult to read than moderately slanted type. But this concern is negligible when a dynamic effect is desired and the audience is not fussy about readability.

33 | **1.4.1** slight

34 | **1.4.1** slight

The role of typographic experimenta-tion is to extend the boundaries of language by freely probing visual and verbal syntax and the relationships between word and image. Syntactic

35 | **1.4.2** medium

36 | **1.4.2** medium

The role of typographic experimenta-tion is to extend the boundaries of language by freely probing visual and verbal syntax and the relationships between word and image. Syntactic

37 | **1.4.3** extreme

38 | **1.4.3** extreme

The role of typographic experimenta-tion is to extend the boundaries of language by freely probing visual and verbal syntax and the relationships between word and image. Syntactic

39 | **1.4.4** combination

40 | **1.4.4** combination

The role of typographic experimenta-tion is to extend the boundaries of language by freely probing visual and verbal syntax and the relationships between word and image. Syntactic

All letterforms possess the property of weight, a factor determined by the thickness of letter strokes. Type with slight strokes appears thin and frail, while type with thick strokes appears robust and confident. Letters with thin strokes possess open and airy counterforms, which are the shapes within and surrounding letters (fig. **41**), while the opposite is true for heavy letters (fig. **45**). In fact, the counters of extremely heavy letters decrease significantly in size. Compare the varying weights of the letterforms shown below. In the course of typographic experimentation, consider which typographic elements should be emphasized and assign weights accordingly. Remember that extreme weight contrasts among typographic elements is almost always effective.

type

41 | **1.5.1** light

The role of typographic experimentation is to extend the boundaries of language by freely probing visual and verbal syntax and the relationships between word and image. Syntactic exploration enables

42 | **1.5.1** light

type

43 | **1.5.2** medium

The role of typographic experimentation is to extend the boundaries of language by freely probing visual and verbal syntax and the relationships between word and image. Syntactic

44 | **1.5.2** medium

type

45 | **1.5.3** heavy

The role of typographic experimentation is to extend the boundaries of language by freely probing visual and verbal syntax and the relationships between word and image. Syn-

46 | **1.5.3** heavy

47 | **1.5.4** combination

The role of typographic experimen-tation is to extend the boundaries of **language by freely probing visual** and verbal syntax and the relationships **between word and image. Syntactic**

48 | **1.5.4** combination

1.6 Width

Computer software enables the horizontal or vertical scaling of type, an effect that distorts the proportions of letterforms. When type is scaled vertically, horizontal strokes appear thicker (fig. **49**). When type is scaled horizontally, vertical strokes appear thicker (fig. **53**). Scaling type in this manner is abhorred by many type purists, for it detroys the integrity of the original type designs. While this is indeed a valid concern, violating letters in this way can also provide expressive and visually curious results.

type

49 | **1.6.1** narrow

The role of typographic experimentation is to extend the boundaries of language by freely probing visual and verbal syntax and the relationships between word and image. Syntactic exploration enables designers to discover among typographic media an enormous potential to edify, entertain, and surprise. As in other forms of language typography is capable of infinite expression. The only

50 | **1.6.1** narrow

type

51 | **1.6.2** medium

The role of typographic experimentation is to extend the boundaries of language by freely probing visual and verbal syntax and the relationships between word and image. Syntactic

52 | **1.6.2** medium

type

53 | **1.6.3** wide

The role of typographic experimentation is to extend the boundaries of language by freely probing visual

54 | **1.6.3** wide

55 | **1.6.4** combination

The role of typographic experimentation is to extend the boundaries of language by freely probing visual and verbal syntax and the relationships between word and image. Syntactic exploration enables designers to discover among typographic media an enormous

56 | **1.6.4** combination

Creating gradient transitions in color and tone modulates the surface of type and provides an illusion of dimensionality. Many blending possibilities exist, the two most common being linear and radial blends. Linear blends progress from one side of a letter or group of letters to another, and may be horizontal, vertical, or diagonal (figs. **57-60, 64**). Radial blends progress inwardly or outwardly, depending on tones and colors and their assigned positions in the blend (figs. **61, 62**). Blends are most vivid when the contrasts between color and tone are distinct, and most subtle when these contrasts are minimal.

57 | **2.1.1** linear

The role of typographic experimentation is to extend the boundaries of language by freely probing visual and verbal syntax and the relationships between word and image. Syntactic

58 | **2.1.1** linear

59 | **2.1.1** linear

The role of typographic experimentation is to extend the boundaries of language by freely probing visual and verbal syntax and the relationships between word and image. Syntactic

60 | **2.1.1** linear

61 | **2.1.2** radial

The role of typographic experimentation is to extend the boundaries of language by freely probing visual and verbal syntax and the relationships between word and image. Syntactic

62 | **2.1.2** radial

63 | **2.1.3** combination

The role of typographic experimentation is to extend the boundaries of language by freely probing visual and verbal syntax and the relationships between word and image. Syntactic

64 | **2.1.1** linear

Distorting type provocatively transports it into the visual realm, for letters and words that function normally as symbols for spoken sound are transformed into expressive images. When type is distorted, it acquires strange and unfamiliar visual characteristics. Depending upon how and why it is distorted, there exists a potential for new and extended meaning. Fragmented type, for example, may allude to disjointed conversation or chaos (fig. **65**), while blurred type may exude calm as it floats softly and atmospherically (figs. **73, 74**). Skewed and stretched type can represent movement or direction (figs. **67, 68, 71, 72**). Used in combination, the specific factors guiding type distortion can lend nearly infinite possibilities. All that is required is a sense of play, some ingenuity, and a bit of software knowledge. Text can appear to blister (fig. **70**), or blow in the wind like a flag (fig. **72**). Computer software provides typographic experimenters with a dazzling array of tools for distorting type.

65 **2.2.1** fragmenting

66 **2.2.1** fragmenting

67 **2.2.2** skewing

68 **2.2.2** skewing

type

69 **2.2.3** bending

The role of *typographic* experimentation is to *extend* the boundaries of language *by* freely probing visual and verbal syntax and the *relationships* between word and *image*. Syntactic

70 **2.2.3** bending

71 **2.2.4** stretching

The role of typographic experimentation is to extend the boundaries of language by freely probing visual and verbal syntax and the rela-

72 **2.2.4** stretching

73 | **2.2.5** blurring

The role of typographic experimenta-
tion is to extend the boundaries of
language by freely probing visual and
verbal syntax and the relationship
between word and image. Syntactic

74 | **2.2.5** blurring

75 | **2.2.6** inverting

petween word and image. Syntactic
verbal syntax and the relationship
language by freely probing visual and
tion is to extend the boundaries of
The role of typographic experimenta-

76 | **2.2.6** inverting

77 | **2.2.7** mutilating

The role of typographic experimenta-
tion is to extend the boundaries of
language by freely probing visual and
verbal syntax and the relationships
between word and image. Syntactic

78 | **2.2.7** mutilating

79 | **2.2.8** combination

80 | **2.2.8** combination

To elaborate upon type is to add or subtract from its complexity, or augment it with detail or ornamentation. The result of elaboration is a heightened emphasis of typographic elements. Enclosing letters or words within a shape (figs. **81, 87**), isolating letters by means of color (fig. **82**), and extending letter strokes (fig. **85**) are all tangible examples of elaboration. Removing letters or words from text (figs. **83-84**) emphasizes these elements by means of their conspicuous absence.

type

81 | **2.3.1** addition

The role of typographic experimentation is to extend the boundaries of language by freely probing visual and verbal syntax and the relationships between word and image. Syntactic

82 | **2.3.1** addition

typ

83 | **2.3.2** subtraction

Th rol of typographic xp rim nta-tion is to xt nd the boundari s of languag by fr ly probing visual and v rbal syntax and the r lationships b tw n word and imag . Syntactic

84 | **2.3.2** subtraction

type

85 | **2.3.3** extension

The role of typographic experimentation is to extend the boundaries of language by freely probing visual and verbal syntax and the relationships between word and image. S y n t a c t i c

86 | **2.3.3** extension

t pe

87 | **2.3.4** combination

The role of typographic experimentation is to extend the boundaries of language by freely probing visual and verbal syntax and the relationships between word and image. Syntactic

88 | **2.3.4** combination

Letterforms can exist as solid shapes or as outlines. Outlines trace the contoured edges of letter shapes, and they appear in their most basic form as unbroken lines (fig. **89**). When text is outlined, its normal texture is transformed into a complex pattern, a transparent field of tiny windows (fig. **90**). More elaborate manifestations of outlined letters are those expressed with broken lines that are dotted, dashed, and intermittent (figs. **95, 97**). These letters suffer significantly in terms of legibility, but at the same time they achieve intriguing visual qualities. Letters expressed with just a few broken elements vaguely resemble the original form. These ambiguous letterforms provide a visual riddle for the reader's eye (fig. **99**). Outlines can also be expressed in various patterns and shapes (figs. **101-102**), and in many thought-provoking combinations (figs. **103, 104**). Text set in broken outlines sacrifices readability for visual tactility (figs. **98, 100**).

89 | **2.4.1** thin

91 | **2.4.2** medium

93 | **2.4.3** thick

95 | **2.4.4** broken

90 | **2.4.1** thin

92 | **2.4.2** medium

94 | **2.4.3** thick

96 | **2.4.4** broken

97 | **2.4.4** broken

The role of typographic experimentation is to extend the boundaries of language by freely probing visual and verbal syntax and the relationships between word and image. Syntactic

98 | **2.4.4** broken

99 | **2.4.4** broken

The role of typographic experimentation is to extend the boundaries of language by freely probing visual and verbal syntax and the relationships between word and image. Syntactic

100 | **2.4.4** broken

101 | **2.4.4** broken

102 | **2.4.4** broken

103 | **2.4.5** combination

104 | **2.4.5** combination

When type is expressed as visual texture, it evokes tactile sensations. A reader's individual response to texture depends on a number of factors, among which are the fineness or coarseness of a texture, and the regularity or irregularity of its pattern.

In typography, texture can be observed in two ways. The first is naturally found in the tactile appearance of text, an effect established by individual letters in repetition. Differences in typeface design and in spacing of letters, words, and lines within text provide different textural qualities (figs. **106, 108**). A second means of achieving textural effects is by applying various textures directly to letter surfaces. As textures increase in coarseness, letterforms – depending upon their design and size – decrease in legibility (compare figs. **105, 107**). Infinitely varied textures may appear in

105 | **2.5.1** fine

107 | **2.5.2** coarse

109 | **2.5.3** regular

111 | **2.5.3** regular

The role of typographic experimentation is to extend the boundaries of language by freely probing visual and verbal syntax and the relationships between word and image. Syntactic

106 | **2.5.1** fine

The role of typographic experimentation is to extend the boundaries of language by freely probing visual and verbal syntax and the relationships between word and

108 | **2.5.2** coarse

HE ROLE OF TYPOGRAPHIC EXPERIMENTATION IS TO EXTEND THE BOUNDARIES OF LANGUAGE BY FREELY PROBING VISUAL AND VERBAL SYNTAX AND THE RELATIONSHIPS BETWEEN WORD AND IMAGE. SYNTACTIC EXPLORATION ENABLES DESIGNERS TO

110 | **2.5.3** regular

The role of typographic experimentation is to extend the boundaries of language by freely probing visual and verbal syntax and the relationships between word and image.

112 | **2.5.3** regular

regular patterns of dot, line, and other geometric parts (figs. **109, 111**), or in irregular patterns of organic shapes (figs. **113, 115**).

Letterform size also plays a significant role in the expression of texture. Used in combination, large and small letters provide a wide variety of dynamic textural effects (fig. **116**).

113 | **2.5.4** irregular

The role of typographic experimentation is to extend the boundaries of language by freely probing visual and verbal syntax and the relationships between word and image.

114 | **2.5.4** irregular

115 | **2.5.4** irregular

The role of typographic experimentation is to extend the boundaries of language by freely probing visual and verbal syntax and the relationships between

116 | **2.5.4** irregular

117 | **2.5.5** combination

The role of typographic experimenta-**tion is to extend the boundaries of language** by freely probing visual and verbal **syntax and the relationships between word** and image. Syntactic exploration enables

118 | **2.5.5** combination

119 | **2.5.5** combination

The role of typographic experimentation is to extend the boundaries of language by freely probing visual and verbal syntax and the relationships between word and image. Syntactic exploration enables designers to discover among typography-ic media an

120 | **2.5.5** combination

The most basic means of achieving illusory space is to juxtapose letters of one size to those of another. Smaller letters appear to recede, while larger forms appear to advance in space. This effect is heightened with the use of color or tone: light and cool colors recede; dark and warm colors advance.

The illusion of spatial dimension is further intensified when letters appear to zoom forward or backward in space (figs. **121, 122**),

bend and warp (figs. **123, 124**), or cast shadows (figs. **125-128**). The reason these effects are so intriguing to the viewer is because they do not exist in reality; they merely tease the eye through a suggestion of reality. With a visual sleight-of-hand, the designer-magician creates an illusion that surprises and woos the audience when effectively performed.

121 | **2.6.1** volumetric

123 | **2.6.1** volumetric

125 | **2.6.2** shadowing

127 | **2.6.2** shadowing

122 | **2.6.1** volumetric

124 | **2.6.1** volumetric

126 | **2.6.2** shadowing

128 | **2.6.2** shadowing

2.7 Tonality

Tonality refers to type that is a screen or a tint of black or a pure color (hue). It should not be confused with typographic "color," the relative lightness or darkness of text, which is inherently linked to the stroke weight of letters. Adjusting the tone of type provides a way to control emphasis: the lighter the type, and the closer it approximates the tone or value of its background, the more it appears to recede in space (figs. **129, 130**). Type assigned lighter tones is de-emphasized in relationship to darker type, providing a means to control the visual strength of elements within a given space (figs. **135, 136**).

129 | **2.7.1** light

The role of typographic experimentation is to extend the boundaries of language by freely probing visual and verbal syntax and the relationships between word and image. Syntactic

130 | **2.7.1** light

type

131 | **2.7.2** medium

The role of typographic experimentation is to extend the boundaries of language by freely probing visual and verbal syntax and the relationships between word and image. Syntactic

132 | **2.7.2** medium

type

133 | **2.7.3** dark

The role of typographic experimentation is to extend the boundaries of language by freely probing visual and verbal syntax and the relationships between word and image. Syntactic

134 | **2.7.3** dark

type

135 | **2.7.4** combination

The role of typographic experimentation is to extend the boundaries of language by freely probing visual and verbal syntax and the relationships between word and image. Syntactic

136 | **2.7.4** combination

Two basic models exist for structuring typographic elements in space: symmetry and asymmetry. Symmetrical organization produces a quiet, complacent, and formal setting, while asymmetrical organization creates a dynamic visual tension. Symmetry often consists of type elements placed bi-laterally along a centered axis. In other words, elements mirror each other and are distributed equally on either side of a central axis (figs. **137-140**). Asymmetry derives its energy from an interaction between positive and negative spaces. In other words, spatial harmony is achieved through a dialogue between typographic elements and the space surrounding them (figs. **141, 142**).

137 | **3.1.1** symmetrical

The role of typographic
experimentation is to extend the
boundaries of language by freely
probing visual and verbal syntax and
the relationships between word
and image. Syntactic

138 | **3.1.1** symmetrical

139 | **3.1.1** symmetrical

a a

The role of typographic experimentation
is to extend the boundaries of language
by freely probing visual and verbal
syntax and the relationships between

a a

140 | **3.1.1** symmetrical

141 | **3.1.2** asymmetrical

The role of
 typographic experimentation
 is to extend the boundaries
 of
 language
 by freely probing visual
 and verbal syntax.

142 | **3.1.2** asymmetrical

t

type

p

y

143 | **3.1.3** combination

The
role
of
typographic
experimentation
is
to extend

(scattered: the boundaries)

144 | **3.1.3** combination

3.2 Direction

Typographic elements exert directional energy by virtue of their intrinsic shapes and the positions they occupy on the page. Type is conventionally viewed horizontally and resting upon an imaginary baseline (figs. **145, 146**). Rotated at other angles, it is charged with varying degrees of energy (figs. **147-150**). Type moving in circular directions acquires a whimsical presence (figs. **151-152**).

type

145 | **3.2.1** horizontal

The role of typographic experimentation

146 | **3.2.1** horizontal

147 | **3.2.2** vertical

The role of typographic

148 | **3.2.2** vertical

149 | **3.2.3** diagonal

150 | **3.2.3** diagonal

151 | **3.2.4** circular

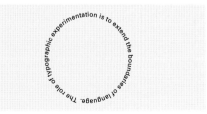

152 | **3.2.4** circular

"Ground" refers to the background stage upon which type performs its many roles. It appears to advance or recede depending upon the proximity of its hue and value to the type. Basically, less contrast between the ground and type encourages the ground to advance (figs. **153-154**), while more contrast between the ground and type causes the ground to recede (figs. **155-156**).

153 | **3.3.1** advancing

154 | **3.3.1** advancing

155 | **3.3.2** receding

The role of typographic experimenta-
tion is to extend the boundaries of
language by freely probing visual and
verbal syntax and the relationships
between word and image. Syntactic

156 | **3.3.2** receding

157 | **3.3.3** combination

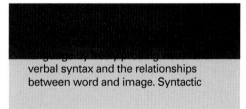

verbal syntax and the relationships
between word and image. Syntactic

158 | **3.3.3** combination

159 | **3.3.3** combination

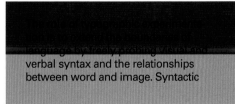

verbal syntax and the relationships
between word and image. Syntactic

160 | **3.3.3** combination

3.4 Grouping

Two important principles should be kept in mind when grouping typographic elements. *Consonance* is a harmonious and unified relationship between elements, while *dissonance* is a discordant and chaotic relationship between elements. Letters may be carefully aligned and grouped into a tight community (fig. **161**). Figures **163** and **164** establish consonance as a result of a deliberate square structure. In contrast, figures **165** and **166** contain groupings of elements expanding outwardly and seemingly out of control. The visual effects achieved by the careful grouping of typographic elements can support and intensify a message's intended meaning.

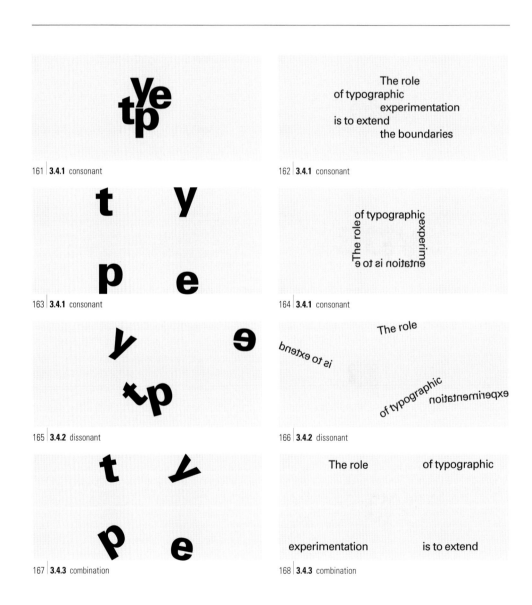

161 | **3.4.1** consonant

162 | **3.4.1** consonant

163 | **3.4.1** consonant

164 | **3.4.1** consonant

165 | **3.4.2** dissonant

166 | **3.4.2** dissonant

167 | **3.4.3** combination

168 | **3.4.3** combination

Related to the factor of typographic grouping, proximity offers another important variable for exploration. Letters, words, lines, and blocks of text may range from severely overlapping to generously spaced. When typographic elements overlap, legibility is severely reduced or eliminated. What is often gained from this compromise are intriguing typographic shapes created by overlapping letters (fig. **169**), or anxious textures established by overlapping

lines of type (fig. **170**). The examples shown here merely scratch the surface of possibilities. Personal exploration will undoubtedly produce surprising and rewarding results.

169 | **3.5.1** overlapping

170 | **3.5.1** overlapping

171 | **3.5.2** touching

The role of typographic experimenta-
tion is to extend the boundaries of
language by freely probing visual and
verbal syntax and the relationships
between word and image. Syntactic
exploration enables designers to dis-
cover among typographic media an
enormous potential to edify, entertain,

172 | **3.5.2** touching

173 | **3.5.3** separating

The role of typographic experimenta-

tion is to extend the boundaries of

language by freely probing visual and

verbal syntax and the relationships

between word and image. Syntactic

174 | **3.5.3** separating

175 | **3.5.4** combination

The role of typographic experimenta-
tion is to extend the boundaries of
language by freely probing visual and
verbal syntax and the relationships

The role of typographic experimenta-
tion is to extend the boundaries of
language by freely probing visual and

176 | **3.5.4** combination

3.6 Repetition

Beyond the obvious but functional task of letters and words repeating one another to deliver written messages, repetition is an important factor in the process of typographic exploration. As typographic elements are repeated, thoughts and ideas are not only heightened through redundancy and exaggeration, but also a distinct visual resonance occurs. Often, dynamic visual patterns result from letters, words, and lines of type that are

repeated (figs. **183, 184**). While exploring typographic repetition, keep in mind the degree of repetition (few or many), and whether the repetition calls for random or pattern.

type
type
type

177 | **3.6.1** few

The role of typographic experimentation

The role of typographic experimentation

The role of typographic experimentation

178 | **3.6.1** few

type type type type type
type type type type type
type type type type type
type type type type type

179 | **3.6.2** many

The role of typographic experimentation The role of typographic experimentation
The role of typographic experimentation The role of typographic experimentation
The role of typographic experimentation The role of typographic experimentation
The role of typographic experimentation The role of typographic experimentation
The role of typographic experimentation The role of typographic experimentation
The role of typographic experimentation The role of typographic experimentation
The role of typographic experimentation The role of typographic experimentation
The role of typographic experimentation The role of typographic experimentation
The role of typographic experimentation The role of typographic experimentation
The role of typographic experimentation The role of typographic experimentation

180 | **3.6.2** many

type **type** **type**
type **type** **type**
type type **type**
type type **type**
type **type** **type**

181 | **3.6.3** random

The role of typographic experimentation
The role of typographic experimentation
The role of typographic experimentation
The role of typographic experimentation
The role of typographic experimentation
The role of typographic experimentation
The role of typographic experimentation
The role of typographic experimentation
The role of typographic experimentation
The role of typographic experimentation

182 | **3.6.3** random

type type type
type type type type
type type type type type
type type type type type
type type type type
type type type

183 | **3.6.4** pattern

The role of typographic experimentation
The role of typographic experimentation
The role of typographic experimentation
The role of typographic experimentation
The role of typographic experimentation
The role of typographic experimentation
The role of typographic experimentation
The role of typographic experimentation
The role of typographic experimentation
The role of typographic experimentation
The role of typographic experimentation
The role of typographic experimentation
The role of typographic experimentation
The role of typographic experimentation

184 | **3.6.4** pattern

Because it is linear in structure, typography is analogous to music; it may be thought of as the visual equivalent of music. The principles of repetition and rhythm are tied closely together. But unlike repetition, wherein identical elements are repeated, rhythm occurs through the repetition of contrasting elements. In other words, for rhythm to be born, typographic parts must not only be repeated, they must also oppose one another in a distinct rhythmic sequence. Contrast in typography may be

established by juxtaposing different type sizes, faces, weights, widths, colors, and the intervals of space separating typographic elements. Demonstrated in the examples below are four distinct rhythmic variations that can be instituted while exploring typography. Regular rhythm repeats similar typographic parts separated by equal intervals of space (figs. **185, 186**). This is typography's most common rhythmic quality. Irregular rhythm is characterized by elements – identical or contrasted – separated

185 | **3.7.1** regular

186 | **3.7.1** regular

The role of typographic experimentation is to extend the boundaries of language by freely probing visual and verbal syntax and the relationships between word and image. Syntactic

187 | **3.7.2** irregular

188 | **3.7.2** irregular

The role of typographic experimentation is to extend the boundaries of

language by freely probing visual and

verbal syntax and the relationships

between word and image. Syntactic

189 | **3.7.3** alternating

190 | **3.7.3** alternating

The role of typographic experimentation is to extend the boundaries of language by freely probing visual and verbal syntax and the relationships between word and image. Syntactic

191 | **3.7.3** alternating

192 | **3.7.3** alternating

The role of typographic experimentation **is to extend the boundaries of** language by freely probing visual and **verbal syntax and the relationships** between word and image. Syntactic

by unequal intervals of space (figs. **187, 188**). In alternating rhythm, the typographic parts alternate between two contrasting attributes (size, weight, tone, etc.). Spatial intervals remain constant between the parts (figs. **189-192**). Progressive rhythm occurs when element attributes and/or the intervals of space separating the elements increase or decrease gradationally (figs. **193-196**). The rhythmic variations discussed here may be combined and expanded into nearly infinite possibilities.

193 **3.7.4** progressive

The role of typographic experimentation is to extend the boundaries of language by freely probing visual and verbal syntax and the relationships

between word and image. Syntactic

194 **3.7.4** progressive

195 **3.7.4** progressive

The role of typographic experimentation is to extend the boundaries of language by probing visual and verbal syntax and the relationships between word and

196 **3.7.4** progressive

197 **3.7.5** combination

The role of typographic experimentation **tion is to extend the boundaries of** language by freely probing visual and **verbal syntax and the relationships**

between word and image. Syntactic

198 **3.7.5** combination

199 **3.7.5** combination

The role of typographic experimentation is to extend the boundaries of language by probing visual and verbal syntax

and the relationships between word and

200 **3.7.5** combination

Rotating type seems a rather basic exercise, but the effect of angling type and thereby removing it from the safety of its conventional, horizontal baseline can powerfully influence type's energy and emotion. As rotations progress from slight (figs. **201-202**) to extreme (figs. **205-206**), dynamic forces and emotional impact increase. Juxtaposing typographic elements at different angles can produce intriguing visual results (figs. **207-208**).

type

201 | **3.8.1** slight

The role of typographic experimentation is to extend the boundaries of language by freely probing visual and verbal syntax and the relationships between word and image. Syntactic

202 | **3.8.1** slight

type

203 | **3.8.2** moderate

The role of typographic experimentation is to extend the boundaries of language by freely probing visual and verbal syntax and the relationships between word and image. Syntactic

204 | **3.8.2** moderate

type

205 | **3.8.3** extreme

The role of typographic experimentation is to extend the boundaries of language by freely probing visual and verbal syntax and the relationships between word and image. Syntactic

206 | **3.8.3** extreme

type

207 | **3.8.4** combination

The role of typographic experimentation is to extend the boundaries of language by freely probing visual and verbal syntax and the relationships between word and image. Syntactic

208 | **3.8.4** combination

4.1 Ruled lines

Referred to as typographic support elements, ruled lines serve as visual punctuation. Deliberately placed ruled lines can emphasize thoughts, separate units of information for hierarchical clarity, and contribute to type's throbbing presence. A simple underline (figs. **221, 222**) makes an emphatic statement. More complex variations connote architectonic spaces, for they divide and define typographic space. Consider the stair-stepped architectural motifs (figs. **217, 218**). In combination, type and ruled lines are also capable of evoking musical attributes by entering into a rhythmic dialogue (figs. **223, 224**). Not shown here, but equally important to consider for exploration are other varieties of ruled lines such as swelled, dotted, dashed, and double ruled lines.

type

209 | **4.1.1** horizontal

The role of typographic experimentation is to extend the boundaries of language by freely probing visual and verbal syntax and the relationships between word and image. Syntactic

210 | **4.1.1** horizontal

211 | **4.1.2** vertical

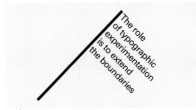

The role of typographic experimentation is to extend the boundaries of language by freely probing visual and verbal syntax and the relationships between word and image. Syntactic

212 | **4.1.2** vertical

type

213 | **4.1.3** diagonal

The role of typographic experimentation is to extend the boundaries

214 | **4.1.3** diagonal

215 | **4.1.4** curved

The role of typographic experimentation is to extend the boundaries

216 | **4.1.4** curved

217 | **4.1.5** stair-stepped

The role
of typographic
experimentation
is to extend
the boundaries

218 | **4.1.5** stair-stepped

type

219 | **4.1.6** thin

The role of typographic experimenta-
tion is to extend the boundaries of
language by freely probing visual and
verbal syntax and the relationships
between word and image. Syntactic

220 | **4.1.6** thin

type

221 | **4.1.8** thick

The role of typographic experimenta-
tion is to extend the boundaries of
language by freely probing visual and
verbal syntax and the relationships
between word and image. Syntactic

222 | **4.1.8** thick

223 | **4.1.9** combination

The role of typographic experimenta-
tion is to extend the boundaries of
language by freely probing visual and
verbal syntax and the relationships
between word and image. Syntactic

224 | **4.1.9** combination

4.2 Shapes

Shapes in boundless variety can be invented to create intimate spaces for typographic parts, or to highlight and separate them. As images, shapes connote meanings that potentially amplify type's content: the resolute, stable square – a room (fig. **225**); an amorphous shape – a cloud (fig. **226**). Shape may serve as a background for type (figs. **227, 228**), or as adjacent support elements (figs. **229, 230**). Intriguing dimensional environments can be created by inventively overlapping shape and type (figs. **231, 232**).

225 | **4.2.1** geometric

226 | **4.2.2** organic

227 | **4.2.3** background

228 | **4.2.3** background

229 | **4.2.4** adjacent

The role of typographic experimentation is to extend the boundaries of language by freely probing visual and verbal syntax and the relationships between word and image. Syntactic

230 | **4.2.4** adjacent

231 | **4.2.5** combination

The role of typographic experimentation is to extend the boundaries of language by freely probing visual and verbal syntax and the relationships between word and image. Syntactic

232 | **4.2.5** combination

Symbols, including dingbats, fleurons, and isotypes, can be used as support elements to augment type, or to stand alone as part of a typographic composition. Symbols are often designed to accompany a specific font, and can be used with or without further computer manipulation. Inventively altering symbols with the aid of a computer provides pleasing and unexpected results.

✳type

233 | **4.3.1** normal

✳The role of typographic experimentation is to extend the boundaries of language by freely probing visual and verbal syntax and the relationships between word and image. Syntactic

234 | **4.3.1** normal

235 | **4.3.2** manipulated

✳ The role of typographic experimentation is to extend the boundaries of language by freely probing visual and verbal syntax and the relationships between word and image. Syntactic

236 | **4.3.2** manipulated

"type"

237 | **4.3.1** normal

"The role of typographic experimentation is to extend the boundaries of language by freely probing visual and verbal syntax and the relationships between word and image."

238 | **4.3.1** normal

239 | **4.3.2** manipulated

The role of typographic experimentation is to extend the boundaries of language by freely probing visual and verbal syntax and the relationships between word and image.

240 | **4.3.2** manipulated

4.4 Images

Images may appear as backgrounds (figs. **241, 242**), or adjacent elements (figs. **243, 244**), or may be contained within letters and words (figs. **245, 246**). They may be presented normally, distorted in various ways by means of computer software, and/or color manipulated. For comparison, figures **247-256** illustrate various computer manipulations of the same photograph.

241 | **4.4.1** background

The role of typographic experimentation is to extend the boundaries of language by freely probing visual and verbal syntax and the relationships between word and image. Syntactic

242 | **4.4.1** background

243 | **4.4.2** adjacent

The role of typographic experimentation is to extend the boundaries of language by freely probing visual and verbal syntax and the relationships between word and image. Syntactic

244 | **4.4.2** adjacent

245 | **4.4.3** contained

The role of typographic experimentation is to extend the boundaries of language by freely probing visual and verbal syntax and the relationships between word and image. Syntactic

246 | **4.4.3** contained

247 | **4.4.4** manipulated

The role of typographic experimentation is to extend the boundaries of language by freely probing visual and verbal syntax and the relationships between word and image. Syntactic

248 | **4.4.4** manipulated

249 | **4.4.4** manipulated

The role of typographic experimentation is to extend the boundaries of language by freely probing visual and verbal syntax and the relationships between word and image. Syntactic

250 | **4.4.4** manipulated

251 | **4.4.4** manipulated

The role of typographic experimentation is to extend the boundaries of language by freely probing visual and verbal syntax and the relationships between word and image. Syntactic

252 | **4.4.4** manipulated

253 | **4.4.4** manipulated

The role of typographic experimentation is to extend the boundaries of language by freely probing visual and verbal syntax and the relationships between word and image. Syntactic

254 | **4.4.4** manipulated

255 | **4.4.5** combination

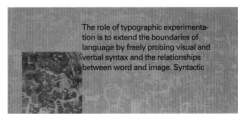

The role of typographic experimentation is to extend the boundaries of language by freely probing visual and verbal syntax and the relationships between word and image. Syntactic

256 | **4.4.5** combination

Typographical journey

An experimental typography course taught by the author at Virginia Commonwealth University is the focus of this chapter. You will observe how the morphological factors presented in the previous chapter are interpreted and investigated by individual students. Only the most significant factors of each investigation are mentioned, and these are cross-referenced by number to the morphology on page 165.

In the chapter's first section, student designer Minh Ta takes you on a fascinating journey of typographic exploration. The processes and thinking in which he engaged are unfolded as you move through the pages. A few things regarding the designer's journey should be mentioned. The pages contain preliminary sketches of typographic explorations as well as final computer realizations. Students are encouraged to make trace sketches of ideas before going to the computer. It is interesting to compare the sketches with final computer output. The designer identifies his sketches, which appear in black and white, with broken outlines. The final computer-generated plates are printed in full color and are bordered by solid ruled lines. Numerals referencing the morphological chart are connected to the plates by dotted lines. Significant details are explained with descriptive captions. Finally, this journey is a typographic exploration in and of itself. Be prepared for challenging, unconventional reading and a kinetic visual experience.

The second part of the chapter features a portfolio of experiments by selected students from the class. These also are keyed to the morphology in Chapter 7.

Project brief:

explore

unfamiliar regions

pioneer the unknown

[maps not necessary]

word as image

see/feel/hear/touch:

the sensuous curve of an s

the intersection of an x

nuance of

point

line

plane

surface

edge

texture

modulation

type as metaphor:

love song

city

galaxy

jazz orchestra

threering circus

starry night

meandering river

scream

whisper

new form +

new content +

new expression

Make 20 typographical explorations based on the factors in the accompanying morphology. Freely explore all of the factors in each of the four categories, but for each composition, focus specifically upon selected variables. One exploration, for example, might focus upon 1.3.1, 2.7.2, and 3.1.2, while another might concentrate upon 1.1.1, 1.6.3, 2.5.2, and 3.4.3. Strive for as much diversity in your investigations as possible.

Use three elements for all explorations:

single letter (point): any
word (line): "type"
text (plane): as provided.

The size of the compositional space for each investigation is 8 x 8 inches.

Make preliminary idea sketches on trace as well as on the computer. Select and use software as appropriate.

3.1.2

1.2.1

1.4.2

This plate focuses on visual clarity,
where concentration is reserved
for the experimentation
of lower- and upper-
case letters, a serif typeface,
and various type sizes.

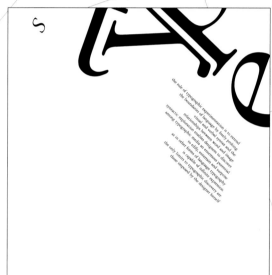

This composition
relies on the
formal qualities
of a serif face
to establish
the structure of the word *type* and in turn,
to influence the placement
of the letter *s* and the sup-
porting text. Moderately slanting
these elements creates a subtle
directional emphasis.
Positioning the letters to the upper
right encourages asymmet-
rical balance and a restful negative space.

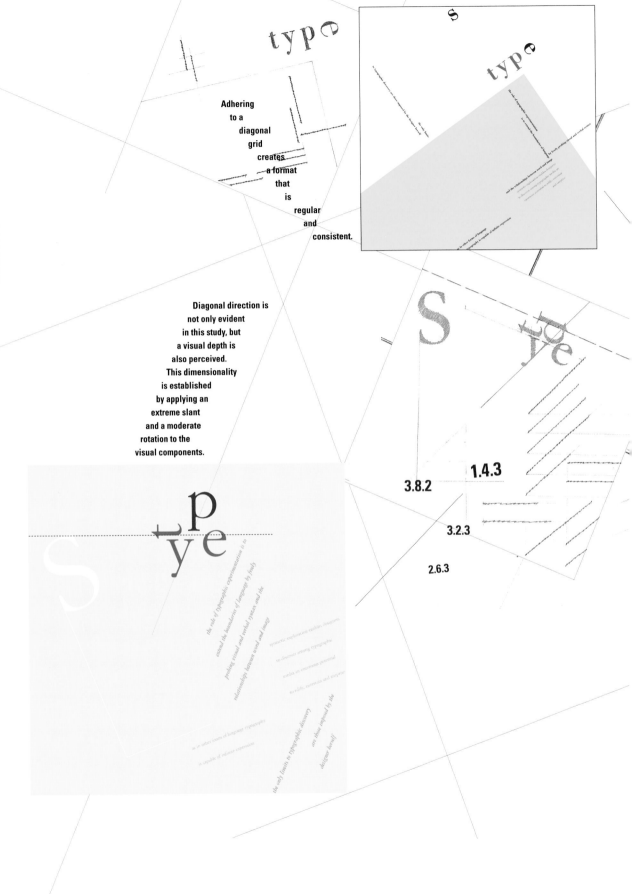

Adhering
to a
diagonal
grid
creates
a format
that
is
regular
and
consistent.

Diagonal direction is
not only evident
in this study, but
a visual depth is
also perceived.
This dimensionality
is established
by applying an
extreme slant
and a moderate
rotation to the
visual components.

1.4.3

3.8.2

3.2.3

2.6.3

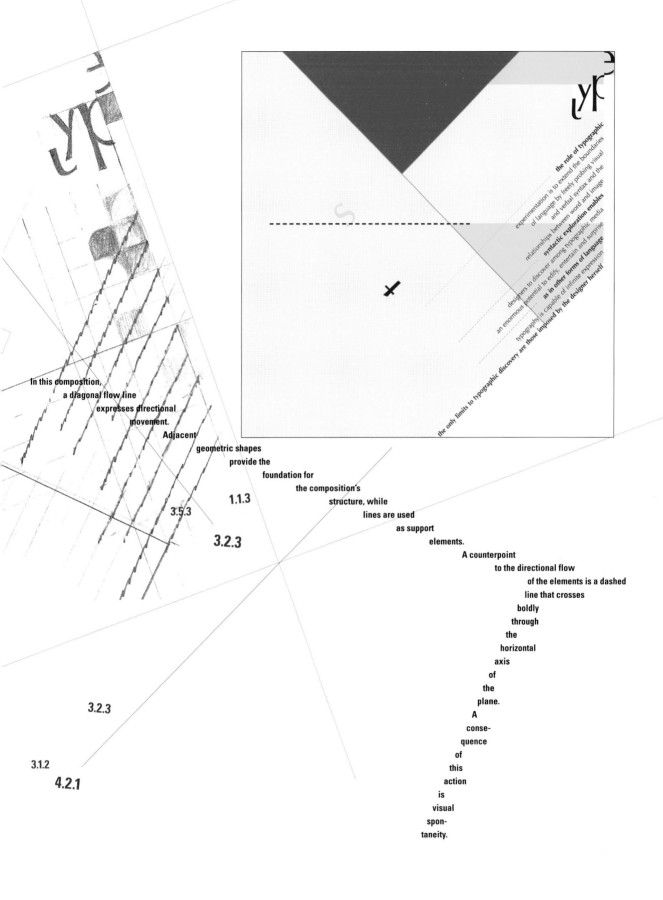

the role of typographic
experimentation is to extend the boundaries
of language by freely probing visual
and verbal syntax and the
relationships between word and image.
syntactic exploration enables
designers to discover among typographic media
an enormous potential to edify, entertain and surprise ...
as in other forms of language
typography is capable of infinite expression
the only limits to typographic discovery are those imposed by the designer herself

In this composition,
a diagonal flow line
expresses directional
movement.
Adjacent
geometric shapes
provide the
foundation for
the composition's
structure, while
lines are used
as support
elements.
A counterpoint
to the directional flow
of the elements is a dashed
line that crosses
boldly
through
the
horizontal
axis
of
the
plane.
A
conse-
quence
of
this
action
is
visual
spon-
taneity.

1.1.3

3.5.3

3.2.3

3.2.3

3.1.2

4.2.1

Two different varieties of distortion appear in this work,
and are realized by means of PhotoShop software.
Mezzotinting the letter *s* and slightly blurring the word *type* add a
level of complexity to the clean design, which is shaped by its basic geometric construction.
Cropping the two manipulated elements intensifies the geometry by creating imaginary
edges that divide the space.

4.2.1

2.2.8

2.3.2

The focal point
is the
mezzotinted *s,*
which
expresses
the
coarse
quality
of texture.

To manipulate a form
by the simplest gesture
and still maintain its legibility is a most basic concern.
The inversion of selected letters of various weights in this design
still permits recognition of the word *type.*
Also apparent is the irregular visual rhythm
expressed by the text through different point sizes
and vertical alignments.

1.5.4

3.7.2

1.3.4

2.2.6

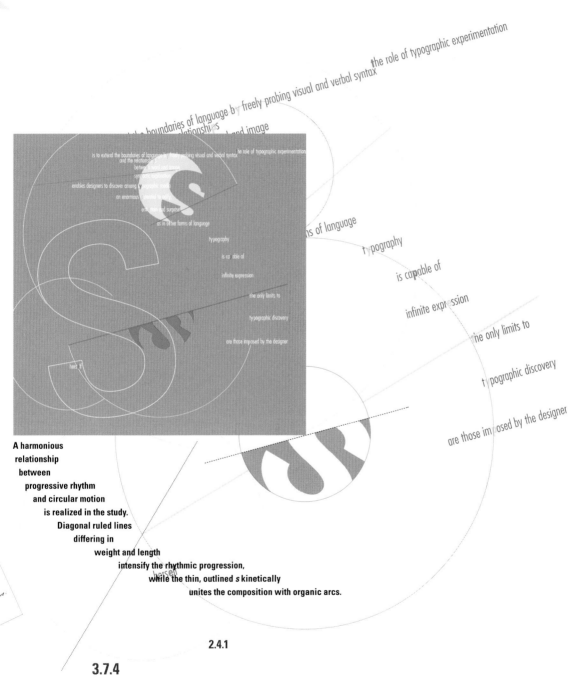

the role of typographic experimentation

the boundaries of language by freely probing visual and verbal syntax

and image

is to extend the boundaries of language by freely probing visual and verbal syntax he role of typographic experimentation
and the relationships
between word and image
symbolic expression
enables designers to discover among typographic means
an enormous potential to yield
enrichment and surprise
as in other forms of language

typography

is capable of

infinite expression

the only limits to

typographic discovery

are those imposed by the designer

ns of language

typography

is capable of

infinite expression

the only limits to

typographic discovery

are those imposed by the designer

A harmonious
relationship
between
progressive rhythm
and circular motion
is realized in the study.
Diagonal ruled lines
differing in
weight and length
intensify the rhythmic progression,
while the thin, outlined *s* kinetically
unites the composition with organic arcs.

2.4.1

3.7.4

3.2.4

4.1.9

the role of typographic
experimentation
is to extend
the boundaries of language
by freely probing
visual and verbal syntax and the relationships between word and image

3.2.3

3.4.1

4.4.1

This study is derived from
a repetition of dots whose
close proximity
shapes the squares.
The result is a
geometric pattern
combined with
typographic
characters.
The complexity
of the structure
is organized
and unified
by a stair-
stepped line
that divides
the composition
into halves.

4.2.1

3.5.1

4.1.5

3.1.3

type

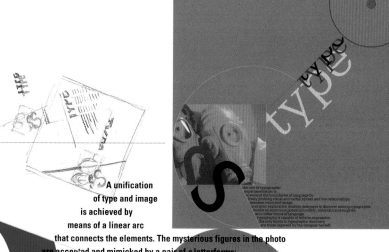

the role of typographic
experimentation is
to extend the boundaries of language by
freely probing visual and verbal syntax and the relationships
between word and image.
syntactic exploration enables designers to discover among typographic
media an enormous potential to edify, entertain and surprise.
as in other forms of language
typography is capable of infinite expression.
the only limits to typographic discovery
are those imposed by the designer herself.

**A unification
of type and image
is achieved by
means of a linear arc
that connects the elements. The mysterious figures in the photo
are accented and mimicked by a pair of *s* letterforms;
one is cropped, the other is seen in its entirety.**

the role of typographic experimentation is to extend the boundaries of language by freely probing visual and verbal syntax and the relationships between word and image. syntactic exploration enables designers to discover among typographic media an enormous potential to edify entertain and surprise. as in other forms of language typography is capable of infinite expression. the only limits to typographic discovery are those imposed by the designer herself.

type

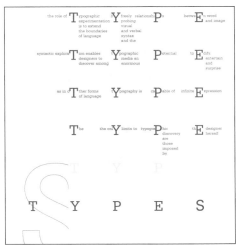

All compositions are a blend of spatial articulation and form manipulation. In this example, text is repeated to touch and overlap the fragmented *s*. The irregular background shape divides the space into two distinct regions.

This design's utter dedication to consonant grouping is evident. Each constituent element is aligned to the next for a centralized unity. The informal field of *s* letters stands in contrast to the more rigid column of text. Alternative rhythm is achieved by modifying the leading in the body of text.

4.2.1

2.2.1

3.5.4

3.6.1

Typographic elements are organized by separating them into ordered groups. The square shape formed by the repeated word *type* casts a soft shadow, seen below and to the left as a color tint. Identical in size, this device implies dimen-sionality. The use of upper-case and lower-case letters accentuates the division between top and bottom layers.

3.1.1

3.5.1

4.1.2

2.2.8

1.1.3

3.5.3

2.6.2

3.7.4

2.2.1 3.2.4

3.1.3

3.6.2

3.4.1

3.7.3

In this study, dynamic symmetry is a manifestation of the concentric circles. The circular paths of text zoom progressively out from a center point in the composition. The asymmetrical placement of the secondary components is significant, for it counterbalances the strong circular pattern.

A white *s* is superimposed upon a blurred *s* for a convincing three-dimensionality.

Despite the many layers of intricate, interwoven type, the impression achieved in this experiment is one of a soft and subtle texture. The shadow cast by the *s* provides transparency and dimensionality. The symmetry of the composition stands in contrast to the asymmetrical orientation of the letter *s* and the word *type*.

2.6.2

3.1.3 3.5.1

2.7.1

Pushing the boundaries of perception, the letter *s* is redefined by type rather than by the conventional solid stroke.

A typographic motif originates in the symmetrical interaction of overlapping elements. A transparent screen of ruled lines mingles with the tiles in the background, suggesting the existence of a second ground.

the role of typographic experimentation
is to extend the boundaries of language
by freely probing visual and verbal syntax
and the relationships
between word and image
syntactic exploration enables designers
to discover among typographic media
an enormous potential to edify, entertain and surprise
as in other forms of language
typography is capable of infinite expression
the only limits to typographic discovery
are those imposed
by the designer herself

2.1.1

A visual constellation consists of interdependent parts that, when suspended in space, form a Gestalt. The constellation in the adjacent experiment consists of a relaxed text block and a rigid repetition of words that form a harmonious duet.

3.1.2

3.6.1

3.5.4

the
syntactic
role
as
of exploration
the
typographic
enables in
experimentation only
is designers
other
limits
to
to
extend
forms to
the discover
boundaries typographic
among of
of
language typographic discovery
language
by
media are
freely
typography
probing an those
visual
enormous is,
and imposed
verbal potential
capable by
syntax
to
and
the
the edify,
relationships designer
entertain infinite
between
herself
word and
expression
and
surprise
image

type

Unique design can arise from the simplest of devices.

As in this example, flushing text to the left and severely reducing the number of words per line arouse visual interest.

Compositional tension increases as sentences are aligned along a vertical reading path.

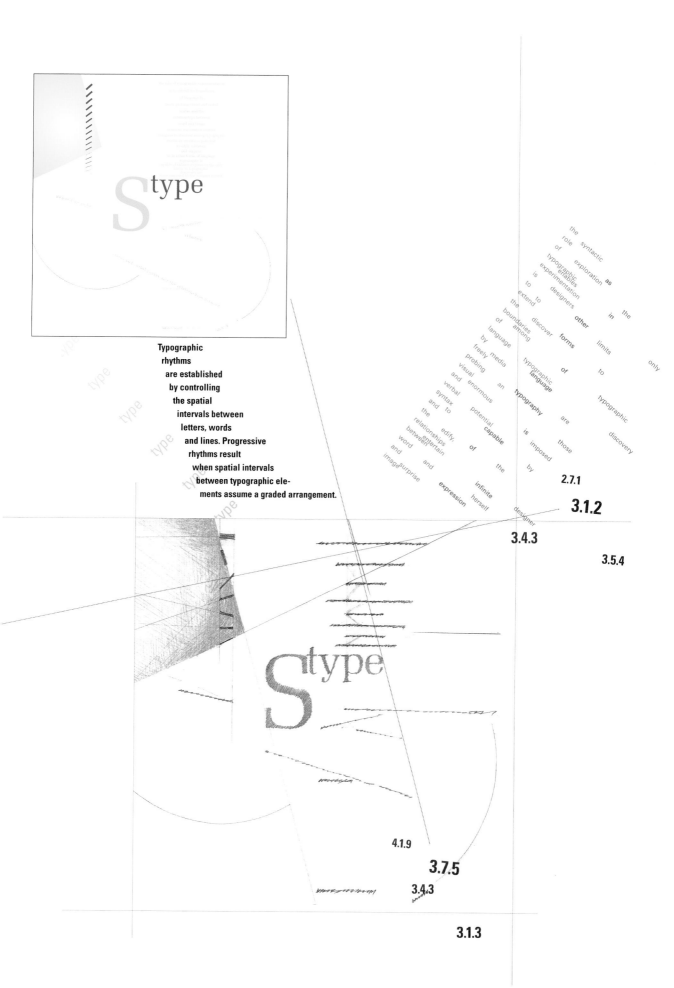

S type

Typographic
rhythms
are established
by controlling
the spatial
intervals between
letters, words
and lines. Progressive
rhythms result
when spatial intervals
between typographic ele-
ments assume a graded arrangement.

the syntactic
role exploration as
of
typographic enables
experimentation
is designers in the
to
extend discover other limits
the forms only
boundaries of among
of
language
by typographic typographic
freely media language discovery
probing an typography
visual enormous
and verbal is imposed those
syntax potential capable
and to by
the of
relationships the 2.7.1
between
word and infinite 3.1.2
image surprise expression herself
designer

3.4.3

3.5.4

S type

4.1.9

3.7.5

3.4.3

3.1.3

2.1.2

3.1.2

3.2.3

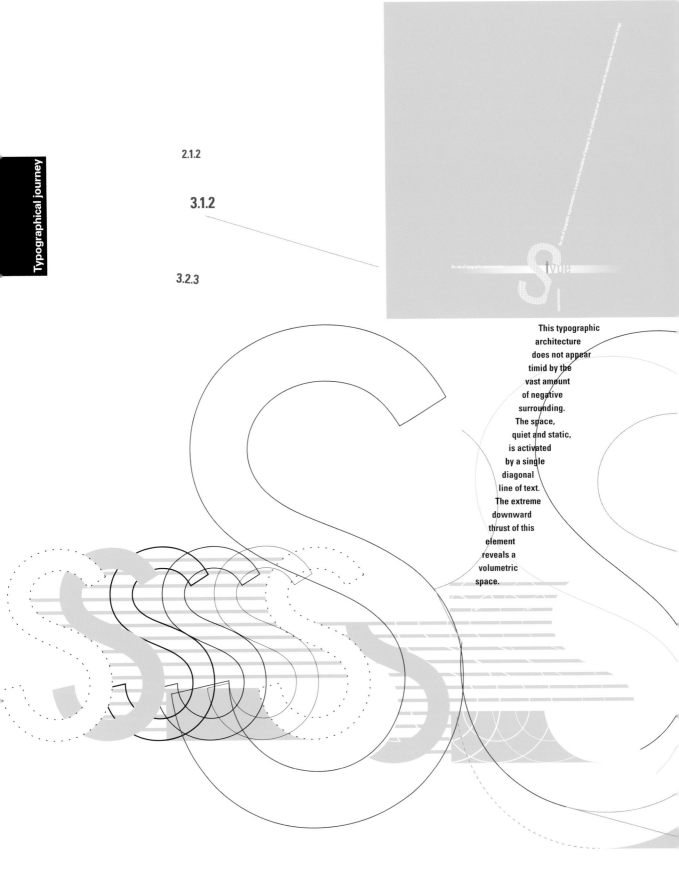

This typographic
architecture
does not appear
timid by the
vast amount
of negative
surrounding.
The space,
quiet and static,
is activated
by a single
diagonal
line of text.
The extreme
downward
thrust of this
element
reveals a
volumetric
space.

type

the role of typographic experimentation
is to extend the boundaries of
language by freely probing visual
and verbal syntax and the
relationships between word and
image. syntactic exploration enables
designers to discover among
typographic media an enormous
potential to edify, entertain and surprise.
as in other forms of language typography is capable of
infinite expression. the only limits to typographic discovery
are those imposed by the designer herself.

Text and ruled lines
separated by equal
intervals of space
are densely
packed to
reveal an
irregular
texture
and
rhythm.
The effect is pleasingly ambiguous;
one senses order amidst the chaos.

type

3.6.3

2.5.4

3.5.1

2.3.4

Though the
characters
in the
word *type*
are frag-
mented,
reduced,
and sub-
stituted
with mathe-
matical
symbols,
the word
remains
readable.
The *y* is
a curious
combination
of a symbol
and a
curving
line of text.

tγμє

the only limits to typographic discovery are those imposed by the designer herself

3.4.3

2.3.2

2.2.1

3.1.2

4.3.1

2.3.2

the role of **graphic**
experiment **on is to**
extend the **ndaries**
of language **y freely**
probing **sual and verbal**

ween word and image

While at first glance
this composition
appears fragmented
and discordant,
further observation
reveals a deliberate
positioning of parts.
The alignment of the
edges of the characters
and text provides an
orderly structure that
belies the disheveled
appearance. The directional
attributes of the elements move
the eye in a circular path through the
composition.

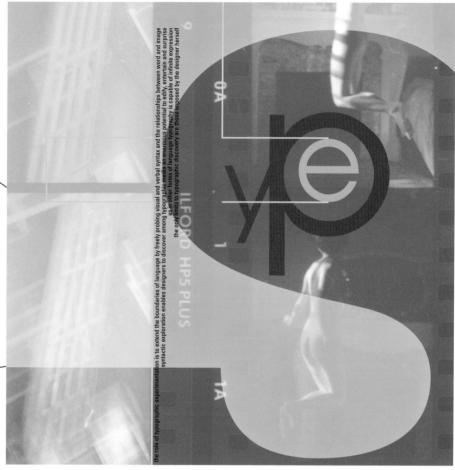

the role of typographic experimentation is to extend the boundaries of language by freely probing visual and verbal syntax and the relationships between word and image syntactic exploration enables designers to discover among typographic media a tremendous potential to edify, entertain and surprise as other forms of language typographically is capable of infinite expression the only limits to typographic discovery are those imposed by the designer herself

ILFORD HP5 PLUS

Dependent on
the sensuous
silhouetted *s*
as the foundation
from which
organic shapes
evolve, this
experiment
explores elab-
oration as
the primary
design factor.
Not only is
the *s* form
reduced from
its original
structure,
its final shape
is resolved
with the
addition of
transparent
imagery.

4.2.2

2.5.1

2.3.4

4.4.1

Computer manipulation energizes the letterform.

THE SYNTACTIC AS TH
ROLE EXPLORATION IN ONL
OF ENABLES OTHER LIMIT
TYPOGRAPHIC DESIGNERS FORMS OF
EXPERIMENTATION TO OF TYPOGRAPH
IS DISCOVER LANGUAGE DISCOVER
TO AMONG TYPOGRAPHY AP
EXTEND TYPOGRAPHIC IS THOS
THE MEDIA AN IMPOSE
BOUNDARIES ENORMOUS E
OF INFINITE TH
LANGUAGE POTENTIAL EXPRESSION DESIGNE
BY TO HERSEL
FREELY EDIFY
PROBING ENTERTAIN
VISUAL AND
AND SURPRISE
VERBAL
SYNTAX
AND
THE
RELATIONSHIPS
BETWEEN
WORD
AND
IMAGE

3.7.2

3.5.1

Rippling and blurring effects.

2.5.2

Here, the procedure is to produce an active plane of type by separating the text into active groups. Repetition of vertical dashes, progressing from thick to thin, rhythmically slice through the space. The dissonant grouping of words and lines produces an energetic and irregular visual field.

A font possessing a boxed frame for each of its individual letters comprises the main text. The diagonal placement of the text is reminiscent of an architectural layout. Supporting this angular layout is a square of moving cubes with an imprinted *s*. A thin vertical line plays off the predictability of the composition's directional structure.

typographic experimentation

3.6.2

3.7.2 **3.5.3**

4.1.2

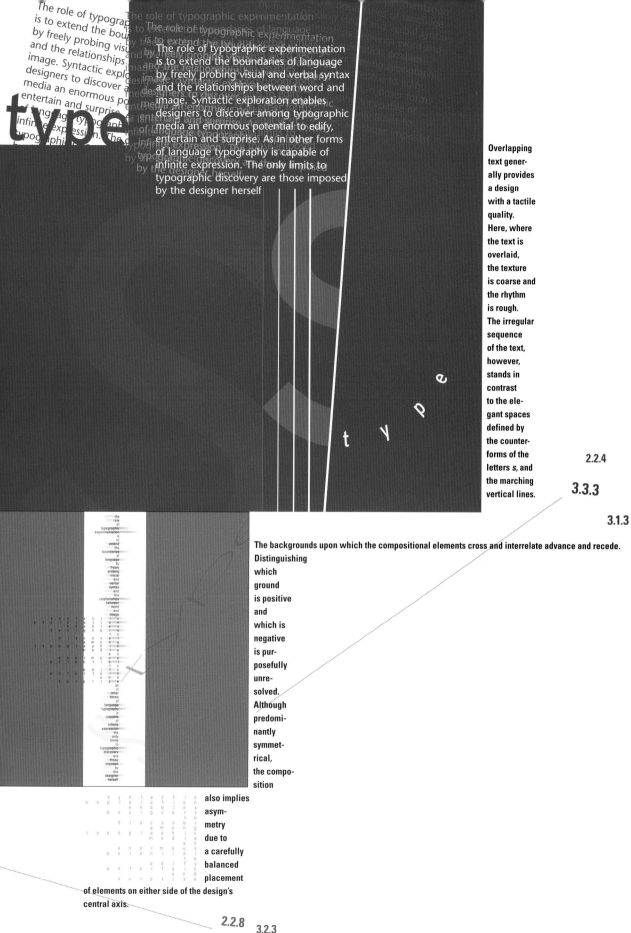

The role of typographic experimentation is to extend the boundaries of language by freely probing visual and verbal syntax and the relationships between word and image. Syntactic exploration enables designers to discover among typographic media an enormous potential to edify, entertain and surprise. As in other forms of language typography is capable of infinite expression. The only limits to typographic discovery are those imposed by the designer herself

type

t y p e

Overlapping text gener- ally provides a design with a tactile quality. Here, where the text is overlaid, the texture is coarse and the rhythm is rough. The irregular sequence of the text, however, stands in contrast to the ele- gant spaces defined by the counter- forms of the letters *s,* and the marching vertical lines.

2.2.4

3.3.3

3.1.3

The backgrounds upon which the compositional elements cross and interrelate advance and recede.

Distinguishing which ground is positive and which is negative is pur- posefully unre- solved. Although predomi- nantly symmet- rical, the compo- sition

also implies asym- metry due to a carefully balanced placement of elements on either side of the design's central axis.

2.2.8 3.2.3

1.2.4

the role of typographi
is to extend the boun
language by freely pr
and verbal syntax and
between word and im
syntactic exploration
designers to discover
media an enormous p
entertain and surpris
as in other forms of l
is capable of infinite
the only limits to type
are those imposed by

The emotive qualities of type can be heightened through the manipula-
tion of computer software filters. These powerful tools enable
infinite possibilities for letter distortion. Fragmenting
and blurring type add a visual dimension that
challenges typographic conventions.

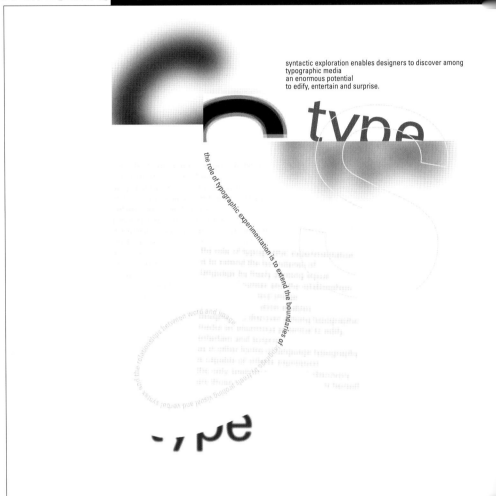

syntactic exploration enables designers to discover among
typographic media
an enormous potential
to edify, entertain and surprise.

the role of typographic experimentation is to extend the boundaries of

the relationships between word and image and the visual and verbal syntax

type

type

type

the relationships between word and image.

the role of typographic experimentation is to extend the boundaries of language by freely probing visual and verbal systems.

The letter s vibrates as if surrounded by a magnetic force.

Overlapping type and ruled lines create a complex field of visual information. Dashed lines form the positive shapes as well as the negative white spaces. The interaction between foreground and background appears ambiguous as the components weave in and out of one another.

the role of typographic experimentation

is to extend the boundaries of language

by freely probing visual and verbal syntax

and the relationships between word and image

syntactic exploration enables designers

to discover among typographic media

an enormous potential to edify, entertain and surprise

as in other forms of language

typography is capable of infinite expression

the only limits to typographic discovery

are those imposed by the designer herself

the role of typographic experimentation
is to extend the boundaries of language
by freely probing visual and verbal syntax
and the relationships between word and image
syntactic exploration enables designers
to discover among typographic media
an enormous potential to edify, entertain and surprise
as in other forms of language
typography is capable of infinite expression
the only limits to typographic discovery
are those imposed by the designer herself

4.2.1

3.5.3 2.5.2

2.3.4

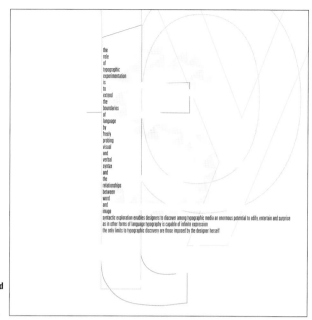

the
role
of
typographic
experimentation
is
to
extend
the
boundaries
of
language
by
freely
probing
visual
and
verbal
syntax
and
the
relationships
between
word
and
image
syntactic exploration enables designers to discover among typographic media an enormous potential to edify, entertain and surprise
as in other forms of language typography is capable of infinite expression
the only limits to typographic discovery are those imposed by the designer herself

Letterform design and constructed
texture are the basis of this typo-
graphic design. Individual letters
of varying outlined strokes are abstracted to compose a series of shapes.
Repeated triangular stars establish a dazzling kinetic pattern.

3.5.4

2.2.8

2.5.5

Distortion is an essential extension of
typographic language, and the free
expression of typographic form contri-
butes to contemporary visual culture. At
the same time, sensitivity to typographic
tradition remains a critical concern, for
without harmony there is no beauty.

The rippling filter offers a letter a malleable characteristic.

2.5.1

2.7.1

2.4.5 3.5.1

Blurring
and
tiling
blend
to
render
an
exquisite
expression.

1

Note: As you study the work in this portfolio, be mindful that the student designers pinpointed specific factors from the morphology in Chapter 7 for investigation. Though you may discover that other factors also play some role in the experiments, only the prominent ones are mentioned.

1

Factors:

1.1.1	case	*upper*
2.6.1	dimensionality	*volumetric*
4.2.2	shapes	*organic*

Designer: **Veronica Ledford**

2

Factors:

2.2.1	distortion	*fragmenting*
2.4.5	outline	*combination*
3.7.4	rhythm	*progressive*

Designer: **Timea Adrian**

3

Factors:

1.3.3	size	*large*
3.7.4	rhythm	*progressive*
4.1.9	ruled lines	*combination*
4.2.3	shapes	*combination*

Designer: **Joshua Sandage**

2

3

4

5

6

8

4

Factors:

1.3.3	size *combination*
3.2.5	direction *combination*
3.6.1	repetition *few*
4.1.3	ruled lines *diagonal*

Designer: **Ginger Cho**

5

Factors:

1.3.3	size *combination*
3.1.3	balance *combination*
3.8.2	rotation *moderate*

Designer: **Timea Adrian**

6

Factors:

3.2.3	direction *diagonal*
3.7.3	rhythm *alternating*
3.8.2	rotation *moderate*
2.3.2	elaboration *subtraction*

Designer: **Rosemary Sabatino**

7

Factors:

1.2.1	face *serif*
3.5.2	proximity *touching*
3.8.2	rotation *combination*
4.2.2	shapes *organic*

Designer: **Joshua Sandage**

8

Factors:

1.3.4	size *combination*
2.2.7	distortion *mutilating*
2.4.5	outline *combination*

Designer: **Chris Raymond**

9

Factors:

2.2.4	distortion *stretching*
3.2.3	direction *diagonal*
3.6.4	repetition *pattern*

Designer: **Ann Ford**

10

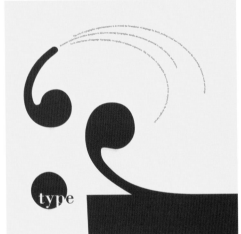

11

10

Factors:

1.6.4	width *combination*
2.5.5	texture *combination*
2.7.4	tonality *combination*
3.2.1	direction *horizontal*

Designer: **Rosemary Sabatino**

11

Factors:

2.2.2	distortion *skewing*
3.2.3	direction *diagonal*
4.1.9	ruled lines *combination*

Designer: **Joshua Sandage**

12

Factors:

3.4.2	grouping *dissonant*
1.2.4	face *eccentric*
3.5.1	proximity *overlapping*
4.3.1	symbols *normal*

Designer: **Krysta Higham**

13

Factors:

1.3.3	size *large*
3.2.4	direction *circular*
3.4.1	grouping *consonant*
4.2.3	shapes *combination*

Designer: **Joshua Sandage**

14

Factors:

| **2.2.8** | distortion *combination* |
| **3.5.1** | proximity *overlapping* |

Designer: **Chris Raymond**

15

Factors:

1.3.3	size *large*
1.5.1	width *narrow*
2.2.1	distortion *fragmenting*
4.2.3	shapes *combination*

Designer: **Ann Ford**

12

14

15

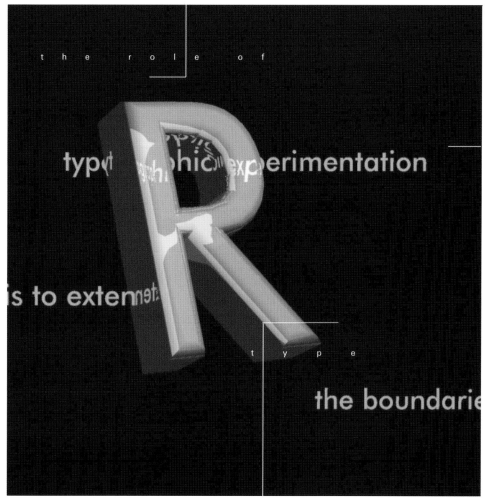

the role of

typographic experimentation

is to extend

type

the boundaries

17

17

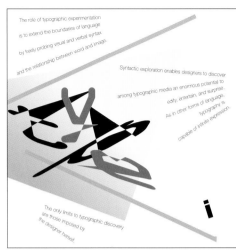

18

17

Factors:

1.2.5	face *combination*
2.2.5	distortion *blurring*
3.2.1	direction *horizontal*
3.5.1	proximity *overlapping*

Designer: **Ginger Cho**

18

Factors:

2.2.1	distortion *fragmenting*
3.2.3	direction *diagonal*
3.7.1	rhythm *regular*
4.1.8	ruled lines *thick*

Designer: **Chris Raymond**

19

Factors:

2.3.1	elaboration *addition*
3.2.4	direction *circular*
3.3.1	ground *advancing*
4.2.2	shapes *organic*

Designer: **Chris Raymond**

20

Factors:

2.3.2	elaboration *subtraction*
3.7.2	rhythm *irregular*
4.1.3	ruled lines *diagonal*

Designer: **Priya Rama**

21

Factors:

3.7.2	rhythm *irregular*
4.1.8	ruled lines *thick*

Designer: **Priya Rama**

22

Factors:

2.2.1	distortion *fragmenting*
2.3.2	elaboration *subtraction*
3.7.2	rhythm *irregular*
4.2.1	shapes *geometric*

Designer: **San Van**

19

20

21

22

23

24

25

27

26

28

23

Factors:

1.2.5	elaboration *combination*
3.5.1	proximity *overlapping*
2.4.1	outline *thin*
4.1.6	ruled lines *thin*
4.2.1	shapes *geometric*

Designer: **San Van**

24

Factors:

2.5.4	texture *irregular*
3.5.1	proximity *overlapping*
4.1.1	ruled lines *horizontal*

Designer: **Priya Rama**

25

Factors:

3.2.4	direction *circular*
3.5.1	proximity *overlapping*
3.8.2	rotation *moderate*
4.1.4	ruled lines *circular*

Designer: **Joshua Sandage**

26

Factors:

3.2.3	direction *diagonal*
3.6.2	repetition *many*
4.2.1	shapes *geometric*

Designer: **Timea Adrian**

27

Factors:

3.1.2	balance *asymmetrical*
3.3.1	ground *advancing*
3.4.2	grouping *dissonant*
4.2.1	shapes *geometric*

Designer: **Ginger Cho**

28

Factors:

2.2.5	distortion *blurring*
3.2.1	direction *horizontal*
3.5.1	proximity *overlapping*
4.1.6	ruled lines *thin*

Designer: **San Van**

29

Factors:

2.3.1	elaboration	*addition*
3.2.2	direction	*vertical*
3.7.2	rhythm	*irregular*

Designer: **San Van**

29

30

31

32

33

34

35

36

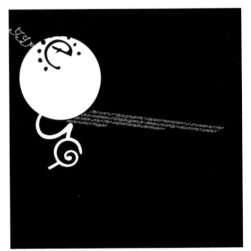

37

36

Factors:

1.2.4	face	*eccentric*
2.6.1	dimensionality	*volumetric*
4.2.5	shapes	*combination*

Designer: **Jesus Palacios**

37

Factors:

1.3.4	size	*combination*
1.2.5	face	*combination*
2.2.2	distortion	*skewing*
4.2.1	shapes	*geometric*

Designer: **Ginger Cho**

38

Factors:

1.2.4	face	*eccentric*
2.6.1	dimensionality	*volumetric*
3.5.1	proximity	*overlapping*
4.2.2	shapes	*organic*

Designer: **Kelly Perkins**

39

Factors:

1.2.5	face	*combination*
2.2.2	distortion	*skewing*
3.8.4	rotation	*combination*
4.2.2	shapes	*organic*

Designer: **Jesus Palacios**

40

Factors:

1.3.4	size	*combination*
3.5.3	proximity	*separating*
2.2.7	distortion	*mutilating*

Designer: **Rosemary Sabatino**

41

Factors:

1.2.5	face	*combination*
2.2.8	distortion	*combination*
2.4.1	outline	*thin*
3.5.4	proximity	*combination*

Designer: **Timea Adrian**

38

39

40

41

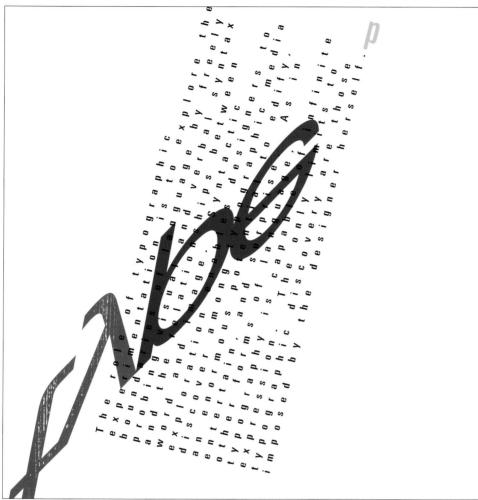

The role of typographic experimentation to explore the bounding visual and verbal syntactic media by freely exploration and the relationship between the and word discovery image and surprise graphic designers to and an exploration among expressive capable of infinite to discover enormous surprise, language discovery are those typography and possibilities of The only limit to the others entertain, poetic forms of typographic discovery are those and typographic expression. typography is capable of imposed by the designer herself.

42
Factors:
1.1.2 case *lower*
2.2.8 distortion *combination*
2.5.3 texture *regular*
Designer: **Veronica Ledford**

43
Factors:

1.3.4	size	*combination*
2.3.2	elaboration	*reduction*
3.6.5	repetition	*combination*
4.2.2	shapes	*organic*

Designer: **Joshua Sandage**

43

44

45

46

47

48

49

44

Factors:

1.3.4	size *combination*
3.5.1	proximity *overlapping*
4.1.1	ruled lines *horizontal*
4.4.4	images *manipulated*

Designer: **Ginger Cho**

45

Factors:

1.3.4	size *combination*
3.2.4	direction *circular*
4.4.1	images *background*

Designer: **Ginger Cho**

46

Factors:

1.3.4	size *combination*
2.2.3	distortion *bending*
3.7.4	rhythm *progressive*

Designer: **Timea Adrian**

47

Factors:

1.3.1	size *small*
2.1.1	blending *linear*
3.7.5	rhythm *combination*
4.2.1	shapes *geometric*

Designer: **Rosemary Sabatino**

48

Factors:

1.3.1	size *small*
2.1.1	blending *linear*
2.2.7	distortion *mutilation*
3.6.4	repetition *pattern*
4.2.1	shapes *geometric*

Designer: **Chris Raymond**

49

Factors:

1.2.5	face *combination*
2.6.2	dimensionality *shadowing*
3.4.2	grouping *dissonant*
3.8.4	rotation *combination*

Designer: **Chris Raymond**

Typography workshop

9

Typography workshop

In April of 1997, 13 students and five teachers from the Gerrit Rietveld Academy in Amsterdam joined students and teachers from the Visual Communication program at Virginia Commonwealth University in Richmond, for a continuation of an exchange begun the previous year. The purpose of this workshop was twofold: first, to bring together an international community of people for a cross-cultural exchange of ideas; second, to create a climate for free typographic exploration and expression. The workshop consisted of presentations, films, critiques, and informal group discussions that often continued late into the night. The workshop culminated with an all-day presentation by the students. Three guest critics were invited to share their insights.

Many differences and similarities were discovered in the approaches of the two design programs. But what was learned from the shared ideas of individual participants and the resulting sense of community was most significant. At a preliminary gathering of faculty and students, Margit, a Dutch student who was visiting America for the first time, commented on how she felt like she entered a movie set when she stepped off of the airplane at Dulles International. Prior to her visit, her perception of America had been largely shaped by Hollywood films. During the two weeks of the workshop, cultural differences among the students and faculty – particularly those along social, economic, and political lines – would be revealed and discussed, a process that would melt away many preconceptions and cultural biases. Representative nationalities included Bulgarian, Dutch, Hungarian, Polish, Swiss, and American. Ironically, the foreign students would discover that America is a manifestation of many cultures, a land woven together from many different threads. The exploration of typography, a universal communication vehicle with ties to language and culture, led to the discovery of many issues that both connect and separate us as human beings.

Experimentation was guided by an open-ended project that gave impetus to exploration and interpretation of content, and provided a context for the investigation. The nucleus of the project is a poem, "In Those Years," by the influential American poet, Adrienne Rich:

In those years, people will say, we lost track
of the meaning of *we*, of *you*
we found ourselves
reduced to *I*
and the whole thing became
silly, ironic, terrible:
we were trying to live a personal life
and yes, that was the only life
we could bear witness to

But the great dark birds of history screamed
 and plunged
into our personal weather
They were headed somewhere else but their
 beaks and pinions drove
along the shore, through the rags of fog
where we stood, saying *I*

What has happened to community? In technologically advanced civilizations, it appears a thing of the past. Living today is a solitary, anonymous endeavor: invisible people living in invisible cities, walking straight lines with straight backs. Eyes focused on the horizon, peripheral vision lost for lack of use. Bodies brushing but never touching; voices muffled amidst a deafening drone. What has happened to community? What has happened to "we"?

During the workshop, the I/We dichotomy was evident in the way the students interacted with or isolated themselves from others, and in the way the project was interpreted. Generally, some of the students (especially the Dutch, and a small minority of Americans) questioned every aspect of the project brief or ignored some of the constraints. Their quest was for absolute individuality (the "I"). Others felt obligated to precisely follow the brief, to conform (the "We"). These varying attitudes inevitably led to a wide range of solutions, and a dynamic creative environment. The experiments shown on the following pages represent a small but informative cross-section of the total work produced. Examples span the entire design process, from preliminary investigations to final solutions.

As the dust of the workshop has settled, one significant question arises: what is the role of typography in the global communication frenzy?

Project brief:

The departure point of this project is an interview by Bill Moyers of poet Adrienne Rich. Here you will find three voices: the voice of Moyers as interviewer; the voice of Rich as interviewee; the voice of Rich's poetry. In the process of everyday living we hear voices that shape our individual worlds, and together these voices shape culture.

During the course of this project you will typographically interpret your voice as it converses with the voices of the interview. Your voice will be discovered as it emanates from workshop experiences, observations, and travels.

Process:
Several considerations will guide this project, including the manifestations of culture as represented by the participants of the workshop; viewing the content from different/many perspectives; personal background; world view; personal values; and the social, economic, and political forces that ultimately define culture.

Maintain a sketch-book/journal to record your experiences and observations, and the voices that inform you during the workshop experience. The poem is typeset in many variations for your use. Other typographic material, including found typography, can be appropriated and integrated as needed.

Considerations:
Self discovery and
Self expression
Problem seeking and solving
Permutation
Transformation
Shifting problem boundaries
Message clarity
Type as word and image

Possible realization:
2-d typography
3-d typography
Type as object
Environmental typography
Projected typography
Time-based typography
Kinetic typography

1

"It seems as though the Rietveld students bring a sense of humor to their work that really comes across. I don't have a sense of humor when it comes to design. I can't do that, so I really respect this ability, and, I am in awe of it. I wish I could be funny when I design, but I can't. As a former graduate of the program here, I would say that the students are very process oriented, very methodological in their approach."
N.D.

2

2

We are many and we are all
individuals.

3

A pictographic
anthropomorph overlays a
sea of people, suggesting
that we all share the same
ancestral roots. It also
provides a primitive
signature that states
"I am me."

4

An ordinary sticker
containing an advertising
slogan is repeated and thus
reinterpreted to suggest
American consumerism.

5

As individuals, we have ears
but we don't always hear.

6

A typographical
interpretation of the poem,
with letters evenly spaced
and repeated to signify
individuality.

7

In this experiment, a
photograph of corn is
juxtaposed with a field of
human isotypes to reference
feeding the world.

8, 9

Pages from a sketchbook are
indicative of ideas that could
lead to further
experimentation.

2-9: Nicolet Schouten

3

4

5

8

9

7

10

11

12

wemempty

in those years, people will say, we lost
track of the meaning of we, of you
we found ourselves reduced to i and
the whole thing became silly, ironic,
terrible: we were trying to live a
personal life and yes, that was the only life
we could bear witness to but the great
dark birds history of screamed and
plunged into our personal weather they
were headed somewhere else but their
beaks and pinions drove along the
shore, through the rags of fog where
we stood, saying i

13

"'More' seems to be an environmental statement. If it is an environmental statement, then the statement should be based on a fact. It should mean something. It should be this or that. I mean you can't stand outside of that. In your idea something is wrong because it doesn't do this or that. You can't stand on the side with this kind of subject. . .you **must express an opinion one way or another, but you don't do that.** V.L.

14

15

16

17

18

The handprint is often found in primitive cultures as a sign for personal identity. Here it is used as a symbol in combination with the letter *i* to say "i am here; i am important."

19

In this permutation, selected lines from the poem appear on torn strips of paper running along the fingers of the hand.

20

The hand and the letter *i* joined into a single sign.

21

Page from a sketchbook showing further interpretive possibilities.

22

American price stickers attached to the notebook. Ordinary typographical objects found in the environment can provide impetus for investigation.

23

The poem written alternately in English and Dutch suggests a blending of two different cultures.

24

Type is extracted from its original context and presented in a new context to form a mirror image.

18-24: Barbara van Ruyven

18

19

22

24

23

e g (i) n s v e g (g) i n s v e g (i) n s v e g i (n) s v e g i n (s) v

e g i n s (v) scheveningen

25

26

"It is true that with a flip book, you can add something to make a transformation. I think there is some confusion between more and a lot. You must take care that you don't deal with the meaning of a lot instead of more. More is growing. It is *something active.*"

H.G.

A personal track

I drove somewhere, along the shore
we headed into rags of people
they were silly, reduced to beaks
great, their life was history

but then, in the fog
stood that whole terrible dark thing
we screamed to the birds:
we found a bear

and so we were trying
to witness the only meaning of life
for years and years and years and yes

the weather plunged
I became ironic
we lost the pinions

27

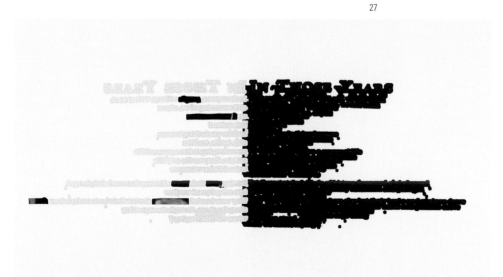

25
An experimental interactive program enables the user to click various letters with the computer mouse. This activates an equivalent sound in the voice of the person seen on the screen. Potentially, any word or phrase can be generated. In the last frame, the word *scheveningen,* a Dutch beach resort, is heard.

26
The poem is rearticulated into a new poem with a new meaning.
25, 26: Persijn Broersen

27
A computer is used to swell the type of the poem beyond recognition. Only the poem's title is readable. The new image represents the failure of the poem's idealism.
27: Dima Stefanova

29

28

"One of the things I want to say about the format and the type size is that unlike Michel's piece, where he brought things that are very public and very large to a small space, you brought something very very small to a large space. What you have done in a very different way is to encourage people in a public setting to get close to something, to get intimate with it." S.W.

28

For this poster, which is perhaps more like a book due to the degree of text, dictionary definitions of the poem's words are presented. Whereas in most graphic design something large is introduced into a small space, this poster presents something small in a large space.

29

Detail of poster

28, 29: Esther de Vries

30

This experimental poster obliquely references the separateness of *I* and *WE*, as indicated in the poster's title, *Film sans me.*

31-34

A series of experimental postcards based upon the social and cultural words and images of workshop participants.

30-34: Jason Smith

30

31

32

33

34

I y l o l u l w l e l
l w l e l y l o l u l
l y l o l u l w l e l
l y l o l u l w l e l
I w l e l y l o l u l
l w l e l y l o l u l

36

IYOUWE

37

l y l o l u l w l e l

38

35

The Dutch words *IK* (I), *JIJ* (YOU), and *WIJ* (WE) simultaneously form a rhythmic typographic pattern and a representation of human interaction. Red letters *I* suggest individuality within a social group.

36

The *I* forms in this experiment separate letters of the words *you* and *we* to suggest compartmentalization, alienation, and privacy.

37

A further investigation physically links the words *I*, *YOU*, and *WE* into a single new word, a statement of cooperation and community.

38-39

Environmental typography (billboard), and kinetic poster (t-shirt).

35-39: Christine Alberts

"There was a study that preceded this, I think it was last night I saw you working on it. And I guess again I am not trying to find solutions for you, but if your goal is to find a purity of this form and idea, it seemed that what I saw was going in the right direction. It's kind of interesting, too, to think about the polemic of something being both pure and heroic. But that's a topic for another day. . .but then you know we do have examples of heroic sculpture on Monument Avenue, and there are days when it is more heroic than others. If you're looking for conditions that emphasize that sort of emotion, consider the sky, the way the monuments are lit from below, the effect of sunny and rainy days, how a specific group of people is interacting with them. All of this decreases or increases the heroicism of these objects."

J.M.

39

IKJIJWIJ
WIJJIJIK
JIJIKWIJ
IKWIJJIJ
WIJIKJIJ
JIJWIJIK

35

40

"That is a valid function for a poem on a poster. But in the end, a poem is more at home in a book. Very few poems are suitable for a poster, particularly if it is complex poetry. As poetry becomes a little more complex, as it becomes necessary to read a piece four or five times before it makes sense, the book is the most appropriate form.

W.B.

40

A portrait of the city. Within crowded cities live both the rich and the poor, the famous and the obscure. The reality of the city is that it is a conglomerate of individuals.

41

The student's initial reaction to the poem was to write another poem, which focuses on an I/We theme in the context of his relationship to his wife.

42

The wing is part of a typographic performance wherein actual wings are worn as the poem is read aloud. The wings represent the student's wish to fly alone, though the bond to his wife beckons him to stay.

43

A sketchbook investigation of words and phrases about the student's life, which led to the design of a typographic time line.

44

By modifying the word *exist* with plus and minus signs, a statement about existence and nonexistence is made. The period separating the two parts of the word evokes a decimal point, and its role in denoting the whole and the fraction.

40-44: Erik Brandt

43

42

i sometimes wish to fly
quietly
impossibly on air

but when i see you
i smile
wave hello
and want to stay

41

+ex.ist
–ex.ist

44

DONT WALK **LIVE FAST**

TOGO AWAY **GULP FUEL**

 PUSH THRU

FEEL SURE **FLOW INTO**

YOUR MYTH

45

Shown here are spreads from a small, experimental book based on the designer's three obsessions: 1) cars, speed, and horses; 2) vernacular American type; 3) four-letter words. The word pairings, which express the obsession themes, consist entirely of four-letter words and are set in Venus Bold Extended. The title, 4★4 refers to the 16 words used in the book.
45: Harmen Liemburg

47

49

46

48

46, 47
Sketchbook investigations showing a rubber stamp design that reads *me* before it is stamped, *we* after it is stamped, and *me* after it is stamped and turned upside down.

48
The double reading of the stamp is used as an effective element in a poster design.

49
In an exploratory page from the sketchbook, the rubber stamp is used in combination with a multitude of cultural artifacts.

50
The American dollar bill, a global economic symbol, is deconstructed into typographic units and reconstructed into a thought-provoking visual poem related to wealth, greed, and selfishness.
46-50: Michel van Duyvenbode

we lost track
of the meaning of **ME**, of you

50

MARGIT

IN

AMERICA

53

54

55

51

52

51, 52

Fascinated by American suburbia, this Dutch student created collages that make statements about things people buy but really don't need. Amenities for purchasers of new homes are extracted from home listings magazines and presented as a dizzying repetitive pattern. Another collage combines this typographic information with suburban images.

53-55

Expressive sketches by a Dutch student visiting America for the first time, reveal impressions of social and economic conditions.

51-55: Margit Lukacs

56

Interpretive poster.

57

Type and image combine to express the you/I duality. An outstretched finger is substituted for the *I*.

56, 57: Jennifer McMaster

56

57

"It was towards the end of the book that you established the idea of the meshing and cluttering of everything. I don't feel that this device is as effective. At some point it becomes too muddy." B.R.

COMMUNITYSM

59

60

In Those Years - a poem by Adrienne Rich

61

62

63

58
COMMUNITY and ISM are combined into COMMUNITYSM to reveal an active, ideal word for community.

59
In a poster, the concept of an ideal community is illustrated through a combination of type and image.

60
Pronouns extracted from the poem are placed upon pages of a swatch book for an interactive book that is each time read differently.
58-60: Monika Wiechowska

61
The question of how a poem might be used in a poster is answered by enlarging the provocative typographic phrase, *we lost*. The comma suggests that the phrase is but a part of the poem.

62
In a preliminary study, the theme "we lost" is referenced by that which is missing. Words of the poem encircle a torn hole in the paper.

63
The poem forms *we* to reveal its essence.

64
WE as a typographic expression of many *I* s

65
Studied analysis of the poem's content.
61-65: Yael Seggev

i

lostlostlostlostlostlostlostlostlost*we*lostlostlostlostlostlost
lostlostlostlostlostlostlostlostlost*I*lostlostlostlostlostlostlost
lostlostlostlostlostlostlostlostlostlostlostlostlostlost
findfindfindfindfindfindfindfindfindfindfindfind
findfindfindfind*a*findfindfindfindfind*you*findfindfindfindfind
findfindfindfind*a*findfindfindfindfindfindfindfindfindfind
findfindfindfindfindfindfindfindfindfindfindfindfind
findfindfindfindfindfindfindfindfindfindfindfindfind
findfindfindfindfindfindfindfindfindfindfindfindfind
findfindfindfindfindfindfindfindfindfindfindfindfind
findfind*I*findfindfindfindfindfindfindfindfindfindfind
findfindfindfindfindfindfindfindfindfindfindfindfind
findfindfindfind*you*findfindfindfindfindfindfindfindfind
findfindfindfindfindfindfind*they*findfindfindfindfind
findfindfindfindfindfindfindfindfindfindfindfindfind
findfindfind*you*findfindfindfindfindfindfindfind*we*findfind

Adrienne Rich A Typographic Interpretation 3

lost*we*lostlostlostlostlostlost*we*lostlostlostlostlostlostlostlost
lostlostlostlostlostlostlostlostlost*I*lostlostlostlostlostlostlost
lostlostlost*he*lostlostlostlostlostlost*him*lostlostlostlostlost
lostlostlostlostlostlostlostlostlost*our*lostlostlostlostlostlost
lostlostlostlostlostlostlostlostlostlostlostlostlostlost
findfind*I*findfindfindfindfindfindfindfindfindfindfind
findfindfindfindfindfind*you*findfindfindfindfindfindfind
findfindfindfind*a*findfindfindfindfindfindfindfindfindfind
findfindfindfindfindfindfindfindfindfindfindfindfind
findfindfindfindfindfindfindfindfindfind*we*findfind
findfindfindfindfindfindfindfindfindfindfindfindfind
findfind*me*findfindfindfindfindfindfindfindfindfindfind
findfindfind*you*findfindfindfind*they*findfindfindfind

Adrienne Rich In Those Years 4

findfindfindfindfindfindfindfindfindfindfindfindfindfind
findfindfindfind*a*findfindfindfindfindfindfindfindfindfind
findfindfindfindfindfindfindfindfindfindfindfind*we*findfind
lost*we*lostlostlostlostlostlostlostlostlostlostlostlostlost
lostlostlostlostlostlostlostlostlostlostlostlostlost
lostlost*he*lostlostlostlostlostlostlostlostlostlostlost
lostlostlostlostlost*I*lostlostlostlostlost*our*lostlostlost
lostlostlostlost*a*lostlostlostlostlostlostlostlostlostlost

lost*and*found

Adrienne Rich A Typographic Interpretation 5

we all
wear jeans

"Going back to your stamp, I think there is potential here that you haven't tapped in terms of the technology or the process of making a stamp. . . that by making it into a stamp there is an opportunity to make many of them very easily. Yet there has remained a singular, one-of-a-kind juxtaposition of me/we. I think that the ease with which you can now make a hundred of these gives you the opportunity to expand on the opposition between the two things. As you have it now, "me" is one object; "we" is another object. They are related in their reflection. I think you have the opportunity through the technology you have used to very easily make multiples of them. In what I see, this potential is untapped." C.W.

Because the Europeans came to the Americas from a political system just emerging from feudalism and still based on authoritarian *making decisions based by consensus* Algonquian control, they had very little experience making decisions based by consensus. They adapted this concept and this word from the Algonquian Indians.

66 A typographic experiment exploring the relationship between numbers and words: 1 is for me, 2 is for we, 3 is for community.

67, 68 Pages of an experimental book with the theme of being lost and then found.
66-68: Sheila Barrett

69 The statement "we all wear jeans" references human equality, and the fact that many people share similar needs and desires.
69: Libby Hiller

70 The letters of the word *CAUCUS,* which refers to a group of people seeking agreement on an issue, are formed by plucking kernels from ears of corn. The kernels provide an apt metaphor for people cooperating with other people, and of parts creating a whole.
70: Barbara Spies

This chapter presents profiles of four professional graphic designers, each with a distinct and innovative typographic voice. Each profile features a designer's statement, a portfolio of work, and typographic experiments conducted specifically for this book.

Elliott Peter Earls

For Elliott Peter Earls, experimentation is not a luxury for which he must scratch time out of his day. Since his student days at Cranbrook Academy of Art, where he received an MFA in design, it has been integral to his creative process, something wired into his psyche, a driving force in his life and work.

Earls is founder of The Apollo Program, a design firm, type foundry, and multimedia studio. As well as his involvements in print-based graphic design and type design, he freely crosses inter-disciplinary boundaries to create highly sensory, interactive, multimedia environments that combine images, sound, type, poetry, and movies.

His work is driven by a personal philosophy shaped in large part by an amalgamation of thought. Based on the writings of futurists, literary figures, and filmmakers, including Alvin Toffler, Hal Foster, and Italo Calvino, he has defined the "prosumptive" designer. The prosumptive designer is totally immersed in culture, a relentless consumer of new technology and a producer of "info-tainment" products – products ranging from basic broadsides to interactive CD-ROMs. The prosumptive designer is uncompromisingly self-reliant, passionate, committed, and true to self. The prosumptive designer is a lateral thinker who subverts and deconstructs convention, intentionally misreads and misinterprets, rejects his or her own conclusions, and shifts comfortably between related disciplines.

A series of posters designed by Earls for the Apollo Program have over the years gained wide notoriety. They function simultaneously to promote The Apollo Program's fonts, among which are *Dysphasia, Blue Eye Shadow, Hernia,* and *Subluxation.* They also provide a canvas for exploring poetry and thought. The viewer is jerked about in a curious discourse of form, and if typographic conventions are adhered to at all, they are intentionally masked.

Throwing Apples at the Sun, a pioneering interactive CD-ROM by Earls, is a richly layered and highly unpredictable experience. Without actually experiencing it firsthand, any attempt at describing it in words falls far short. But here is a vain attempt: by passing the cursor or clicking the mouse over a dense backdrop of images and type elements, additional layers are revealed. These layers are not only visual; they are also audible and kinetic. Clicking on a text block, for example, activates another image, a movie, or a spoken phrase. Upon interacting with this CD, one soon finds that it bears no resemblance to the predictable structures of most other multimedia projects. This one is totally unpredictable, and it is this attribute that makes it so enjoyable. This interactive feast reveals Earls' unconventional visual sensitivity, and his uncanny ability to remove the viewer from cultural expectations by making the familiar strange.

1

The Apollo Program
experimental poster

1997, situated like a human head on the shoulders of the millennium, forces us into solitary dialog with his-story. Think of this as my Vision Induced by a String Found on my Table or my Pietà, or Revolution by Night. The grotesque caricature of the post world war one avant-garde, the ennui of the venetian-poser-skate-punk, all tools at our disposal. Like the half-wit Karl Appel, flung cannonballish at circus clown canvas, I too paint grunt "like a barbarian in a barbaric age." I'm thoroughly disinterested in the eloquence and simulated profundity that lies between quotation marks, but for the sake of ritualized discourse, let me take a stab at it:

"A painter is lost if he finds himself." –Max Ernst
The fact that he has succeeded in not finding himself is regarded by Max Ernst as his only 'achievement'.

Well played. . . I too cherish the suppression of logic and midnight games of linguistic Chinese checkers. But to what end? This question sweeps across my cerebellum like some medieval bubonic plague. Leaving in its foul wake the stench of value relativism and post-utopian thought. I'm the sad child of a tribe of ebola monkeys. Intellectually, environmentally and financially disenfranchised.

2

3

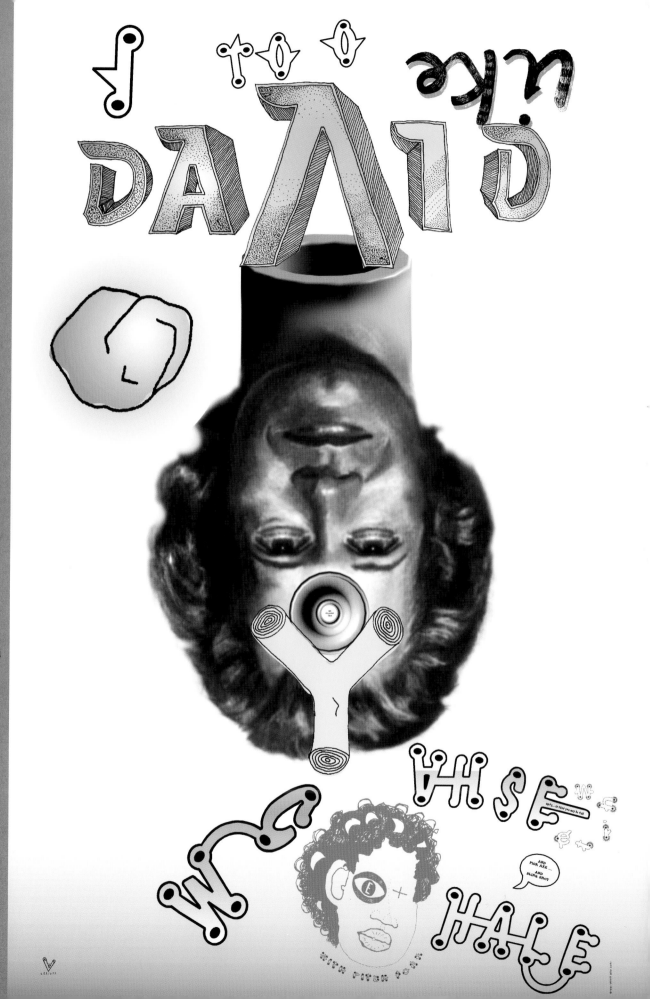

**Screen samples from
interactive CD-ROM,
*Throwing Apples at the Sun***

Designer profiles

5

6

7

8

9

experiment

Jean-Benoît Lévy

Jean-Benoît Lévy was born in a small village in the vineyards overlooking Lake Geneva, Switzerland. He now lives and works in Basel. His studio, which he founded in 1988, is named AND (Trafic Grafic). "AND" because without clients, designers are nothing; (Trafic Grafic) because once graphic design is produced, it travels, and because Lévy himself loves travel.

Without knowing the city's reputation for design, Lévy went to Basel to study graphic design. In 1978, he entered the graduate program at the Allgemeine Kunstgewerbeschule (School of Design), where he studied with Armin Hoffman, Wolfgang Weingart, and Max Schmidt. Since then, he has lived and worked in San Francisco, and taught at various design schools, including the Art Center College of Design, Europe, and the Rhode Island School of Design. Having a passionate need to be aware of current design developments, he stays in close contact with designers throughout Europe and America.

Lévy finds ample opportunity to experiment with typography while designing street posters, large-scale broadsides that evocatively and dramatically inform pedestrian traffic. These posters visually suggest moments frozen in time through various graphic processes. Lévy uses the street poster as a platform for typographical exploration, for he finds this medium provides opportunities for free and lively expression.

A pivotal characteristic of Lévy's posters is a magnetic synergy between type and image. He often art directs or relies upon talented photographers to create evocative images and contribute to visual solutions. These images, often montages of photographs, are characteristically sensuous and surreal. Through experimental processes, he then applies typography that visually optimizes and energizes the images and thus the message.

The street posters on pages 126 and 127 reveal Lévy as a visual poet who rather than persuading his audience, creates mood pictures that evoke positive responses in viewers. "I want to create posters that have the impact of modern poems or rock songs," he says. Lévy does not ascribe to a specific visual style or formula; rather, he explores many different possibilities, attempting to find solutions that through some twist, transcend the ordinary and the mundane.

The theater posters shown on pages 128 and 129 evolved from preliminary sketches, made after reading the plays. Lévy then art directed the photography, using the actors for models. The experiment for these posters was to push the limits of his design and typography, while also preserving the spirit of the theater company's advertising.

A point of fact about street posters in general is their impressive scale and dominant presence in the environment. Though their life is usually very short, they can potentially remain in the mind of the viewer long after they weather and decay. Lévy's posters achieve this with an articulate blend of type and image. He states, "My work is really good to me when I feel I can view my own posters without becoming bored. I am able to observe what they give to the public and to me, as if someone else had designed them."

The secret to Lévy's experimentation lies not only in his playful typographic processes, but also in his creative involvement with clients and talented photographers.

My life is an experiment

Being experimental with typography is a complex exercise, because it requires time. In my life I have met only a few people who have decided to use some of their precious time for typographic experiment. Wolfgang Weingart and Helmut Schmidt are among those that appear to have this desire. Weingart's Basel School program remains one of the rare places in the world where it is still possible for the willing student to try and try again, and to reserve time for this process.

It is rare to provide yourself with an opportunity to make what you want, particularly in graphic design. I am an independent graphic designer, and beyond the "real" works that I do for my clients, I find much less time to be really experimental in my work. Posters are one of the only chances for me to play as I wish. If I'm lucky, I can make between 3 to 5 posters in a year's time.

Personally, I don't see myself as an experimental graphic designer. For me, "experimental" is more related to how the public reacts to my work. I then use this feedback as a guide for my global work. When designing a poster or a special page as in this book, I feel more involved in a process of expression than of experiment. Personally, I'm not really sure if I am just reproducing what I know graphically or if I am experimenting with emotions.

Experimenting involves real creation. Maybe it is about making typographical accidents, recognizing them, and then finding the courage to use them in applied projects. That's why I'm always pushing young students to take the opportunity – when they are in school – to be experimental, and not just to try to imitate what they see in books in order to develop a style. Style may or may not come later.

For the four experimental pages in this book, I chose 20 postcards – messages written to me by women over a period of about 20 years. Half of them are relatives or good friends; others are more a part of my sentimental life. From each postcard I chose a sentence that is important to me. From each sentence I selected an expression. Combining all the statements together results in a new message, something that is like a resumé of my past life, a record of my relationships with women over the years. The experiment here aims to extract written statements and to reorganize them into a typographical composition.

Where I go from here in typography or in my life, remains to be seen. But I think of this open future as an opportunity. With a little bit of luck, this fragile state of things could lead me to a few moments of real experiment.

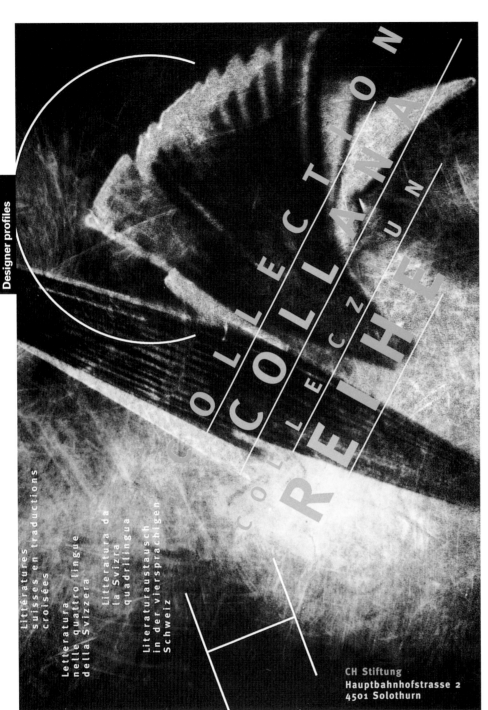

1

1
Poster
Photography: Alan Humerose

2
Exhibition poster
3
Poster for the Watch &
Jewelry Store
Photography: Franz Werner
4
Concert poster
Photography:
Jean-Pascal Imsand
5
Poster for a hairdresser
Photography: Leah Demchick

CH Stiftung
Hauptbahnhofstrasse 2
4501 Solothurn

Littératures
suisses en traductions
croisées

Letteratura
nelle quattro lingue
della Svizzera

Litteratura da
la Svizra
quadrilingua

Literaturaustausch
in der viersprachigen
Schweiz

2

3

4

5

6

7

8

11

9

10

6-10
Theatre posters
Photography:
Stefan Meichtry (6-9)
Martin Klotz (10)

11-13
Dance theatre posters
Photography: Philippe Pache

12

13

B

Merveilleux endroit pour les amoureux: Hôtel de charme, vue sur la mer, pâtisseries magiques

B i r t e

Ton téléphone m'a fait plaisir, je suis heureuse pour l'affiche

N a t h a l

Comment vas-tu? Que fais-tu? Où es-tu? Combien es-tu? Un, un 1/2, deux, deux 1/2, trois?

I e a

Je suis contente que tu aies chaud avec ce pull. J'ai reçu ce pain de fruit, je te l'envoie car j'en ai deux

M i r

Nous espérons que le beau temps va continuer à nous gâter, avec le soleil il fait bon vivre

John Malinoski

Through his work, John Malinoski attempts to reconcile the complexity and contradictions of society, which he observes with intense curiosity and amusement. His typographic design and related work are simultaneously ordered and chaotic, logical and intuitive, crude and refined. These and other dual themes are the means by which he structures his life and makes sense of it all.

Malinoski was born and raised in a tiny rural town in west upstate New York. He enjoyed a Tom Sawyeresque boyhood which fed his curiosity of the world and fueled his imagination. He studied graphic design at SUNY College at Fredonia and the Rochester Institute of Technology. At RIT he was mentored by Heinz Klinkon and most significantly by R. Roger Remington. Here, he was thrown into the headwaters of graphic design history, most particularly the avant-garde period. He empathized with the work and theories of El Lissitzky, Alexander Rodchenko, Herbert Bayer, Moholy-Nagy, and Piet Zwart. Malinoski's formal vocabulary is clearly reminiscent of these and other individuals of the avant-garde. His desire to is to delve into complexity at times, and at other times to express ideas and form with great economy, a commitment intensified by his close association with the Dutch architect, Han Schroeder.

Malinoski's typographic work is informed by playful explorations that challenge his intellect and provide an escape from purely applied projects. Since his childhood, he has had an affinity for making things, for recycling material from old objects into new objects. Malinoski appropriates found and discarded materials to create three-dimensional, architectonic constructions that reflect a passion for form and space, line and shape, texture and tone. They are meant to serve no practical purpose other than to provide fuel for thought and a model for the design process. In these fantasy objects, one sees evidence of flying machines, of sailboats; they are the embodiment of his passion for straight-ahead jazz, the strains of John Coltrane, Miles Davis, Keith Jarrett. This music provides a backdrop for his studio activities.

Referred to as the last Gepetto, Malinoski also makes unconventional hand puppets consisting of fabric, cardboard, papier maché, wood, metal, buttons, cork, and type fragments. Through the use of abstract, geometric forms, these puppets express a plethora of human emotions, recalling the costume designs of Oscar Schlemmer of the Bauhaus. Malinoski's typographic designs are consistent with this visual vocabulary.

In a very real sense, Malinoski is a typographic archeologist, a practitioner who digs and rummages through the past in an attempt to revitalize and give new form to the present.

In addition to his addiction to typography and design issues in general, Malinoski heads the graduate program in Communication Design at Virginia Commonwealth University. His focus is to provide a program that encourages independent thinking and a global outlook in design.

i am asked to write something about my work for this book

this is a difficult thing to do for two reasons:

1. it is hard to write about design (matters of my heart).

2. it is hard to write about typographic experimentation. (what is/isn't it now)

but i will try.

someone told me lately that design was something a lot more than pushing

two squares around on a piece of paper to make them look good.

for a while i got absorbed by this thought --- the formalist in me was

ridiculed into a minor, insignificant position.

then i started thinking true to myself.

i respect the good concept.

i laugh, i choke, i think when involved with the very good narrative.

but can i make people do this?

can i make things that result in evocative responses?

does printed ephemera ever succeed in doing these things?

i present here what i think i do best.

critics may call it fun with form.

(the last formalist?)

i am activator of relationships.

each piece is placed with a consideration for an architectonic whole.

i am thinking in three dimensional space.

it is a nice space and my thought actions fluctuate between extreme scale

changes

sometimes i am standing between two forms, other times i am looking down on

them from a very distant vantage point.

i am touching and feeling form --- senses are activated and acute.

when i am this deep in the composition it is a very private, romantic,

insular and unique place to be.

a fellow creator and i were talking about the uniqueness of this experience,

we agreed it's like being in a movie.

that was the first half of my statement.

here is the second. . .it is my admission, my response to experimentation

and its dovetailing with computer type.

i don't like the premise of computer type for this book because i see

typography as being so much more.

in my mind, the computer is only a small part of things.

however it has evolved into too big a part.

this isn't probably going to change but shouldn't individuals monitor it?

everything is computer type now.

this is my point.

i find a shard of a letter in a rain gutter.

i glue it.

it gets scanned.

it becomes digital.

chances are this is its second time through the binary process.

we live in a day when typographic and human anatomy are increasingly

digitally governed

sometimes this frightens me and threatens and even debilitates my process.

what of the senses?

the act can still be digital free.

i am not saying it should be, only that it could be.

maybe experimentation is computer free,

flush left, rag right.

objective,

formal prowess, and restraint

two points of lead,

if this is the case then we have effectively turned things upside down.

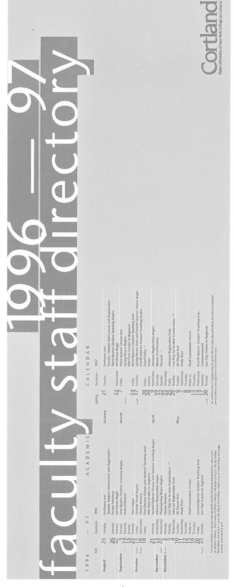

1

Faculty/staff directory
State University of New York
College at Cortland

dvc

semester	credit hours	department prefix	course number	course title
1	6 cr	CDE	611	Visual Communications Workshop
	3 cr	CDE	621	Visual Communications Seminar
	3 cr			Graduate Elective:
		CDE	692	Research/Individual Study
2	6 cr	CDE	611	Visual Communications Workshop
	3 cr	CDE	621	Visual Communications Seminar
	3 cr			Graduate Elective:
		CDE	692	Research/Individual Study
		CDE	631	Teaching Practicum
		CDE	519	Virtual Reality
		CDE	537	Integrated Electronic Information/ Communication Systems
3	6 cr	CDE	611	Visual Communications Workshop
	3 cr	CDE	621	Visual Communications Seminar
	3 cr			Graduate Elective:
		CDE	692	Research/Individual Study
4	6 cr	CDE	697	Directed Research
	6 cr	CDE	699	Creative Project Option
		CDE	799	or Thesis
	3 cr	CDE	692	Visual Communications Seminar

2

mfa
vcu

The Department of Communication Arts and Design develops the philosophy and personal direction of each student and focuses his/her resources on functional and expressive visual communications. To this end, the department develops the philosophy and personal direction of each student and focuses his/her resources on functional and expressive visual communications. The Department of Communication Arts and Design prepares graduate students to assume a leadership role in a complex and expanding profession. To this end, the department develops the philosophy and personal direction of concepts. The graduate program in Visual Communications is oriented toward individuals interested in pursuing a career in design education and/or furthering their professional practices, in conducting visual or theoretical research, and in investigating the intersection of function and expression in design problem solving. Students concentrate on the philosophical, communicative, and aesthetic relationships of visual problem solving and the interacting skills leading to the effective articulation of concepts. The department encourages and actively design encourages and actively basis for addressing present and future communication problems. The faculty emphasize a rigorous theoretical framework, an historical perspective, and an awareness of contemporary issues as the basis for addressing present and future communication problems. The faculty emphasize a rigorous theoretical framework, an historical perspective, and an awareness of contemporary issues design on society and culture and its capability to affect both the natural environment in its curriculum. Faculty continually stress the contextual significance and influence of visual communications design on society and culture and its capability to affect both the integrates ethical issues and a concern for the natural environment in its curriculum. Faculty continually stress the contextual perception and reality of the individual's quality of life.

master of fine arts
design visual communications
virginia commonwealth university
school of the arts

more
info
:
graduate program coordinator
vcu / dvc / cde
po box 842519
325 north harrison street
richmond, va
23284 2519
phone: 804 828 1709
fax: 804 828 8939
design : IVI0I_!n05!<!
paper man : polly, mfa, 93

2
Promotional poster
MFA Program in Visual
Communication
Virginia Commonwealth
University
Photography: Polly Johnson
3
Experimental hand puppets

3

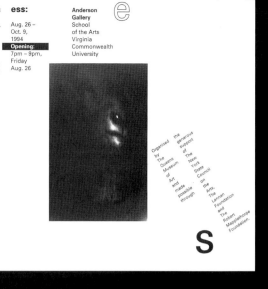

Charles C. Renick
15 Jan. – 28 Feb. 93

Opening: 23 Jan., 7 – 9 pm
Anderson Gallery
Virginia Commonwealth University
School of the Arts

Exhibition supported in part by the
Department of Sculpture,
and Susan, Martha, Aileen and Tim Renick

barbara ess:

Photography,

Installation

and Video,

S

Aug. 26 –
Oct. 9,
1994
Opening:
7pm – 9pm,
Friday
Aug. 26

**Anderson
Gallery**
School
of the Arts
Virginia
Commonwealth
University

e

Organized
by
The
Queens
Museum
of
Art
and
made
possible
through

the
generous
support
of
The
New
York
State
Council
on
the
Arts,
The
Lannan
Foundation
and
The
Robert
Mapplethorpe
Foundation.

S

4

5

4, 5
Exhibition postcards
Anderson Gallery
Virginia Commonwealth University
6
Faculty Biennial Announcement
Anderson Gallery
Virginia Commonwealth University

7
Visual identity program
Tom McLaughlin, Architect

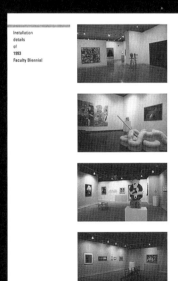

Installation
details
of
1993
Faculty Biennial

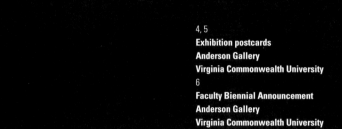

Opening: August 31, 6 — 9 pm

August 31 — September 24

Faculty Biennial
School of the Arts,
Virginia Commonwealth University

A diverse show featuring
School of the Arts' faculty.

19**95**

Opening: September 28, 6 — 9 pm

September 29 — October 20

Faculty Focus
Richard Carlyon
Myron Helfgott
Richard Kevorkian
Elizabeth King
Nancy Lensen-Tomasson
Jim Long
James Meyer
Carlton Newton
Allan Rosenbaum
Camden Whitehead

A new program of solo and small group
exhibitions by selected faculty throughout
the School of the Arts.

Hours:
10 am — 5pm Tuesday — Friday
1 pm — 5pm Saturday and Sunday

Tom McLaughlin

a r c h

i

ph + fax t e
804 231 6686

c

1110 t
West 42nd Street
Richmond, Virginia
2 3
2 2
5

Tom McLaughlin

architect

ph + fax
804 231 6686

1110
West 42nd Street
Richmond, Virginia
2 3 2
2
5

Tom McLaughlin

a r c h

i

ph + fax t e
804 231 6686

c

1110 t
West 42nd Street
Richmond, Virginia
23225

Tom McLaughlin

architect

1110
West 42nd Street
Richmond, Virginia 2 3 2
2
5

ph + fax
804 231 6686

Paul Sych

Paul Sych is a stalwart individualist who has invented an approach to typography based on the synthesis of two passions: design and music. Concurrently, Sych studied design at the Ontario College of Art, and jazz at York University. Upon leaving school, and after deciding he could not make it as a graphic designer, he made his living as a jazz musician. Seven years passed before he decided to re-enter the design field. Performing in the smoke-filled night clubs of Toronto proved a pivotal experience that undoubtedly nurtured his unique vision of graphic design practice.

Sych integrates that which he both sees and hears into a highly sensory and evocative typographic style, a rare blend of form and rhythm. His design process parallels musical improvisation in that it is highly intuitive spontaneous, and emotional. Sych describes structure in music as the number of bars in a piece of music. Within this structure is form consisting of melody, harmony, and rhythm, which may be freely interpreted. In design, structure is a problem's parameters, and the formal elements of color, shape, and texture may be freely explored in the course of solving a problem.

Sych is continuously influenced by what is happening in the world around him, but he ignores the trappings of conventions and trends. Looking at problems from the inside out rather than from the outside in, he attempts to take his audience (and himself) to where they have never been before. Because he is a visual adventurer who takes many risks, he relies entirely on the power of faith.

Sych's studio, appropriately named Faith, is located in Toronto, Canada. Studio involvements include a comprehensive range of design/advertising/ typographic projects for established international clients. Sych's clients have also learned to exercise faith as they hand projects over to him, but rarely do they impose restrictions, for they have gained confidence in the power of the visual messages that he creates through his experimental processes. The primary studio activity is typography, including typeface design. Among the fonts he has designed are *Dig, Dog,* and *Hip,* available from FontShop, and the *P.S. Faith* collection for ThirstType, which includes four fonts: *Wit, Toy, Fix, and U.S.*

Despite the fact that technology is inextricably linked to Sych's creative process, he believes that the computer is no substitute for good ideas and that it is not the most important tool for graphic designers. Often, Sych makes rough, hand-drawn sketches that are scanned and then placed into the computer to be used as a template for further development. Then, as in a good jam session, he experiments with the arrangement of line, shape, color, and type, constructing, deconstructing, and synthesizing these elements until an image emerges, a blend of harmony and emotion.

Sych's typographic designs are charged with emotion, a quality that lures viewers into them, providing exotic experiences far beyond expectation. His goal is always to excite his audience in some way, to stretch the imagination, to provoke. His work is either loved or hated; but regardless of opinion, it continues to make a profound impact on the international typographic scene.

In recent years, I have made an attempt to focus my Design and Typographic sensibility into a distinct and personalized vision. In this endeavour, my curiosity, suspicion and trepidation with regard to design have become the driving forces behind the manifestation of my emotions on paper - in a truly honest and sincere way. As a jazz musician, my musical peers have been a unique inspiration to me and I have striven to isolate the spirit in which their self-expression is employed and to understand the methods by which they create their own artistic voice. I have listened not for the outward musical devices that make up who they are, but rather for those that define who they have become. These are the principles that guide my work and which nurture my typographic sensibility.

It has been a difficult process for me to bridge these parallels between the musical and visual arts, but at the same time it has represented an exciting challenge for me. Through an ongoing visual experimentation I have come to understand who I have become and where I am going. This period of evolution has been met, like anything new or different, with criticism and rejection; but these criticisms have only helped nurture and develop my current work and have helped me to regain a trust in myself and what I have to say visually.

I feel especially fortunate that Rob Carter has invited me to participate in this book and, through these typographic experiments, it has enabled me to contribute a body of work that is entirely personal and unbridled by rules or commercial considerations. I hope that these works are received favourably more as a reflection of my own personal vision and not simply as a demonstration of technical and creative artifice.

1

2

3

4

1-3
Promotional posters
for Annan and Sons Trade
Lithography
4
Self-promotional postcard:
faith

portfolio

5-7
Self-promotional postcards:
Our Father
Rip Off
Flower Power

5

6

Either Or:
**Which way to go, good or
bad, happy or sad.**

experiment

Be Thy Name:
To believe in oneself – no matter who we are, and the uniqueness of us as individuals.

Popeye:
A tribute to Popeye who was my idol when I was 10, and how I visualize his persona today.

AND (Traffic Grafic)
Spalenvorstadt 11
4051 Basel
Switzerland

Cahan & Associates
818 Brannan Street,
Suite 300 San Francisco,
California 94103

David Colley
2820 East Grace Street
Richmond, Virginia 23223

Drenttel Doyle Partners
1123 Broadway
New York, New York 10010

Ernest Bernhardi
Communication Arts and Design
School of the Arts
Virginia Commonwealth
University
P.O. Box 842519
Richmond, Virginia 23284-2519

**Hornall Anderson Design
Works, Inc.**
1008 Western, 6th Floor
Seattle, Washington 98104

Hutchinson Associates, Inc.
1147 West Ohio, Suite 305
Chicago, Illinois 60622

John Malinoski
2508 East Franklin Street
Richmond, Virginia 23223

Kode Associates, Inc.
54 West 22 Street
New York,
New York 10010-5811

Mark Oldach Design, Ltd.
3316 N. Lincoln Avenue
Chicago, Illinois 60657

Minelli Design
381 Congress Street, 5th Floor
Boston, Massachusetts 02210

Philip B. Meggs
10211 Windbluff Drive
Richmond, Virginia 23233

Planet Design Co.
605 Williamson Street
Madison, Wisconsin 53703

Rob Carter Design
603 West 30th Street
Richmond, Virginia 23225

Scott Allison
Communication Arts and
Design School of the Arts
Virginia Commonwealth
University
P.O. Box 842519
Richmond, Virginia 23284-2519

Skolos/Wedell
529 Main Street
Charlestown,
Massachusetts 02129

Stoltze Design
49 Melcher Street
Boston, Massachusetts
02210

Willi Kunz Associates, Inc.
2112 Broadway
New York, New York 10023

Elliott Peter Earls
82 East Elm Street
Greenwich, Connecticut 06830

Jean-Benoît Lévy
Spalenvorstadt 11
4051 Basel
Switzerland

Paul Sych
1179a King Street West #202
Toronto, Ontario
M6K 3C5 Canada

Students from Rob Carter's class in Experimental Typography whose work appears in Chapter 3:

Typography workshop participants from the Graduate Program, Communication Arts and Design at Virginia Commonwealth University (CDE) and the Gerrit Rietveld Academy (GRA):

	Faculty:	Students:	Guest critics:
Timea Adrian	Wigger Bierma (GRA)	Christine Alberts (GRA)	Ned Drew, New York City
Ginger Cho	Rob Carter (CDE)	Sheila Barrett (CDE)	Brad Rhodes, Boston
Ann Ford	David Colley (CDE)	Erik Brandt (CDE)	Sandy Wheeler, Boston
Krysta Higham	Ben Day (CDE)	Persijn Broersen (GRA)	Camden Whitehead, Richmond
Veronica Ledford	John DeMao (CDE)	Esther de Vries (GRA)	
Jesus Palacios	Leo Divendal (GRA)	Libby Hiller (CDE)	
Kelly Perkins	Aaf van Essen (GRA)	Kristin Hughes (CDE)	
Priya Rama	Henk Groenendijk (GRA)	Harmen Liemburg (GRA)	
Chris Raymond	Victor Levie (GRA)	Margit Lukacs (GRA)	
Rosemary Sabatino	John Malinoski (CDE)	Jennifer McMaster (CDE)	
Joshua Sandage	Roy McKelvey (CDE)	Margaret Pharr (CDE)	
Minh Ta	Mary McLaughlin (CDE)	Nicolet Schouten (GRA)	
San Van	Philip Meggs (CDE)	Yael Seggev (GRA)	
	Akira Ouchi (CDE)	Jason Smith (CDE)	
		Barbara Spies (CDE)	
		Dima Stefanova (GRA)	
		Monika Wiechowska (GRA)	
		Judith van der Aar (GRA)	
		Michel van Duyvenbode (GRA)	
		Sonja van Hamel (GRA)	
		Barbara van Ruyven (GRA)	

Acknowledgements

The realization of this book would not have been possible were it not for the generosity, support, and commitment of several people. My warmest thanks go to all the featured designers whose excellent work grace these pages. The four profiled designers, Elliott Peter Earls, Jean-Benoît Lévy, John Malinoski, and Paul Sych contributed many hours of precious time, providing information and samples of their work, preparing statements, and making typographic experiments specifically for this book. I thank them sincerely. My very talented student, Minh Ta, shared his typographic journey by designing and writing part one of Chapter 8. Kristin Hughes provided the experiments for the book's front and back pages, and Erik Brandt designed the chapter division pages in the experimental typography sections. Profound thanks go to Simon den Hartog, Victor Levie, and the students and faculty of the Gerrit Rietveld Academy in Amsterdam. The exchanges have yielded significant experiences, ideas, and lifelong friendships.

I am indebted to poet Adrienne Rich whose poem inspired and informed the experimental typography workshop. As always, my regarded colleagues Philip Meggs, John Malinoski, and Sandy Wheeler shared gentle but cogent criticism. As copy editor, Diana Lively brought precision and refinement to the book. My daughters Molly and Mindy Carter read the manuscript and provided excellent feedback. At Virginia Commonwealth University, Richard Toscan and John DeMao provided support and encouragement. Jerry Bates provided technical support and resources. I am deeply indebted to Brian Morris, Barbara Mercer, Angie Patchell, Kate Noel-Paton, and Luke Herriott at Rotovision for their continuing support and confidence in this project. My climbing partner, Jamie McGrath, energized me with his spirit and friendship.